Speed — Visions of an Accelerated Age

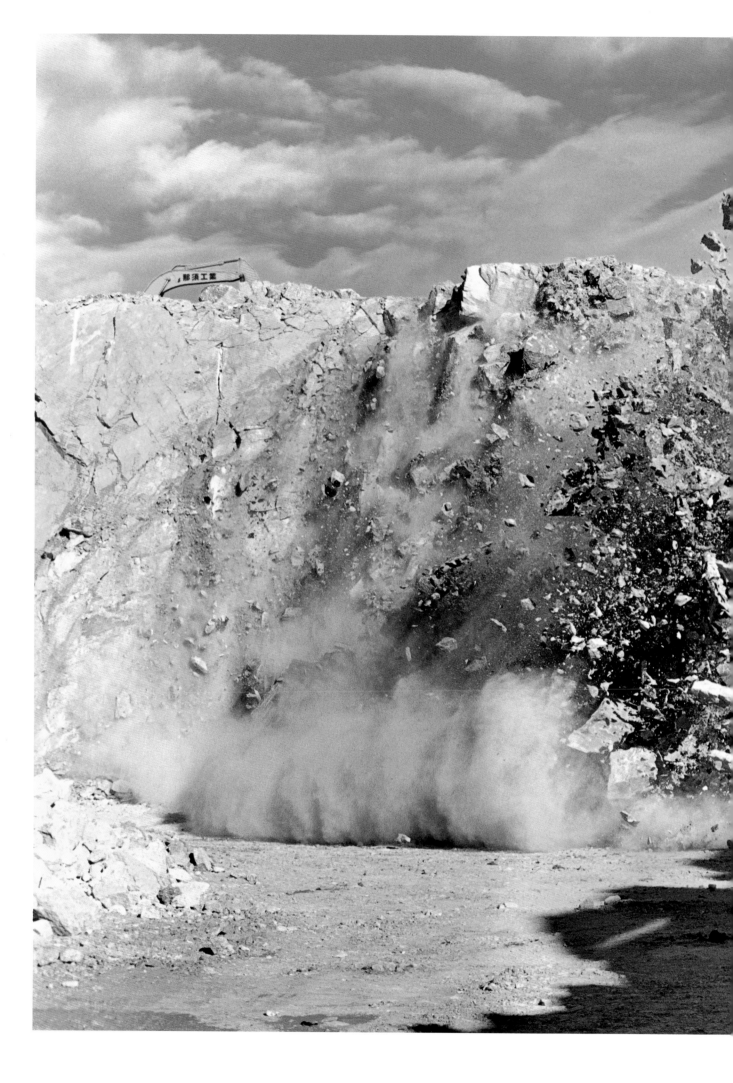

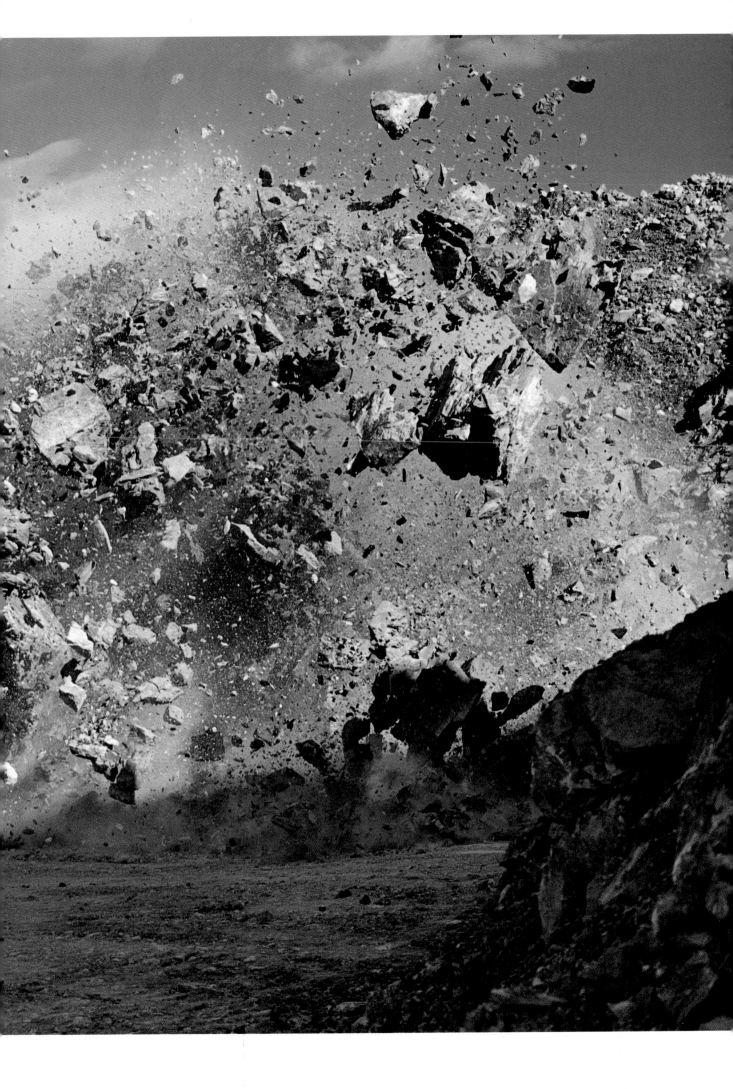

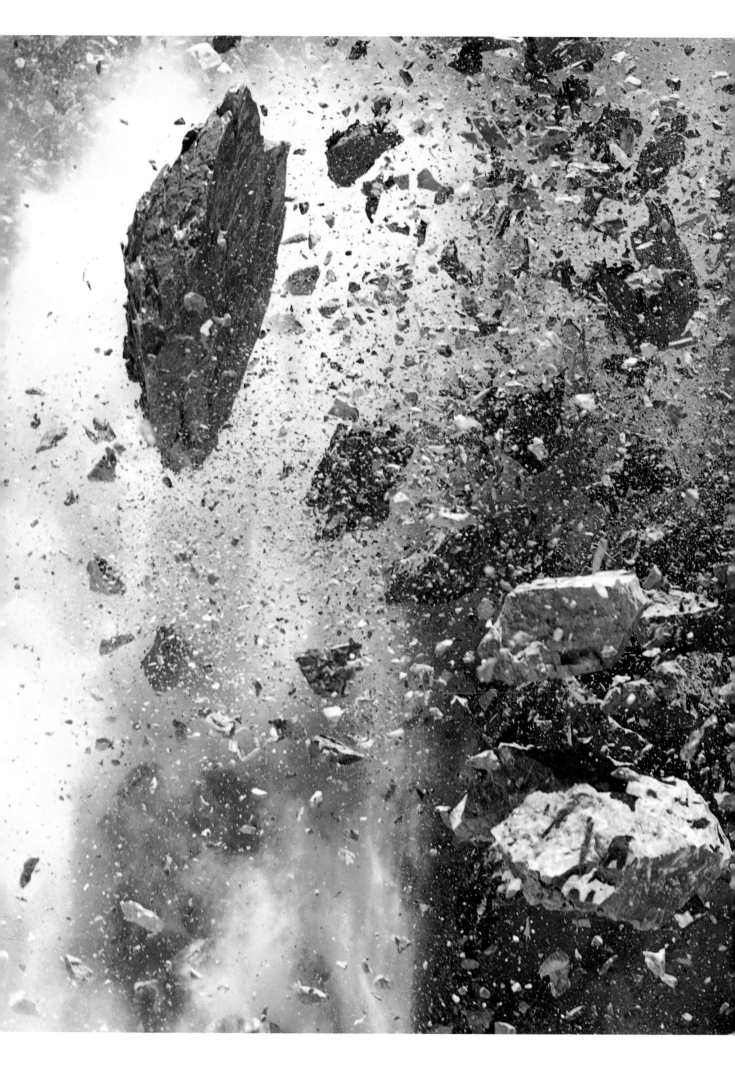

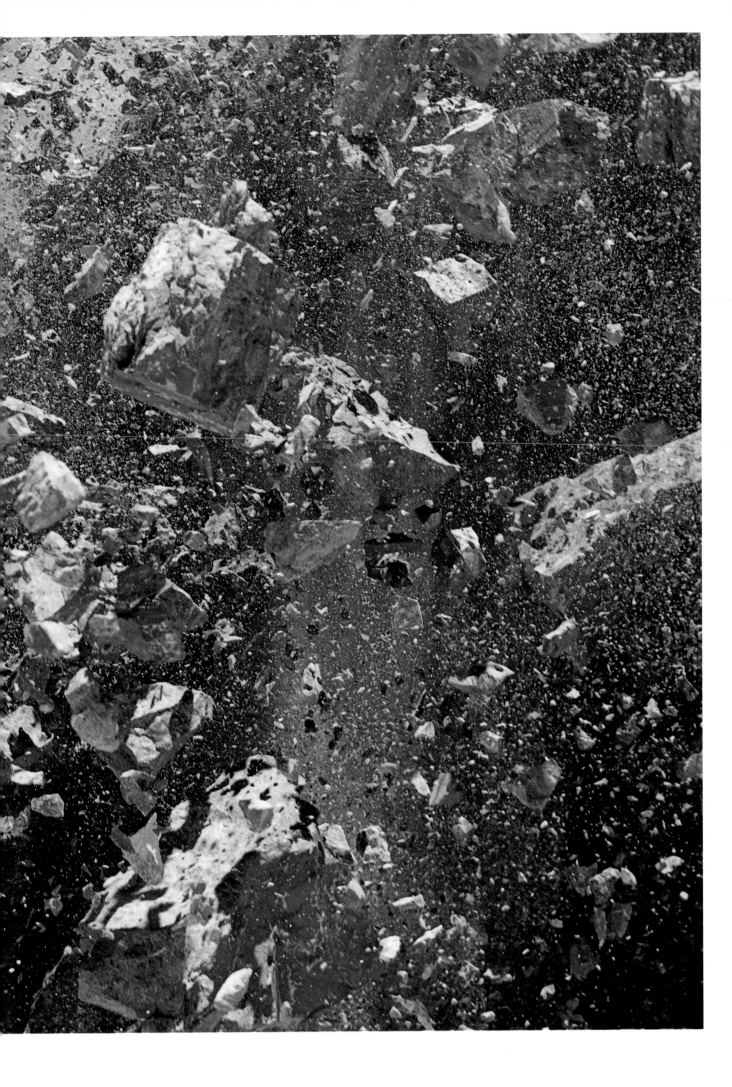

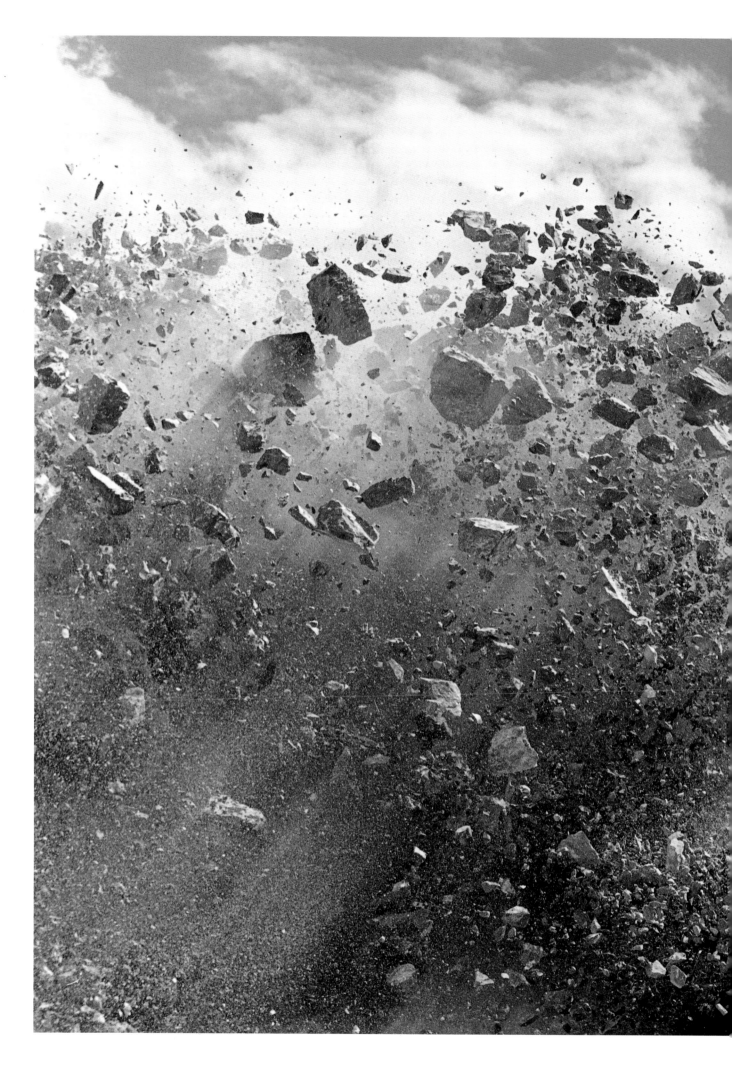

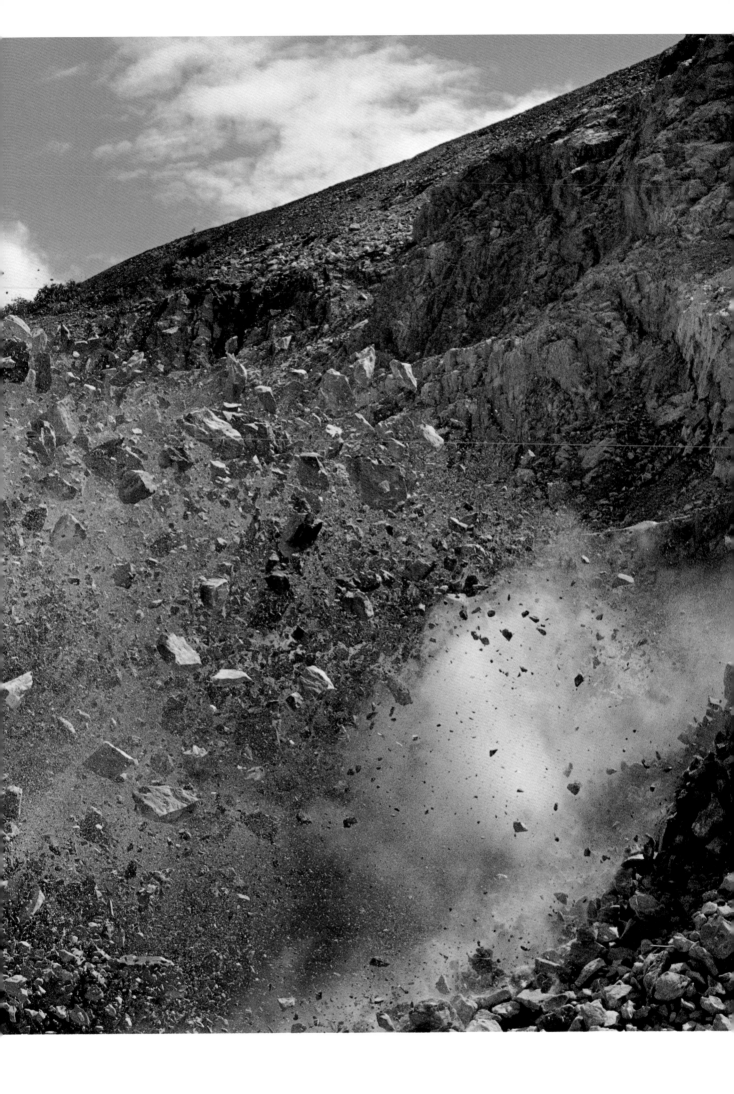

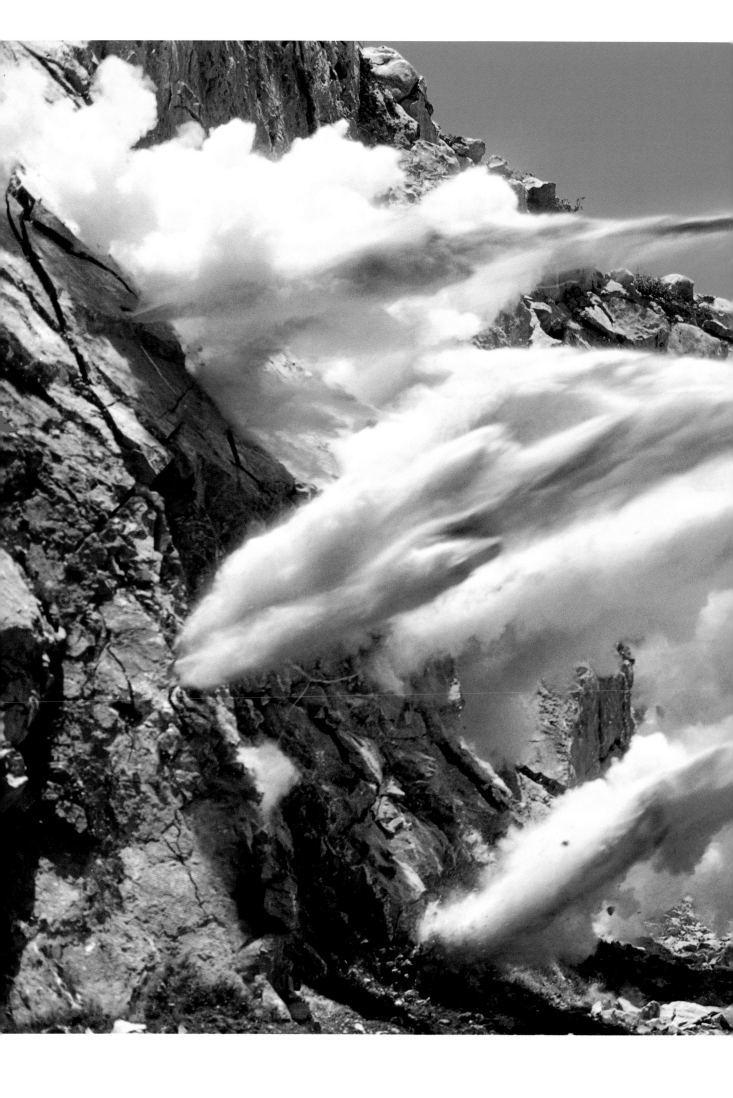

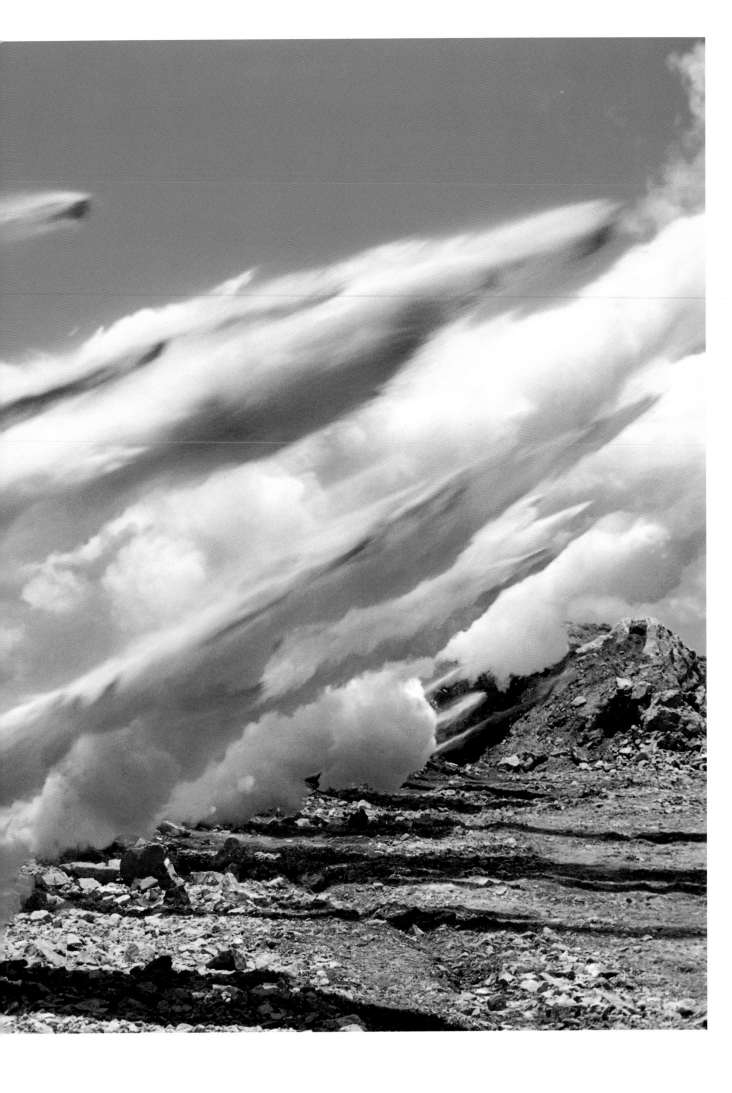

Speed — Visions of an Accelerated Age

Edited by Jeremy Millar and Michiel Schwarz

Published by The Photographers' Gallery, London and the Trustees of the Whitechapel Art Gallery, in association with the Macdonald Stewart Art Centre, Guelph and the Netherlands Design Institute, Amsterdam.

Designed by North

Previous pages 2–9
Naoya Hatakeyama
Photographs from the Blast series 1995–98
Colour C-Type photographs
Each 100 x 150cm
Courtesy the artist

Catherine Lampert and Paul Wombell
Foreword

The realisation of ambitious projects sometimes requires the resources of more than one organisation. Some projects necessitate new forms of collaboration and partnerships. Some projects are of their time. Speed is such a project.

Speed has brought together four different cultural organisations which have not previously collaborated, either because of their own historical backgrounds and professional remit or because of geography. This is the first time that The Photographers' Gallery and Whitechapel Art Gallery have worked together on such a large project which has grown to include two international partners, the Netherlands Design Institute in Amsterdam and the Macdonald Stewart Art Centre in Guelph, Ontario. Each organisation has brought to the project their own particular skills and knowledge of art, photography and design. We wish to thank our international partners for joining us in this enterprise.

Speed — Visions of an Accelerated Age was originally conceived by Jeremy Millar and Michiel Schwarz. The theme of speed was subsequently introduced by Michiel Schwarz at the Doors of Perception conference organised by the Netherlands Design Institute, Amsterdam in 1996, which he co-directed. This conference, and the accompanying exhibition The Speed of Light, The Speed of Sound curated by Jeremy Millar and held at the Netherlands Design Institute, played an important role in the highlighting of themes and issues which have been further developed in this publication. Jeremy Millar has acted as curator for the exhibitions Speed at The Photographers' Gallery and the Whitechapel Art Gallery, where the hard work of Suzanne Cotter and Sarah Martin has been crucial to the success of this project. The exhibition at the Macdonald Stewart Art Centre has been curated with Nancy Campbell, and we are grateful to her for her support of the project.

The Whitechapel Art Gallery has a long record of presenting thematic exhibitions which draw together the ideas of living artists and evidence of historical and contemporary material; This is Tomorrow in 1956 is among the most remembered. More recently, The Photographers' Gallery has presented thematic exhibitions exploring the relationship between technology and culture, Airport being the most recent of these exhibitions held in the autumn of 1997.

We are indebted to the museums, galleries, private collectors and artists who have generously lent important works to Speed.

The exhibition required the additional support of both the private and public funding sectors. We would like to thank Beck's Bier and London Arts Board for supporting The Photographers' Gallery. Speed at the Whitechapel Art Gallery has been supported by Horace W. Goldsmith Foundation, The Henry Moore Foundation and Royal Mail.

We also wish to extend our sincerest gratitude to The Arts Council of England who have so generously supported initial research as well as the publication of this book along with the Netherlands Design Institute and the Macdonald Stewart Art Centre.

We are particularly grateful to the writers and publishers who have granted permission to reprint texts within this book, and in particular Peter Wollen for his new essay on speed within film, and JG Ballard for his extended captions written to accompany photographs selected by the editors.

Finally, we wish to thank the artists, photographers, and owners of images reproduced here, together with the creative involvement of North without which this book would not have been possible.

Catherine Lampert, Director
Whitechapel Art Gallery, London

Paul Wombell, Director
The Photographers' Gallery, London

At the Whitechapel Art Gallery, _Speed_ has been generously supported by the Horace W. Goldsmith Foundation, The Henry Moore Foundation and Royal Mail.

The Whitechapel Art Gallery is also grateful to Her Majesty's Government for its help in agreeing to indemnify many loans within the exhibition under the terms of the National Heritage Act 1980, and to the Museums and Galleries Commission for its assistance in arranging this indemnity.

At The Photographers' Gallery, _Speed_ has been supported by Beck's and London Arts Board.

The organisers at The Photographers' Gallery and the Whitechapel Art Gallery also wish to thank the following people for their invaluable advice, support, and collaboration on _Speed_:

Zeev Aram, John Austin, Theo Baart, Nick Barley, Ian Barker, Julian Barran, Tim Beard, Jacques Beauffet, Robert P. Bergman, Christiane Berndes, Monica Biondi, Pierre Bismuth, Steven Bode, Jean-Michel Bouhours, Iwona Blazwick, René Block, Tanya Bonakdar, Paul Bonaventura, Mark Edelman Boren, Simon Browning, Chris Burden, Dr. Steve Bury, Kate Bush, Martin Caiger-Smith, Richard Calvocoressi, The Canadian High Commission, Vija Celmins, Bernard Ceysson, Sylvia Chivaratanond, Kitty Cleary, Tim Clifford, Beverley Cole, Catriona Colledge, Richard Cork, Walter Cotten, Martin Creed, Jan Debbaut, Nick Devlin, Jo Digger, Judy Digney, Diller + Scofidio, Gregory Eades, Joost Elffers, David Elliot, Kowdo Eshun, Karen Eslea, Mark Fletcher, David Fitzgerald, Kathleen Flanagan, Gerard Forde, Mark Francis, Simonetta Fraquelli, Professor Christopher Frayling, Rudi Fuchs, Carlotta Gelmetti, Luke Gertler, Sarah Glennie, Adrian Glew, Manuel González, Robert Graham, Rodney Graham, Cornelia Grassi, Robert Greene, Catherine Gryparis, Graham Gussin, Maarten Hajer, Siobhán Hapaska, Nancy Holt, Antonio Homem, Rebecca Hurst, Elisabeth Kaufmann, Fritz Keers, Martin Kemp, Els Kerremans, Liz Kilburn, Hannah King, Jari Lager, Lisa Le Feuvre, Barry Le Va, Maria Lind, James Lingwood, Irvin Lippman, Katy Lucas, Ilona Lütken, Rody Luton, Conor Maklin, Patrick McCaughey, Sheila McGregor, Francis McKee, David and Renée McKee, Alex McLennan, Julian Markson, Gustav Metzger, Frances Morris, Jeff Nelson, Hans-Ulrich Obrist, Barbara O'Connor, Eduardo Paolozzi, Sean Perkins, James Peto, Paul Ramírez Jonas, Alan Read, Andrew Ross, Ed Ruscha, Jan Hein Sassen, Alfons Schilling, Nicholas Serota, Augusto Alves da Silva, James Slaughter, Matthew Slotover, Leo Smith, Tom Sokolowski, Gert Staal, Staatsgalerie Stuttgart. Archiv Sohm, Kate Stephens, Graham Tanner, John Thackara, Paul Thompson, Joanna Thornberry, Jan Van Der Wateren, John Weber, Toby Webster, Angela Weight, Lawrence Weiner, Nina Williams, Andrew Wilson, Nick Wise, Susan Yamamoto, Zwemmers Bookshop.

Colophon

Speed — Visions of an Accelerated Age is published by The Photographers' Gallery, London and the Trustees of the Whitechapel Art Gallery, in association with the Macdonald Stewart Art Centre, Guelph and the Netherlands Design Institute, Amsterdam, 1998.

Edited by Jeremy Millar & Michiel Schwarz

Editorial assistance by Suzanne Cotter, Sarah Martin and Sylvia Chivaratanond.

Designed by North

Printed by CTD Printers Ltd, Twickenham
ISBN 0907879543

The Photographers' Gallery, 5 Great Newport Street, London WC2H 7HY, England

Whitechapel Art Gallery, 80–82 Whitechapel High Street, London E1 7QX, England

Macdonald Stewart Art Centre, 358 Gordon Street, Guelph, Ontario, Canada N1G 1Y1

Netherlands Design Institute, Keizergracht 609, NL–1017 DS Amsterdam

Royal Mail

Ontario

PHOTODISC®

The Henry Moore Foundation

Horace W Goldsmith Foundation

Funded by THE ARTS COUNCIL OF ENGLAND

LBG
This organisation is funded by London Boroughs Grants

LONDON ARTS BOARD

Contents

Susan George
Fast Castes
Page 115

Wolfgang Sachs
Speed Limits
Page 123

Helga Nowotny
Time — The Longing for the Moment
Page 133

Mark Kingwell
Fast Forward
Page 141

Ivan Illich, Matthias Rieger and Sebastian Trapp
Speed? What Speed?
Page 148

About the authors
Page 160

Lenders to the exhibition
Page 164

Catalogue of works
Page 166

Photo and text credits
Page 170

Catherine Lampert and Paul Wombell
Foreword
Page 13

Jeremy Millar and Michiel Schwarz
Introduction — Speed is a Vehicle
Page 16

Blaise Cendrars
Profound Today
Page 24

Scott McQuire
Pure Speed — From Transport to Teleport
Page 26

Paul Virilio
The Last Vehicle
Page 32

JG Ballard
Impressions of Speed
Pages 32–55

Peter Sloterdijk
Modernity as Mobilisation
Page 43

Robert Musil
Kakania
Page 53

Edward Dimendberg
The Will to Motorisation — Cinema and the Autobahn
Page 56

Kristin Ross
La Belle Américaine — Car Culture in Post-War France
Page 71

Peter Wollen
The Crowd Roars — Suspense and Cinema
Page 77

Jeremy Millar
Rejectamenta
Page 87

Nancy Campbell and Judith Nasby
Qamanittuaq
Page 89

Jeremy Millar and Michiel Schwarz
Introduction — Speed is a Vehicle

A few years ago, there was a short newspaper article which contained a description of Vanishing Point, a rocket-powered car. The car, based upon a 1981 Ford Mustang chassis, was said to consume 20 gallons of hydrogen peroxide per quarter-mile, produce 28,000hp and accelerate from 0–396mph in 3.58 seconds, passing 100mph in 0.36 seconds. On each run, Sammy Miller, Vanishing Point's driver, would have his heart, liver and kidneys crushed by the 13g thrust, his ears and nose would bleed and he would also be blinded. Speed has exiled him both from himself and the outside world.

Speed is all around us; we can feel its effects even if we are unable to see it. Speed is both forceful and immaterial, like the turbulence from a moving vehicle, like the thrust of a jet, like a good idea. Speed can blow us away.

The twentieth century is without doubt the century of speed. It is true, certainly, that the possession of speed has also been desirable in previous centuries — it is a desire which can be found in Goethe's Faust, for example, or 'The English Mail-Coach' of Thomas De Quincey — but never before has such a desire been so completely met. It is now possible to see the complete works of Shakespeare in three hours or hear a great symphony condensed to the refrain from some advertisement, or other. Television, that great cultural particle accelerator, is one continuous battle against the clock, whether it be to alter a garden within forty-eight hours or to cook a meal within twenty minutes, to complete a report while live via satellite or to hold peoples' attentions for long enough that they can then be sold to advertising corporations.

It is desire which appears central to any consideration of speed. Usually, if reference is made to speed, it is as the by-product of some other action, or development. The jet engine is faster than the petrol engine, which is, in turn, faster than a horse-drawn carriage. Likewise, the e-mail and fax are more rapid than the post. If our lives are being accelerated, then this is usually seen as merely the outcome of technical refinements. Objects are improved, things get faster; within our technological culture, this is known as progress. Perhaps it is now time, as we near this century's end, the end of this millennium, to reconsider these revolutions — the transport revolution, the communications revolution, others too, in politics, and art — as wheels within wheels, epicycles within one larger orbit: The Speed Revolution.

Viewed in these terms, speed is not so much a product of our culture as our culture is a product of speed. Speed is not something that just happens; it is chosen, desired, and it has been desired again and again. As the photographic captions written by JG Ballard for this book testify, this will-to-speed is present wherever we may look, yet its very familiarity may hide it from our gaze. Sammy Miller was blinded by rapid acceleration; we also know that we are travelling at high-speed, but we, too, are no longer conscious of it. It is an aim of this book to make us conscious once more.

While 'speed' refers to the rate at which something occurs, the rate to which it now refers is almost exclusively quick. This simple transformation, that speed now means going fast, in itself speaks volumes of our accelerated age. Yet while this may be what we mean by speed, it is not in rapid situations that we notice its presence. Indeed, speed is often only made apparent by what we moderns would perceive of as its lack, that is, slowness. We are aware of speed when we sit, fog-bound, in an airport lounge; we are aware of speed as we watch the coloured indicator bar on our computer screen creeping pixel by pixel as pages are drained from the internet; we are aware of speed when we wait for the photocopier to warm up in order that that report can be on a colleague's desk, as promised, before they arrive in the morning. And we haven't even mentioned traffic jams, with drivers overheating more rapidly than their car engines. Yet while any person from two hundred years ago, one hundred years ago, fifty, twenty years ago would almost certainly be astonished by the rapidity of our actions, of what we can achieve, instead we sit, fingers tapping, like some super-charged biological metronome. It is as a result of the increased speed of our lives that we now get impatient more quickly than ever before. Constant acceleration is the one constant in our experience of modernity. Speed has become a self-fulfiling prophecy. Speed, itself, has got faster.

The car provides an obvious, if incredibly powerful, example of the effect of speed upon all our lives; there are many others. These effects are often synonymous with the effects of a spreading globalisation, where slower local cultures are displaced by an accelerated global monoculture. Tourism now consists, for the most part, of the inhabitants of Western cities 'getting away from it', and in doing so recreating 'it' wherever they go. Choose not to have 'fast-food'? In some places there is no longer another choice. Both local currency and local customs are being homogenised by the speed of globalism, whether by tourists or the credit cards they wield.

Sometimes the money is even more immaterial, the effects even more devastating. As Susan George notes, George Soros made a billion dollars in a couple of days speculating against sterling; the French Central Bank lost all its foreign currency reserves overnight attempting to prop up the franc against a similar financial onslaught. More damaging, however, was the effect when billions of dollars were removed by financial speculators from the Mexican economy in a few hours in December 1994. The peso collapsed, leaving increased unemployment, malnutrition and crime in its wake. Even those people working within the cycles of a local economy are not safe from the effects of 'Mach 3' financial capital or the incredible turbulence which its movements create.

Perhaps we are approaching an understanding of speed as a tool for cultural analysis, alongside subjects such as race, class or gender. 'Speed offers a way into the entirety of the world and offers a key for reading it,' the French philosopher Paul Virilio has pertinently remarked. Power relations could become analysed not only in terms of capital, but also in terms of the 'speed' of those concerned, whether it be local farmers or the 'fast castes' which George identifies. Speed is a vehicle which allows us to explore the complex ways in which different phenomena interact, without becoming frustrated by the constraints imposed by some forms of cultural analysis. It has allowed us to collect writings from political scientists and environmentalists, philosophers and novelists, images from major museums and commercial photographic agencies. In bringing together material from such diverse sources, we have been able to explore more fully our culture at the end of the first speed age.

Environmental matters could also be considered within a politics of speed. In his essay, Wolfgang Sachs alerts us to the rather alarming fact that each year, world industry consumes as much fossil fuel as it takes the earth to produce in one million years. Such an enormous discrepancy between these two rates, of human consumption and of natural production, highlights an area of industrial acceleration which we do not often consider. We may be able to travel further, and faster, than ever before (or at least some of us can, some of the time), but we must consider at what price, particularly the price to those who have no choice, or have chosen not to travel. We are certainly paying less than the real cost, at least at present. However, there is another resource being consumed here, scarce and non-renewable also, and that is time. Perhaps it is this, more than anything else, that is being bought with each barrel.

If speed has become an attribute, it is perceived as a desirable one. Numerous companies promote themselves in terms of either the swiftness of their services, or their round-the-clock availability (early in the morning, they amount to the same thing). To possess speed is to be modern; to control speed rather than be controlled by it is perhaps the most important form of contemporary power. In order that we might identify ourselves more fully with this power, this twentieth-century drive, we have absorbed speed into our own sense of identity. Speed is not only, as Scott McQuire has remarked, the 'mechanical soul of modernity'; we have also internalised its spirit of modernity. We appreciate the quick answer, the snap judgement, rather than careful consideration or quiet deliberation. Decisiveness is a strength; contemplation a weakness.

Of course, this has had enormous implications for art this century. It has always been true, in a technical sense, that visual art travels at the speed of light, yet the image reflected off a Claude painting and penetrating our eyes at the velocity of a nuclear flash seems to slow sufficiently so that we, too, may rest idly in the idyll. However, if, as Fernand Léger wrote in 1914, 'modern man registers a hundred times more sensory impressions than an eighteenth-century artist,' then modern art must be able to withstand such an intensified relationship to its viewer. As such, it has often accelerated its images, streamlining them, lessening their resistance, in order that they may be perceived more quickly. Art has borrowed heavily from illustration and graphic design this century; the

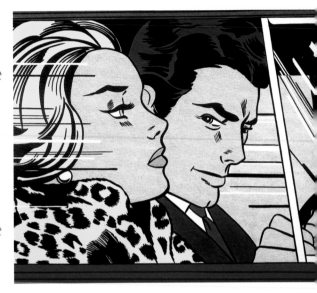

Roy Lichtenstein
In the Car 1963
Oil and magma on canvas
172 x 203.5cm
Scottish National Gallery of Modern Art, Edinburgh

'In modern life "all that is solid melts into air". The innate dynamism of the modern economy, and of the culture that grows from this economy, annihilates everything that it creates — physical environments, social institutions, meta-physical ideas, artistic visions, moral values — in order to create more, to go on endlessly creating the world anew. This drive draws all modern men and women into its orbit, and forces us all to grapple with the question of what is real in the maelstrom in which we move and live.'

Marshall Berman,
All that is Solid Melts into Air
1983

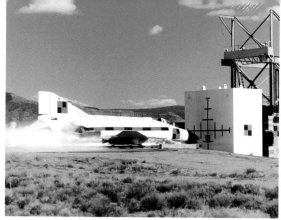

*F–4 Fighter Jet
Rocket Sled Test*

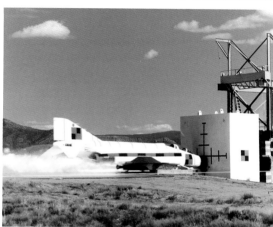

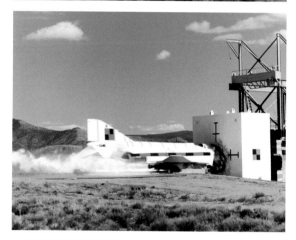

'The motor age has
forced speed on us as
a measurable quantity,
the records of which
are milestones in the
history of the progress
of both men and
machines. But mental
speed cannot be
measured and does not
allow comparisons or
competitions; nor can
it display its results in
a historical perspective.
Mental speed is valuable
for its own sake, for the
pleasure it gives to
anyone who is sensitive
to such a thing, and not
for the practical use that
can be made of it. A
swift piece of reasoning
is not necessarily better
than a long pondered
one, far from it, but
communicates something
special that is derived
from its very swiftness.'

Italo Calvino
<u>Six Memos for the Next
Millennium</u> 1992

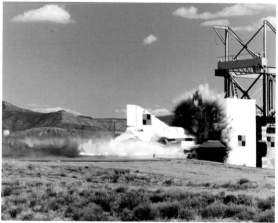

complement has been returned, with a more rapid assimilation of artistic movements within the mass media.

Perhaps the greatest developments within the speed of art concern the increased rate of production of the artist rather than of reception by the viewer. Andy Warhol famously declared that any painting which takes longer than five minutes to make is a bad painting, a comment which perhaps goes some way to explain his fascination with Jackson Pollock, who became emblematic of a form of accelerated art-making. Perhaps even more than his embrace of the technologies of artistic reproduction — the silkscreen, the cinema, the photograph and the polaroid — or the use of pop cultural images within his own artworks, it is his understanding of the soundbite which makes Warhol such an exemplary modern artist (and we mean exemplary in its judicial sense also). Yet speed in the making of art lies not only in an embrace of mass media imagery or its techniques. In art as in industry, manufacturing practices have developed radically this century. If the factory thrived on a division of labour, the artist's studio did likewise. Through the readymade technique of Marcel Duchamp, the artist need no longer make an object to make an artwork — he need simply choose one. As Boris Groys has remarked, 'Today it is enough for an artist to look at and name any chosen fragment of reality in order to transform it into a work of art The readymade technique is probably the greatest technical achievement of the twentieth century next to the splitting of the atom, if you take speed as the decisive criterion.'

If two objects, travelling at different speeds, touch, then friction is produced. Friction can become heat, light and noise, a reasonable description in itself of European culture at the turn of the century. It is hardly surprising that the Futurist movement, arguably the most radical and influential artistic movement of the twentieth-century, emerged from Italy, a country at once dynamised by the early technologies of speed — the cinema, the car, the telegraph, the radio — yet surrounded by antiquity. Like many of the historical avant-gardes, it threatened to destroy all that came before in order that it might be liberated from the weight of history. The area of human activity which was traditionally seen as both timeless and unchanging became subject to what Wyndham Lewis, himself no stranger to the avant-garde, disdainfully referred to as 'the demon of progress in the arts'. It is a demon which resides at the heart of our technological culture.

It is also a demon which is rarely questioned, so fundamental is it to our ideas of contemporary culture. As Peter Sloterdijk remarks, 'Progress is movement to move, movement to move more, movement to increase the possibility to move.' Our ability to move, therefore, is inextricably linked to our ability to be progressive, to be modern, inextricably linked with our own sense of identity, or of how we would to be identified. Speed is as desirable for an individual as it is for a company, and it is as desirable for a country as it is for an individual. Edward Dimendberg's essay shows how the Nazis combined the technical developments of the autobahn and the mass-produced family car with a romantic sense of landscape to create a national identity which was at once ancient and modern, historically rooted and technologically advanced. There was friction here also, as there always is with movement at different speeds, but skillful propaganda and an accelerated

politics soon ensured that these became a barely perceived blur. It has been said that the destruction of the First World War was the result, in part, of nineteenth-century thought being unable to cope with twentieth-century technology. The rise of Nazi Germany would have been impossible without such technologies also, although their use had by this time been mastered. As Hitler himself remarked, 'Without automobile, airplane, and loudspeaker, the conquest of power would not be possible.' Dimendberg's investigation shows how both the cinema and photography also played their part in that conquest.

If, in the cinema of Nazi Germany, motorisation was seen as means of consolidating national identity, then in many French films of the 1950s and 1960s, it was seen as a threat. As Kristin Ross makes clear, the car marked the advent of modernisation in France, and with it came the danger of an invasion of American culture. An American car within such films came to symbolise a sense of intrusion, an intrusion which often had unfortunate consequences, a friction produced by the speed of American consumerism coming into contact with a slowly-modernising post-War France. In Jacques Dhery's comedy La belle américaine, which gives Ross' essay its title, a luxury American convertible brings bad luck to the young couple who take possession of it. It is only when the car crashes into the local horse-drawn ice-cream cart, and the convertible must then take on the cart's role, that order is restored. It is a story of cultural integration, where the beneficial aspects of an outside culture can be absorbed while its corruption is left behind, and where one can modernise without losing one's sense of identity.

If speed is getting faster, where is it more quickly taking us? To the technocratic mind earlier in this century, technological speed would lead to a form of utopia. For Lenin, borrowing the techniques of Scientific Management and the production line from Frederick Winslow Taylor and Henry Ford, rapidly increased production would be used to create a new form of society. The Nazis had a similar idea, although in their irrational deployment of 'rationalist' procedures, mass production instead became mass destruction. Despite the permanent shadows etched at light-speed onto humanity by the flashes above Hiroshima and Nagasaki, speed remained an agent of hope after World War II. Publications such as The Wonder Book of Speed are little more than receipts for a technologically-enhanced future for which we were awaiting delivery. Yet some people had already been examining the warranty, questioning whether it wasn't too late to obtain a refund, or at least request some form of credit note. Yevgeny Zamyatin's We (1920) and Aldous Huxley's Brave New World (1932) are both dystopias extrapolated from the practices of Taylor and Ford respectively, visions of a scientific society which, as Bertrand Russell pointed out, 'is incompatible with the pursuit of truth, with love, with art, with spontaneous delight, with every ideal that men have hitherto cherished'. Perhaps we should recall another of Russell's remarks, concerning the actions of a person bathing in water, the temperature of which is steadily increasing by one degree every hour. After all these years, what is the temperature of that water now, and at what point should we begin to scream?

For many people, including many of the contributors to this volume, the answer is 'Now'. Even if we, as individuals, have not chosen 'speed',

O BRAVE NEW WORLD
THAT HAS SUCH PEOPLE iN iT!

Greeting from Soviet cosmonauts to
American astronauts as they approached
Soyuz spacecraft 1975

we are still subject to the actions of those that have. We may decide not to drive a car, yet we are subject to a transport policy in which the private car is central and where local amenities are replaced with the homogenised satellites of shopping parks which orbit our cities. Of course, that is to say nothing of the destructive effects of airborne pollution and the extraordinary numbers killed or injured on our roads every year. The effects are worsened in the 'Third World', where cultural differences, and a lack of both a transport infrastructure and advanced emergency medical equipment combine with devastating effect. The Red Cross has recently launched a campaign against the effects of the car in these areas, in the same way it would against civil war, disease or famine; perhaps it is time that we consider its effects here also.

Such is the challenge of our accelerated age — the ability to use speed rather than be used by it, and to use it responsibly. Instead of our culture of 'speed-at-all-costs', without actually paying all those costs, perhaps we should instead encourage selective slowness, as Michiel Schwarz has termed it, where speed is a responsible choice rather than an unthinking assumption. As Helga Nowotny implies, perhaps we should reverse of current thinking about speed, or indeed about technology or progress, and think less of what it makes possible and think more of what it makes impossible. It is only then that we might be able to transcend the idea of speed as a function of distance over time and reconfigure it in terms more proportionate to human sensibilities.

In his story, 'A Descent into the Maelström', Edgar Allan Poe tells the story of a sailor who, his watch having stopped, misjudges the passage across a stretch of dangerous water and becomes caught in a maelström. Looking straight down into the steep ebony walls of the water, the sailor is able to make out other objects also caught circulating within the whirlpool:

'I must have been delirious for I even sought amusement in speculating upon the relative velocities of their several descents toward the foam below, "This fir-tree," I found myself at one time saying, "will certainly be the next thing that takes the awful plunge and disappears," — and then I was disappointed to find that the wreck of a Dutch merchant ship overtook it and went down before.'

Rather than experiencing terror at the destruction which he was witnessing, and to which he would, no doubt, shortly become subject, his observations brought the sailor hope. Placed within its heart, he could see the workings of the maelström all the more clearly, and could observe which objects sank faster, and which slower. In doing so, he was able to attach himself to a barrel, which he had noticed sank more slowly, an action which saved his life.
The maelström is a term which has been used to describe the experience of modernity, the turbulence of modern life. Perhaps we, too, should take note of Poe's sailor and learn from his experience. If we are able, within the torrent of our age, to observe the workings of speed, then perhaps we might also be able to extricate ourselves from its seductive, destructive grasp. It is the hope of this book that we are able to do just that. End

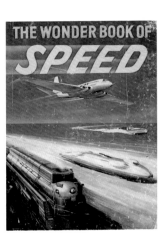

The Wonder Book of Speed
1950

MAY 7, 1991

AID TO BANGLADESH IS STILL HAMPERED

Cyclone Survivors Threatened By Starvation and Illness, Relief Agencies Report

DHAKA, Bangladesh, May 6 (Reuters) — Survivors of last week's cyclone in Bangladesh are suffering from a lack of food and clean water, and many could die of disease, the League of Red Cross and Red Crescent Societies said today.

The official Cyclone Preparedness Center said the death toll as of this evening was 125,672, up only slightly from the previous day.

"An estimated four million people are now at serious risk from lack of fresh drinking water and food," a statement issued by the league said. "Many more deaths could follow from lack of water, food and disease."

Red Crescent officials said the toll could climb to 200,000 when rescue and relief teams reached isolated areas. But Bernard Kouchner, French Minister of State for Humanitarian Action, said the toll might go down as more accurate casualty reports are tallied.

"It has been my experience, weeks and months later, the number of deaths decrease," he said. "But I could be wrong."

Mr. Kouchner toured the disaster area by helicopter on Sunday with Prime Minister Khaleda Zia of Bangladesh, Prime Minister Nawaz Sharif of Pakistan and Mother Teresa.

He said the devastation was colossal and the United Nations should convene a meeting to raise money for reconstruction.

Up to 10 million people living along

the low-lying coast and offshore islands were affected by the storm, and damages so far exceed $1.42 billion, officials said.

The cyclone flooded farmland just before harvest time, when reserves of food were already low.

The Red Cross and Red Crescent societies noted that the cyclone had struck during a full moon and high tide, which "combined to maximize its destructive onslaught."

Pilots braved squalls over the ravaged areas today to drop desperately needed supplies to marooned islanders.

Journalists aboard one flight said riding the small plane buffeted by the wind was "like being on a yo-yo."

Bangladeshi airmen pushed food and medicine from the twin-engine propeller plane over Kutubdia, one of the dozens of islands swamped by a 20-foot tidal wave that was whipped up by 145 mile-per-hour winds a week ago.

Offer From Mother Teresa

Mother Teresa, whose order of nuns operates homes for the destitute and dying in several third world countries, offered to provide temporary shelter for children and old people made homeless by the storm, the state-run television said. She said she was shocked by the scale of the destruction.

More than 2,000 trawlers and thousands of fishermen have been missing in the Bay of Bengal since the cyclone pounded the coast for nine hours on the night of April 29, the Deep Sea Fishing Boat Owners' Association said today.

Journalists aboard the relief plane saw trawlers tossed far inland by the tidal surge and perched incongruously in rice paddies on Kutubdia. Officials said today that the death toll in Kutubdia, which had a population of 90,000,

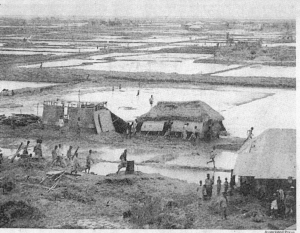

Bad weather and lack of transportation slowed the distribution of relief supplies to isolated coastal areas in Bangladesh. Villagers on Urir Island in the Bay of Bengal ran to a helicopter landing with food supplies.

Aid was airdropped to Kutubdia Island, where damage was severe.

under water in flooded fields. Others shattered on impact.

Nizam Ahmed, a local journalist who visited Kutubdia by boat, said hundreds of human and animal corpses still littered inundated fields and "ghost villages."

"It looked like the area had been carpet-bombed," Mr. Ahmed said, "with

A.I.D. Is Criticized on Population Control

Special to The New York Times

WASHINGTON, May 6 — The Agency for International Development, a primary force in shaping the world's favorable attitude toward population control, is now in disarray on population matters, a private organization says in a new report.

The group, the Population Crisis Committee, said in a report issued Sunday that "over the past decade the U.S. population assistance program has been battered by ideological controversies and constrained by the creeping bureaucratization which now character-

A spokesman for A.I.D., James Kunder, said in response: "Budget priorities limit a lot of worthwhile programs, both domestic and international. As the Population Crisis Committee report itself indicates, the A.I.D. population program is the leader, in the world in size, quality and creativity."

The A.I.D. program provides contraceptives, technical training, research and other support for national programs around the world. The report recommended that A.I.D. broaden its approach to include injectable contra-

New York Bangladeshis Cry for a Battered Land

Mubashir Choudhury takes a break from his job at a Manhattan restaurant at least once a day to pray at the Madina Masjid, a small mosque on the corner of First Avenue and 11th Street. Usually, his thoughts focus on his love of God and his devotion to Islam.

On Sunday night, Mr. Choudhury prayed for Bangladesh.

He was joined by 15 or so other Bangladeshis, all whispering in Bengali, the language that links them to the millions of people whose lives have been devastated by the cyclone that struck their native country on April 29.

"God, help our people," Mr. Choudhury said, bowing his head and clasping his hands as he kneeled on the carpeted floor.

A Sense of Utter Sadness

The cyclone has left many of the tens of thousands of Bangladeshis in the New York area with an almost unbearable sense of sadness. Of all countries, some said, their poor and troubled land could least handle such a calamity.

In restaurants in the East Village and on lower Lexington Avenue, in food stores in Jackson Heights, Queens, and in mosques in Brooklyn, Bangladeshis told stories of frantic but unsuccessful attempts to telephone their relatives to learn whether they were still alive.

More than a week after the disaster, few people have received news.

"I keep trying to call, but there just are no lines," said Zebu Nahar Husain, who in the fall left Cox's Bazar, a resort town and one of the places hit hardest by the storm, for New York. She works at Kalustyan's Orient Expert Trading, a store on lower Lexington Avenue that sells Asian and Middle East food.

Ms. Husain, 23 years old, said she feared that her family was suffering or dead. "I think about them all the time," she said. "I just can't sleep. I stay up every night and I have difficulty working."

The Next Dangers

Absar Chowdhury, 35, who also works at Kalustyan's, said: "We are all scared because nobody knows who died and who survived. It's getting worse now as the days go on because there will be more casualties from famine and lack of medicine."

Mr. Chowdhury's relatives are from Chittagong, the nation's second-largest city, where as many as 90,000 people may have drowned.

In Jackson Heights, many Bangla-

this extent was so long ago. We felt shocked. A lot of people are trying to go back to the country, but they are not getting any seats because there are so few flights going there."

The cyclone, in which at least 125,000 people have died, by official count, has led many Bangladeshis, Indians and Pakistanis to band together and send money to survivors.

On Sunday, a number of local groups met at the United Nations to form a disaster relief committee that hopes to raise $100,000. Jamshed R. Khan, an officer of Bangladesh Shangshad, a social service group, estimated that more than 50,000 Bangladeshis live in the New York area, many of them recent arrivals.

"We just want to help them in any way we can," said Mr. Khan, a marketing executive at Mobil Oil. "We need money and medical supplies.

From a dictator to a cyclone in just a few months.

Everybody is very concerned."

On Friday, the Muslim sabbath, thousands of Bangladeshis packed into mosques in Manhattan, Queens and Brooklyn. Prayers were offered for those affected by the storm. Some dug into their savings to help.

But many Bangladeshi immigrants have low-paying jobs and little money to spare. More than 300 attended prayers on Friday at the Bangladesh Muslim Center at 1013 Church Avenue in the Flatbush section of Brooklyn, and $146 was raised.

For some, the storm prompted harrowing memories of the destruction wrought by cyclones they had lived through before they left the country.

"Even if people live, they live in miserable conditions," said Gulam Kibriya, a 46-year-old accountant who came to New York in 1983, after services on Sunday night at the Madina Masjid. "Everything is scarce. They are helpless. They have no financial or technical resources."

Iqbal Hossain, 31, who left Bangladesh in 1989, said he could not help thinking about how his country has been plagued by misfortune for so long.

"We just passed a stage where we got rid of a dictator," he said, referring to the country's deposed military

On Kawara
May 7, 1991
Liquitex on canvas
25.5 x 33cm
Collection Isabelle and
Jean-Conard Lemaître

Blaise Cendrars
Profound Today
Cannes, 13 February, 1917

I no longer know if I'm looking with my naked eye at a starry sky or at a drop of water through a microscope. Since the origin of the species, the horse moves, supple and mathematical. Machines are already catching up, moving ahead. Locomotives rear and steamships whinny on the water. Never will a typewriter commit an etymological spelling error, but the man of intellect stammers, chews his words, and breaks his teeth on antique consonants. When I think all my senses burst into flame and I'd like to violate all beings, and when I give rein to my destructive instincts I find the triangle of a metaphysical solution. Inexhaustible coal mines! Cosmogonies find a new life in trademarks. Extravagant signboards over the multicoloured city, with the ribbon of trams climbing the avenue, screaming monkeys hanging on to each other's tails, and the incendiary orchids of architectures collapsing on top of them and killing them. In the air, the virgin cry of trolleys![1] The material world is as well trained as an Indian chief's stallion. It obeys the faintest signal. Pressure of a finger. A jet of steam sets the piston going. A copper wire makes the frog's leg jerk. Everything is sensitised. It is all within range of the eye. You can almost touch it. Where is man? The gesturings of protozoa are more tragic than the history of a woman's heart. The lives of plants more stirring than a detective story. The musculature of the back in motion dances a ballet. This piece of fabric should be set to music and that jar of preserves is a poem of ingenuity. The proportion, angle, appearance of everything is changing. Everything moves away, comes closer, cumulates, misses the point, laughs, asserts itself, and gets aggravated. Products from the five corners of the world turn up in the same dish, on the same dress. We feed on the sweat of gold at every meal, every kiss. Everything is artificial and very real.[2] Eyes. Hands. The immense fleece of numbers on which I lay out the bank. The sexual furor of factories. The turning wheel. The hovering wing. The voice travelling along a wire. Your ear in a trumpet. Your sense of direction. Your rhythm. You melt the world into the mould of your skull. Your brain hollows out. Unsuspected depths, in which you pluck the potent flower of explosives. Like a religion, a mysterious pill activates your digestion. You, get lost in the labyrinth of stores where you renounce yourself to become everyone. With Mr. Book you smoke the twenty-five-cent Havana featured in the advertisement. You are part of the great anonymous body of a café. I no longer recognise myself in the mirror, alcohol has blurred my features. He espouses the novelty shop as he would the first passer-by. Every one of us is the hour sounding on the clock. To control the beast of your impatience you rush into the menagerie of railway stations. They leave. They scatter. Fireworks. In all directions. The capitals of Europe are on the trajectory of their inertia.[3] The terrible blast of a whistle furrows the continent. Overseas countries lie still within the net. Here is Egypt on camelback. Choose Engadine for winter sports. Read Golf's Hotels under the palm trees. Think of four hundred windows flashing in the sun. You unfold the horizon of a timetable and dream of southern islands. Romanticism. Flags of countryside float at the windows while flowers fall from the garlands of the train and take root and names, forgotten villages! On the move, kneeling in the accordion of the sky through the telescoped voices. The most blasé go furthest. Motionless. For entire days. Like Socrates. With an activity in the mind. The Eiffel Tower sways on the horizon. The sun, a cloud, anything is enough to stretch it or shrink it. The metal bridges are just as mysterious and sensitive. Watches set themselves. From every direction ocean liners move toward their connections. Then the semaphore signals. A blue eye opens. The red one closes.[4] Soon there is nothing but colour. Interpenetration. Disk. Rhythm. Dance. Orange and violet hues devour each other. Checkerboard of the port. Every crate is heaped with what you earned by inventing that game, Dr. Alamede.[5] Steam-driven cranes empty thunder from their hampers. Pell-mell. East. West. South. North. Everything turns cartwheels along the docks while the lion of the sky strangles the cows of twilight. There are shiploads of fruit on the ground and on the rooftops. Barrels of fire. Cinnamon. European women are like subaqueous flowers confronting the stern labouring of longshoremen and the dark red apotheosis of machines. A tram slams into your back.[6] A trap door opens under your feet. There's a tunnel in your eye. You're pulled by the hair to the fifteenth floor. Smoking a pipe, your hands at the faucets — cold water, hot water — you think of the captain's wife, whose knee you will soon surreptitiously caress. The golden denture of her smile, her accent. And you let yourself slip down to dinner. The tongues are stuffed. Everyone must grimace to be understood. Gesticulate and laugh loudly. Madame wipes her mouth with her loincloth of a napkin. Boeuf Zephir. Café Eureka. Pimodan or Pamodan. Seated in my rocking chair I'm like a Negro fetish, angular beneath the heraldic electricity. The orchestra plays Louise. To amuse myself, I riddle the fat body of an old windbag that is floating at the level of my eyes with pinpricks. A deep-sea diver, submerged in the smoke from my cigar, alone, I listen to the dying music of sentimentality that resonates in my helmet. The lead soles of my boots keep me upright and I move forward, slow, grotesque, stiff-necked, and bend with difficulty over the swamp life of the women. Your eye, sea horse, vibrates, marks a comma, and passes. Between two waters, the sex, bushy, complicated, rare. This cuttlefish discharges its ink cloud at me and I disappear into it like a pilot. I hear the engine of the waters, the steel forge of leeches. A thousand suction pores function, secreting iodine. The skin turns gelatinous, transparent, incandesces like the flesh of an anemone. Nerve centres are polarised. All functions are independent.

1 In *Aujourd'hui*, the collection of these writings published by Grasset in 1931, 'vehicles' replaces 'trams', and 'motors' replaces 'trolleys'. Cendrars' changes indicate his desire to emphasise the technological aspect of modernity.

2 The phrase 'and very real' is omitted in the original manuscript, Cendrars added it by hand on the galley proofs of the 1926 *Ecrivains Réunis* publication. The addition of this phrase reinforces the theory of simultaneous contrasts; in relation to 'very real', 'artificial' becomes a new aesthetic category instead of a derogatory qualifier.

3 'Europe' becomes 'the world' in the 1931 Grasset edition.

4 Cendrars changed 'a' (red one) in manuscript to 'the' (red one) in the 1926 *Ecrivains Réunis* publication.

5 'Palamede' in manuscript, the son of the Argonaut of Nauplios whom the Greeks credit with the invention of the game of chess.

6 In manuscript: 'a tram in your chest, a car in your back.' The original version was obviously more evocative of Charlie Chaplin's *Modern Times*.

Sonia Delaunay and Blaise Cendrars
*La prose du Transsibérien et de la
Petite Jehanne de France* (The Prose
of the Transsiberian and of little Jehanne
of France) Paris: Editions des Hommes
Nouveaux 1913
Paper, ink, parchment covers
197.5 x 35.5cm
The Board of Trustees of the Victoria
& Albert Museum, London

Scott McQuire
Pure Speed — From Transport to Teleport

1 K. Marx, Grundrisse:
Foundations of the Critique
of Political Economy (trans.
M. Nicolaus), London, Allen
Lane/NLR, 1973, p. 539.
2 F.T. Marinetti, 'The
Founding and Manifesto of
Futurism 1909', reprinted in
Apollonio, Futurist
Manifestos, p. 22. Marinetti
also considered 'Dynamism'
as the name for the
movement.
3 Louis Blériot was the
first pilot to fly the English
Channel in 1909, an act of
which the full strategic
implications were scarcely
appreciated until 1940.
Charles Lindbergh made his
thirty-three-and-a-half-hour
trans-Atlantic flight in 1927, a
feat acclaimed in a manner
unrivalled until the Apollo
moon landings.
4 R. Robinson, J.
Gallagher and A. Denny,
Africa and the Victorians:
The Official Mind of
Imperialism, London,
Macmillan, 1972, p.3.
5 Although the
'freedom to drive' has never
been codified, it clearly
resembles the successive
doctrines concerning the
freedom of the seas,
freedom of the skies and
freedom of space which
have been integral to the
geopolitical order of
capitalism.
6 P. Virilio, 'The Last
Vehicle', in D. Kamper and
C. Wulf (eds), Looking Back
on the End of the World
(trans. D. Antal), New York,
Semiotext(e), 1989, pp.
106–19. [Also included in this
volume — pp.32–48]
7 M. McLuhan,
Understanding Media: the
extensions of man, 1964, pp.
11 and 12–13.

'We must try to find a form to express the new
absolute — speed — which any true modern spirit
cannot ignore.'
 — Umberto Boccioni

'Video isn't I see, it's I fly.'
 — Nam June Paik

In 1825, on a gentle 20-mile descent between
Shildon and Stockton Quay, George Stephenson's
Locomotion became the first steam train to haul
passengers along a public railway. Wild scenes
ensued as an excited band of riders accompanied
the train to its journey's end before a crowd of
40,000. The 21-one gun salute celebrating the
achievement announced the emergence of a new
era in which mechanically powered vehicles would
finally sever traditional links between force and
motion. Subsequent history has been so decisively
shaped by this revolution that different incarnations
of the engine — steam, combustion, jet, rocket —
marked successive thresholds of a modern era
which is itself characterized by perpetual
movement. The train, the automobile and the
aeroplane have completely modified all human
relations to distance and speed, approaching a
terminal point with rocketry in which the earth itself
becomes merely a launching pad for potentially
infinite journeys into endless space.
 If velocity has been at the heart of each
of these revolutions, it is not only the increased
speed each new wave of vehicles has achieved, but
also the ascending rate at which they have
transformed social and political relations. Over a
century ago Marx noted the critical importance of
rapid movement to the development of a global
capitalist economy:
 '[W]hile capital on one side must strive to
tear down every spatial barrier to intercourse, i.e. to
exchange, and conquer the whole earth for its
market, it strives on the other side to annihilate this
space with time, i.e. to reduce to a minimum the
time spent in motion from one place to another. The
more developed the capital, therefore, the more
extensive the market over which it circulates, which
forms the spatial orbit of its circulation, the more
does it strive simultaneously for an even greater
extension of the market and for greater annihilation
of space with time.'[1]
 This trajectory underpins the emergence
of speed as the prime quotient of modern social

relations. When Marinetti proclaimed in his Futurist
Manifesto of 1909 that 'Time and Space died
yesterday. We already live in the absolute, because
we have created eternal, omni-present speed', he
was voicing a desire which became a destiny for
the new century.[2] Modernisation has become
synonymous with acceleration across all areas of
social life. Speed has been the mechanical soul of
modernity; not only for the avant-gardes whose
aspirations to burn the libraries and wreck the
museums transformed art, but for entrepreneurs,
inventors, adventurers and all the other apostles of
progress who were captivated by the impulse to go
faster and travel further, to dynamise life and propel
it into the future — by force if necessary.
 In the excitement generated by the
opening of transcontinental railways and
intercontinental sea-routes, and especially the
unbounded public adulation of early aviators such
as Blériot and Lindbergh, we can read parables of
the emergent culture of speed.[3] Pleasure in the
novelty of dynamic vehicles and pride in the
'conquest of the skies' converged with the immense
possibilities for economic growth and colonial
expansion that they created. Imperialism was the
political corollary of modern dynamism: as
Robinson, Gallagher and Denny observed,
'Expansion in all its modes not only seemed natural
and necessary, but inevitable: it was preordained
and irreproachably right. It was the spontaneous
expression of an inherently dynamic society'.[4] The
rapid extension of 'the West' as a political and
economic force in the nineteenth century, which laid
the foundation for the systematisation of world
trade and the global division of labour in the
twentieth, has been paralleled on the domestic front
by the development of the distinct modern culture
of auto-mobility: the Brownian motion of mass
urban population for whom the 'freedom to drive'
has become a fundamental article of political faith.[5]
 Under pressure of these new forms of
circulation which mobilised people and products on
regional, national and transnational circuits, the
centres of lived existence have mutated in a
process whose ends are still not clearly defined.
Suspended between house and car dwells an
antagonism internal to modern culture. A fault line
stretches between the desire for home as a stable
site, a secure space of shelter and enclosure, and
the constant drift towards the frontier as a liminal
space of perpetual transformation and potential
conquest. Modern identity belongs neither in the
home nor on the road, but is perpetually split by the
psychic and social contradictions of its attachments
to both these poles.

Despite constant acceleration throughout this
century, and the technological attainment of speeds
beyond human endurance, locomotive machines
have themselves been overtaken by what Paul
Virilio aptly termed 'the last vehicle': the audio-
visual one.[6] Following Marinetti's tracks, Marshall
McLuhan remains perhaps the most famed post-
war prophet of the manner in which transport would
be displaced by communication:
 'During the mechanical ages we had
extended our bodies in space. Today, after more
than a century of electric technology, we have
extended our central nervous system itself in a
global embrace, abolishing space and time as far as
our planet is concerned As electrically
contracted, the globe is no more than a village.'[7]
 If McLuhan's 'global village' was forever

Blaise Cendrars
Profound Today
Continued

Eyes reach to touch; backs eat; fingers see. Tufts of grassy arms undulate. Sponges of the depths, brains gently breathe. Thighs remember and move like fins. The storm rips out your tonsils. A scream passes over you like the shadow of an iceberg. It freezes and sunders. The being reassembles itself with difficulty. Hunger draws the limbs together and gathers them around the vacuum of the stomach.[7] The body dons the uniform of weight. The spirit, scattered everywhere, concentrates in the rosette of consciousness. I am man. You are woman. Good-bye. Everyone returns to his room. There are shoes in front of the door. Don't confuse them. Mine are yellow. The valet is waiting for his tip. I give him the shield from my coat of arms. I've forgotten to sleep. My glottis moves. This attempt at suicide is regicide. I'm impaled on my sensibility. The dogs of night come to lick the blood running down my legs. They turn it into light. The silence is such that you can hear the mechanism of the universe straining. A click. Suddenly everything is one notch larger. It is today. A great foaming horse. Diseases rise to the sky like stars on the horizon. And here is Betelgeuse, mistress of the seventh house. Believe me, everything is clear, ordered, simple and natural. Minerals breathe, vegetables eat, animals emote, man crystallises. Prodigious today. Probe. Antenna. Door-face-whirlwind. You live. Eccentric. In integral solitude. In anonymous communion. With everything that is root and summit and that throbs, revels, jubilates. Phenomena of this congenital hallucination which is life in all its manifestations and the continual activity of consciousness. The motor spirals. The rhythm speaks.[8] Chemistry. You are. End

7 *In manuscript: 'scattered' limbs.*
8 *'Lives' was added in the original manuscript after 'speaks' and the words 'Profound Today' ended the essay after 'You are.'*

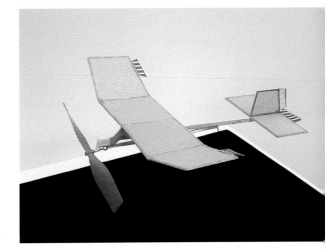

Chris Burden
C.B.T.V. to Einstein
December 28, 1977
Hand-made model airplane, wood and paper mounted within plexiglass box lined with velvet, printed card
21 x 39 x 34cm
Collection Mandy and Cliff Einstein

While seated aboard the Concorde at Mach 2.05 and 60,000 feet I flew a small stick and tissue, rubber-band powered model airplane from the rear of the airplane towards the front.

In accordance with Einstein's theories, the velocity of my model airplane, as seen from earth, is the sum of the velocity of the Concorde (approx. 1400 miles per hour) plus the velocity of my model airplane (approx. 10 miles per hour). My model airplane thus travelled faster than the supersonic Concorde.

8 Arthur C. Clarke discussed the possibilities of geostationary orbit and the communications potential of satellites (now known as 'the Clarke belt') in his 1946 paper 'Extra-terrestrial relays'. Television link-ups to all five continents via satellite occurred in 1964, the year that McLuhan's Understanding Media was published.

9 See D. Gomery, 'Towards an economic history of cinema: the coming of sound to Hollywood', in Heath and De Lauretis, Cinematic apparatus, p. 44.

10 The cine-train was equipped as mobile film studio, processing plant and cinema. It made six expeditions into the Ukraine and Caucasus between 1932 and 1933, producing some 70 short films. The aim was to use the experience of seeing one's own community represented on film to generate feelings of collective goodwill and national fervour. See S. Crofts and M. Enzensberger, 'Medvedkin — Investigation of a citizen above suspicion', Screen 19, 1 (Spring 1978), pp. 71-89. See also the films The Train Rolls On (SLON Collective, 1971) and Chris Marker's The Last Bolshevik (1993).

11 See S. Kracauer, From Caligari to Hitler, Princeton University Press, 1974, pp. 276-7.

12 See Virilio, Lost Dimension, p. 124.

embedded in what could be called — perhaps for the first time — 'global consciousness' with the Apollo moon landing telecast of 20 July 1969, the trajectory he indicated had been evident for some time.[8] The advent of the telegraph in 1794 inaugurated the ability for messages to outpace messengers. By the nineteenth century, the expansion of telegraph services and the successive invention of the camera (1839), the telephone (1876), the phonograph (1877), the wireless radio (1894) and the cinematograph (1895) completely redefined the practice of 'communication' and the notion of 'proximity'. The dichotomy between being present in one place and therefore necessarily absent elsewhere began to waver, as physically separated sites of action were bridged and juxtaposed in new ways. Stephen Kern points to the spectacular blaze of publicity the wireless received in 1910 when it enabled the arrest of Dr. Hawley Crippen (a US physician accused of murdering his wife) while he was on board the ocean liner Montrose. But the new possibilities of 'action-at-a-distance' went beyond merely extending traditional forms of social interaction and political authority; rather, they fundamentally changed the socio-political field itself.

The instantaneous 'live' connection offered by the telephone (and then radio) provided the model that other media sought to emulate. When Charles Lindbergh set off on his epoch-making trans-Atlantic flight in 1927, Fox-Movietone rush-released a four-minute sound newsreel of his take-off to a packed cinema audience in New York's Roxy Theatre that same night.[9] It received a standing ovation, a response worth recalling when the surpassing of such feats has become a part of daily life. Equally notable is the fact that similar examples are spread across what are usually posited as the great political divides of this period. The Soviet ciné-train project led by Alexander Medvedkin in the 1930s (adapted from the civil war agit-trains) also strove to exhibit films the same day they were shot.[10] In Nazi Germany, propaganda Minister Goebbels ordered the airlifting of footage from the battle front so that it could be included in the latest newsreels, while the finished products were then flown around the entire country so that they could be released on the same day.[11] All these examples may be read as attempts to establish film services which approach the speed of television. The desire for simultaneity, which coursed through modern sensibility at the beginning of the century, has transformed the social and political terrain, creating radical new 'communities' dispersed in space but joined in time. What Paul Virilio has termed the displacement of geo-politics by chrono-politics situates the manner in which television has been able to present itself as the destiny and destination of modernity.[12]

Television hybridised the camera with radio to fuse vision and speed in a new way. Rapid seeing — spanning distance without losing time — has become the hallmark of modern perception, defined by the ubiquity of live broadcasts which enable vast audiences distributed across continents to see events happening outside the horizon of their own 'presence'. The fact that the appearance of broadcast television redefined the roles of all other media, including print, radio, photography and cinema, only underlined the extent to which modernity is a speed-driven culture, in which the relative velocity of different media vehicles determines their social utility. With television, photographic and

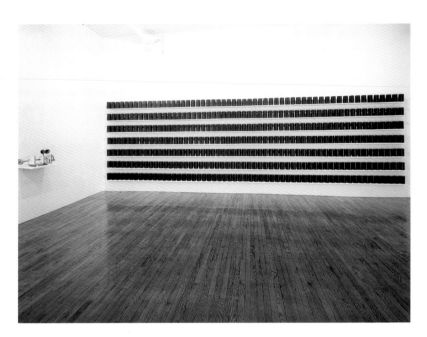

Paul Ramírez Jonas
Man on the Moon 1990–
Installation view
Wax cylinders, wood and metal phonograph, book
Cylinders: each 17.3 x 12.2cm diameter
Courtesy the artist

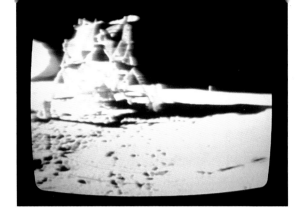

Michiel Schwarz
Moon on TV, Apollo 14
5 February, 1971

'No human language can
withstand the speed of light.
No event can withstand
being beamed across the
whole planet. No meaning
can withstand acceleration.
No history can withstand the
centrifugation of facts or
their being short-circuited in
real time.'

Jean Baudrillard
The Illusion of the End 1995

cinematic images lose their edge and prove unable
to keep up with demands for a rapid information
flow. Finally, it is television and not the newspaper
or newsreel which works around the clock.[13]

Where it once took military organisation
to deliver images and information at a speed which
ensured that events did not outstrip communications,
today it is the media who are on permanent war
alert and events which cannot move fast enough.
If the Gulf War was notable for the extent to which
television cameras stalked each action and
searched restlessly for the decisive event, an even
more striking threshold (but destined, one suspects,
to become banality itself) was the landing of US
troops in Somalia in December 1992: by the time
the marines arrived, the camera crews already
had a beachhead, and were beaming the action
live to domestic audiences over breakfast. The
much-prophesied creation of a single terrestrial
zone of total visibility suddenly seemed very
close: the world as global TV studio. Decades
earlier, Heidegger had evoked the darker side
of McLuhan's 'global village' by casting television
as the force of a new tyranny:

'All distances in time and space are
shrinking The peak of this abolition of every
possibility of remoteness is reached by television,
which will soon pervade and dominate the whole
machinery of communication Yet this frantic
abolition of all distances brings no nearness; for
nearness does not consist of shortness of distance
... despite all conquest of distances the nearness of
things remains absent.'[14]

'Nearness' is undoubtedly a complex and
elusive quality. For Heidegger, it belonged to the
essential distance which opens the dimensionality
of 'true time'.[15] For Benjamin (who was certainly
no disciple of Heidegger), 'distance' was an
essential attribute of aura and, as is well known,
it is precisely the decay of aura that he posits as
the revolutionary effect of the camera. By allowing
viewers to approach the previously unapproachable,
Benjamin argued that the camera contributed to
the displacement of 'cult value' in every sphere,
bringing the secular disenchantment of the world
to a new pitch.[16] Yet, under the eye of Hollywood
and global television, the political effects of this
revolution have diverged from those Benjamin
once envisaged.[17]

From one man's first steps on the moon
to a football match with an audience a billion
strong, the entirety of the world and its beyond has
been structured as the set of an ongoing spectacle.
In his seminal analysis, Guy Debord argued that this
seizure of the world as spectacle exceeds
traditional questions of vision and representation,
and points instead to the historic moment in which
technologies of vision effectively penetrate the
interstices of all social relations.[18] For Debord, the
primary characteristic of the spectacle is the
pervasive commodification of time and space,
manifested in the homogenisation of territory and
domination of temporality by 'pseudo-cyclical
rhythms' of consumption.[19] Yet, the prospect of a
completely unified and totally homogenised world
has also produced counter-tendencies of conflict
and contestation. Today, the imposition of global
media empires is marked by the resurgence of
cultural difference, and the reassertion of claims of
locality and regionalism, even the much discussed
'collapse' of universalising theories.

For this reason, it is important to
recognise that, inasmuch as television provides an

exemplary image of the capacity of communications technology to produce a 'global culture', it also offers a powerful metaphor for the disjunctive spatial and temporal experiences of the present. The confusion of near and far accentuated by television's drive for a global horizon engineers a new psychogeography in which locality and universality are no longer opposed but in series. Television often seems to upset something in our thinking: the fact that it so regularly slides to an extremity of thought (recalling Heidegger: 'the peak of the abolition of every possibility of remoteness') may yet constitute one of its most strategic attributes.

 From the first successful photographs of the moon taken in the 1840s to space-age images of the earth seen as a solitary luminous orb suspended in a vast black universe — perhaps the most long-awaited 'reverse shot' in history — the camera has been instrumental in opening new vistas to the human eye.[20] Images of the terrestrial surface seen from aeroplanes, or of whole continents seen from satellites, or of entire galaxies imaged via radiophotography are counterpointed by photomicrographs which penetrate the bounds of the discrete atom. The opacity of solid surfaces has dissolved before X-rays, while the shades of darkness are everywhere lifted by infra-red images and thermography. Even the integrity of the living body has been penetrated, as if from within, by endoscopy. Movement of all kinds has been decomposed beyond the threshold of the human eye, and the most transient phenomena, such as sub-atomic particles whose longevity lies at the edge of nothingness, can now be 'seen' by human observers. Contemporary techniques of 'ideography', using positron cameras to register the movement of air around the brain, once again raise the age-old dream of submitting the psychic to the physical by rendering visible the 'event' of thought itself.[21] In short, the bounds of the perceptible universe have been completely redefined.

 Yet to focus solely on this series of spectacular cases would be misleading. The camera's most profound effects on contemporary experiences of time and space are perhaps to be found in those perceptual shifts which have today become so prosaic that they pass almost unnoticed: the snapshot, the close-up, the moving-image, montage, the time-lapse sequence, the live broadcast, the instant replay. What interests me is the profound modulation of social rhythms, the reconstruction of living and working spaces, the emergence of new social relationships and the deployment of new forms of power in a world in which every site and situation is subject to potential incursion. The institutional forms different camera technologies have taken — postcards, illustrated magazines and newspaper, domestic photography, cinema, broadcast television, and so on — have been instrumental in the production of a network of functional spaces, new scenes of watching which are both sites of consumption and cells for surveillance. In the uncertainty generated by the camera's disjunctive effects on the authority of embodied perception, qualities of time and space long thought to be 'fundamental' are themselves shifting. In one sense, 'modernity' can be defined by this shift which affects both physical boundaries and psychic formations: the destabilisation of architectural and geographical borders (the room, the nation) as much as the disruption of discursive traditions (the unity of the book, the universality of reason, are part of the crisis of referents and

13 Although there had been experimental broadcasts since the 1920s, television did not gain sizeable audiences until after the Second World War. The direct relation between the rise of television and the decline of cinematic newsreel and news-related programmes can be seen in the demise of the major US productions: The March of Time and This is America ceased in 1951, Pathé News in 1956, Paramount News in 1957, Fox-Movietone News in 1963, MGM News of the Day and Universal News in 1967.

14 M. Heidegger, 'The thing', Poetry Language, Thought, p. 165.

15 See M. Heidegger, On Time and Being (trans. J. Stambaugh), New York, Harper and Row, 1972, p. 15.

16 For Benjamin, cult value belonged to the myth-laden sacred world: 'The definition of aura as a "unique phenomenon of a distance however close it may be" represents nothing but the formulation of the cult value of the work of art in categories of space and time perception The essentially distant object is the unapproachable one. Unapproachability is indeed a major quality of the cult image.' Benjamin, Illuminations, pp. 245 and 224–8. In contrast, he argues that the camera is characterised by the dominance of exhibition value: its images exist to be seen, and this fact instils them with new political possibilities.

17 This point is complicated, insofar as Benjamin did not subscribe to the thesis, most commonly attributed to Max Weber, equating post-Enlightenment modernisation with the process of 'disenchantment'. Rather, Benjamin understood the rise of commodity culture in the nineteenth century as the imposition of a new mode of enchantment. He posited the historic role of the camera as its ability to 'awaken' the masses from their commodity-induced slumber.

18 For Debord: 'The spectacle is not a collection of images, but a social relation among people, mediated by images.' Society of the Spectacle, paragraph 6.

19 See Society of the Spectacle, especially chapters 6–7. It is worth comparing Debord's text with Heidegger's analysis of the 'ground plan' of science.

20 The first full disc colour photographs of the earth taken from Apollo 17 in December 1972 represented a new threshold of the Copernican revolution — a previously unattainable perspective became visible to all eyes.

21 One scientist involved in this research, Jean Changeaux, argues: 'It is not utopian one day to think we will be able to see the image of a mental object appearing on a computer screen' Quoted in Virilio, Lost Dimension, p. 14.

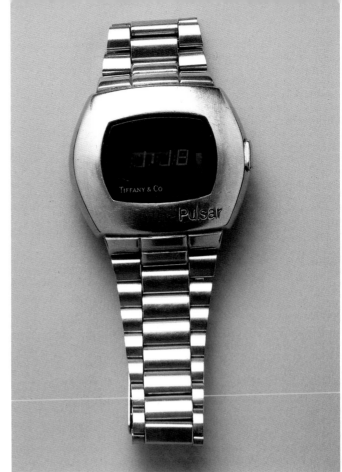

Paul Virilio
The Last Vehicle

'Tomorrow learning space will be just as useful as learning to drive a car.'
— Wernher von Braun

In Tokyo there is a new indoor swimming pool equipped with a basin of intensely undulating water in which the swimmers remain on the same spot. The turbulence prevents any attempt to move forward, and the swimmers must try to advance just to hold their position. Like a kind of home-trainer or conveyor belt on which one moves in the direction opposite that of the belt, the dynamics of the currents in this Japanese pool have the sole function of making the racing swimmers struggle with the energy passing through the space of their mutual encounter, an energy that takes the place of the dimensions of an Olympic pool just as the belts of the home trainer have been replacing stadium race tracks.

 The person working out in such cases thus becomes less a moving body than an island, a pole of inertia. Like a theatre set, everything is focused on the stage, everything occurs in the special instant of an act, an inordinate instant offering a substitute for expanses and long stretches of time. Not so much a golf course but a video performance, not so much an oval track but a running simulator: space is no longer expanding. Inertia replaces the continual change of place.

 Moreover, one observes a quite similar trend in museographic presentation. Being too vast, the most spacious exhibitions have recently been subject to a temporal reduction in inverse proportion to their overall dimensions: Twice the amount of space to cover means twice as little time that one can spend at any one place.

 The acceleration of the visit is measured by the area of the exhibition. Too much space, too little time, and the museum welters in useless expanse that can no longer be furnished with works of art. In any case, this probably is the case because the latter still tend to sprawl, to make a show of themselves, to pour themselves into these vast and utterly uninviting surfaces, just like the grand perspectives of the classical period.

 Whereas our monuments were once erected to commemorate significant works which can now be viewed for long periods by visitors interested in the past, they are presently simply ignored in the excessive zeal of the viewer, this 'amateur' who seems to have to be forced to fixate

Pulsars' first
Digital Watch 1972

Clocks and watches are now far more accurate than we need them to be in our daily lives. Many quartz watches keep virtually perfect time, and minute inaccuracies are probably the fault of the solar system. Perhaps this need to be in possession of the exact time reflects some fault in our perception of the world, and a defect in our grasp of space-time.

Obsessive attention to microscopic detail is usually a symptom of underlying neurosis. Confident people carry neither money nor watches, and expect the world to keep time with them. — JG Ballard

dimensions currently testing the limits of thought and experience.

It is important to treat the emergent space-time of what is commonly called 'media culture' as more than a distorted manifestation of some earlier, more 'genuine' social form. Ever since the invention of the telegraph, developments in transport and communication technologies — from the railway and cinema to television and the space age — have been hailed or condemned for engineering the 'disappearance' of space and time. Since so many pronouncements of 'the end' have proved premature, it seems prudent to be less hasty in equating transformation with annihilation. Contemporary challenges to the authority of values such as linearity, continuity and homogeneity from discourses emphasising relativity, rupture and discontinuity have fundamentally affected the legitimation of the political field. In the process, the profound and often neglected links between politics and time and space have been thrown into relief. Situating the camera in this scene is critical insofar as camera technologies have themselves generated new spatio-temporal experiences crucial to the political force lines of modernity and postmodernity. Today, our task is to reckon with a novel horizon in which 'direct' and 'indirect' perceptions gravitate towards a radical interchangeability in everyday life. This condition undermines the presumption of spatio-temporal continuity which founded the Cartesian-Newtonian universe, and orchestrates a new distribution of bodies, gazes and identities as the frame of contemporary subjectivity. If the front line of every war zone has the potential to cross every living room as a present event, it is the terms of this 'new world order' that we need to understand. End

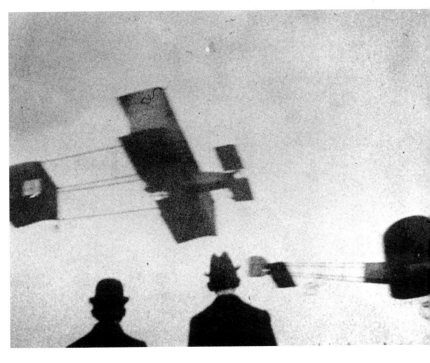

*Blériot aircraft
25 July 1909*

These self-propelled box kites seem almost as bizarre to us today as they must have seemed to the two spectators in 1909. But the sky had changed forever and become the purest medium of speed. Bleriot's cross-channel flight paved the way for the German bomber attacks on Britain little *more than thirty years later. For too many people in the twentieth century the sky was the place from which death came. Now, thankfully, it carries tourists towards the sun. — JG Ballard*

Concorde Wind Tunnel Model
1969

for more than only a moment; for the more impressive the size of the volumes presented, the quicker he tries to escape.

We are talking about the monument of a moment in which the work tends to disappear without a trace rather than expose itself. The contemporary museum vainly attempts to assemble and present these works, these pieces that one ordinarily views only from a distance in the atelier, at the workplace, in these laboratories of a heightened perception that is never the perception of the passer-by, this passing viewer distracted by his exertion. With regard to this perspective of retention, of the restriction of the time to pass through, of passing by, we should point out yet another project. It concerns a miniaturised reconstitution of the state of Israel where 'in complete safety and with a minimum of physical movement, visitors can marvel at the exact copy of the Holocaust museum, a small section of the wailing wall, and the miniaturised reconstitution of the Sea of Galilee created with a few cubic metres of water from the original.' Seizing this opportunity, the directors of this institution could perhaps complete it by exhibiting electronic components, products of Israeli industry. This extraterritorial manifestation could be sited in Douarnenez, on Tristan da Cunha, as soon as this group of islands is finally ceded by France to the Hebrew state.

Even if this utopia does not really come to be, it nevertheless reveals in exemplary fashion this <u>tellurian contraction</u>, this sudden 'overexposure' now befalling the expansion of territories, the surfaces of the vastest objects, and the nature of our latest displacement. Displacement in place, the advent of an inertia, that is what has always been the 'still frame' for the film as far as the landscape through which we walk is concerned. This also applies to the advent of a final generation of vehicles, of means of communication for distances that have nothing in common with those associated with the revolution of transport anymore — as if the conquest of space ultimately confirmed the conquest of the mere <u>images</u> of space. If in fact the end of the nineteenth century and the beginning of the twentieth experienced the advent of the automotive vehicle, the dynamic vehicle of the railroad, the street, and then the air, then the end of this century seems to herald the next vehicle, the audiovisual one, a final mutation: static vehicle, substitute for the change of physical location, and extension of domestic inertia, a vehicle that ought at last to bring about the victory of sedentariness, this time an ultimate sedentariness.

The transparency of space, of the horizon of our travels, of our racing, thus ought to be followed by this <u>cathodic transparency</u>, which is only the successful realisation of the discovery of glass some four thousand years ago, of iron two thousand years ago, and that 'glass showcase', that puzzling object that has constituted the history of urban architecture from the Middle Ages down to our own times or, more precisely, down to the most recent realisation of this electronic glass case, that final horizon of travel of which the most developed model is the 'flight simulator'.

This is also made obvious by the latest developments in amusement parks, those laboratories of physical sensations with their slides, catapults, and centrifuges, reference models for training and flight personnel and for astronauts. In the opinion of the very people responsible, even vicarious pleasure is becoming collective

German Autobahn 1936

World War II accelerated everything — the speed of warfare, the growth of aviation and weapons technology, shifts in mass psychology and the emancipation of women, and the evolution of the road. Built in the 1930s, Hitler's autobahns were both high-speed panzer arteries and ancient runic megaliths laid down like stone dreams that pointed towards the east. — JG Ballard

Bullet Train, Japan

Hiroshi Sugimoto
<u>Union City Drive-In, Union City</u> 1993
Black and white photograph
50 x 60cm, Courtesy Sonnabend Gallery, New York

experimentation with mere mental and imaginary sensations.

In the previous century the leisure park became the theatre of physiological sensations to a working population for which many different physical activities had become things of the past. Thereafter, the leisure park prepared to become the scene of mere optical illusions, the place for a generalisation of simulation, fictitious movements that can create in each person an electronic hallucination or frenzy — 'loss of sight' following upon the loss of physical activities in the nineteenth century. Analogous to dizziness and the unusual calling of gymnasts, it is nevertheless true that the 'panoramas', 'dioramas', and other cinematographies smoothed the way toward the 'panorama', to 'Géode', a hemispheric movie anticipated by Grimoin-Sanson's 'balloon cinerama'. They are all old forms of our present audiovisual vehicles, whose forerunners were made more precise by the American Hale's Tours: after all, a few of them were actually funded by the railroad companies between 1898 and 1908. Remember that these films, which were shot on a panoramic platform either from a locomotive or from the rear of the train, were ultimately shown to the public in halls that were exact imitations of the railroad cars of that epoch. Some of these short films were made by Billy Bitzer, the future cameraman of DW Griffith.

At this point, however, we must return to the origins of kinematic illusion, to the Lumière brothers, to the 1895 film L'entrée d'un train en gare de la Ciotat, and above all to the spring of 1896, when the very first travelling shot was invented by Eugène Promio:

'It was in Italy that I first had the idea of shooting panoramic film. When I arrived in Venice and took a boat from the train station to the hotel, on the Grand Canal, saw the banks recede from the skiff, and I thought that if the immovable camera allowed moving objects to be reproduced, then one could perhaps also invert this statement and should try to use the mobile camera to reproduce immovable objects. So I shot a reel of film, which I sent to Lyon with a request to hear what Louis Lumière thought of this experiment. The answer was encouraging.'

To comprehend the significance of this introduction of the 'mobile camera' or, to put it another way, the first static vehicle, we must again look back at the course of history. Disregarding for the moment Nadar's 'aerostatic negatives' (1858), which were indeed the origin of cinematic weightlessness, one must wait until 1920 to find the first 'aeronautic film', taken on board a Farman aeroplane. The now traditional 'travelling vehicle', which was mounted on tracks and which is inseparable from the contemporary cinema, came about four years later during the shooting of Cabiria by Giovanni Pastrone. For memory's sake, let us also mention the trains of AGIT PROP between 1918 and 1925 and the use of train travel in the work of Dziga Vertov. He joins Moscow's film committee in the spring of 1918, waiting until 1923 to promote the founding of a 'cinematographic automobile department' that would provide cars in emergencies for filming important events. The cars are thus predecessors of the mobile video productions of television. With this use of transport, this combination of the automotive and the audiovisual, our perception of the world inevitably changes the optical and the cinematic blend. Albert Einstein's theory, subsequently to be called the

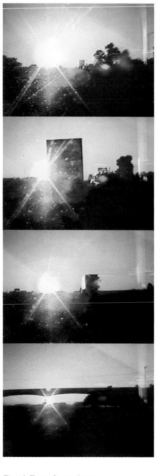

Paul Ramírez Jonas
A Longer Day 1997
VHS video projection
20 minutes
Courtesy the artist

Special Theory of Relativity, appears in 1905. It
will be followed about ten years later by the
general theory of relativity. To make them more
understandable, both take recourse to the
metaphor of the train, streetcar, and elevator,
vehicles of a theory of physics that owes them
everything, or, as people will see, almost everything.
The revolution of transport will coincide with a
characteristic change of arrival, with the progressive
negation of the time internal, the accelerated
retention of the time of passage that separates
arrival and departure. Spatial distance suddenly
makes way for mere temporal distance. The longest
journeys are scarcely more than mere intermissions.

But if, as already shown, the nineteenth
century and a large part of the twentieth really
experienced the rise of the automotive vehicle
in all its forms, this mutation of it is by no means
completed. As before, except now more rapidly,
it will make the transition from the itinerary of
nomadic life to inertia, to the ultimate sedentariness
of society.

Contrary to all appearances, the
audiovisual vehicle has indeed prevailed since the
1930s with the radio, television, radar, sonar, and
emerging electronic optics. First during the war,
then — despite the massive development of the
private car — after the war, during peace, during
this 'nuclear peace', which will experience the
information revolution, the telematic information
that are tightly linked with the various policies of
military and economic deterrence. Since the
decade from 1960 to 1970, what really counts does
not occur through the customary communication
channels of a given geographic region (hence the
deregulation of rates, the deregulation of transport
in general), but rather in ether, in the electronic
ether of telecommunications.

From now on everything will happen
without our even moving, without us even having to
set out. The initially confined rise of the dynamic,
at first mobile, then automotive, vehicle is suddenly
followed by the generalised rise of pictures and
sounds in the static vehicles of the audiovisual.
Polar inertia is setting in. The second screen that
can suddenly be turned on substitutes itself for the
very long time intervals of displacement. After the
ascendance of distance/time in the nineteenth
century to the disadvantage of space, it is now the
ascendance of the distance/speed of the electronic
picture factories: the statue follows upon the
continual stopping and standing still.

According to Ernst Mach, the universe is
mysteriously present in all places and at all times in
the world. If ever a mobile (or automotive) vehicle
conveys a special vision, a perception of the world
that is only the artefact of the speed at which it is
displaced within its terrestrial, aquatic or aerial
milieu, then, vice versa, each of those visions, those
optical or acoustical images of the perceived world,
represents a 'vehicle', a communication vector that
is inseparable from the speed of its transmission.
All this since the telescopic instantaneousness of
the image's rectification in the passive lenses of
Galileo's telescope down to our modern 'means
of telecommunications', our active optics of
videoinformatics.

The dynamic vehicle can thus no longer
be clearly distinguished from the static vehicle, the
automotive no longer from the audiovisual. The
recent priority of arrival over departure, over all
forms of departure and, accordingly, over all forms
of travel and trajectories realises a mysterious

*John F. Kennedy speaking
to Prime Minister of
Nigeria by means of
communication satellite
'Syncom'
26 August 1963*

*Kennedy was speed
reconfigured in terms
of style. The quick wit,
the slim-shouldered
English suits, the
streamlined hair-do and
cortisone-smooth face,
the decision-making
perceived as an aspect
of gesture politics, the
instant rapport with an
audience eager to be
enraptured, together
formed the model for
government in the
space age he launched.
— JG Ballard*

Queen Elizabeth II as seen on TV December 1967

Television promised to bring us a high-speed monarchy, fit for the age of the sound-bite and the peak-hour commercial. But the institution has proved to have all the inertia and flexibility of Stonehenge. One co-opted royal, the most glamorous international figure since Kennedy, died in the attempt to transform her wish-list of emotions into a quasi-religious career.
— JG Ballard

Telstar Satellite 1962

Invisible technologies rule our lives, transmitting their data-loads at the speed of an electron. Vast cash balances move around the world's banking systems, bounced off satellites we never see, but whose electro-magnetic footprints bestride continents and form our real weather. In the near future aesthetic amd cultural shifts in the planetary consciousness will move around the globe with the force and pace of tsunamis, replacing the slow, ancestral drift of politics and religion in the years before the information age.
— JG Ballard

Brain Wave Machine, London Hospital April 1950

Brain waves move slowly, as the potassium pumps at millions of synapses throw their cumbersome electro-magnetic switches. Decisions move through the cortex like population shifts across a continent, and reach our consciousness half a second after the brain has come to its own conclusions. The neurosciences seem to suggest that free will, like consciousness itself, is a virtual artefact created by the interplay of neural networks, as vivid but as illusory as the image of ourselves in the mirror.
— JG Ballard

conspiracy — inertia of the moment, of every place and every instant of the present world, which ultimately allies itself closely with the principle of inseparability, thereby completing indeterminateness in the sense meant in quantum theory.

Even when one witnesses the attempt in Japan today to combine two vehicles technologically by systematically installing video landscapes in the elevators of skyscrapers or by showing feature films during long plane flights as done in commercial air travel, this momentary link will nevertheless inevitably lead to the elimination of the least efficient vector regarding the speed of dispersion. The contemporary forward race of high-speed trains, supersonic aircraft, as well as the deregulation affecting both show better than any other preview that the threatened vector, the threatened vehicle, is really that of terrestrial, aquatic, and aerial automotility.

The era of intensive time is thus no longer that of means of physical transport. Unlike earlier, extensive time, it is solely that of telecommunications, in other words, walking in place and domestic inertia. Recent developments in both the automobile and formula-1 racing prove it. Since the high performance of the audiovisual cannot seriously be improved upon, people go about altering the performance of the racing car, the rules of racing, the weight of the vehicles, and the fuel reserves. They even go so far as to reduce the power of the engines, which is really the limit! Lastly, the dynamic land vehicle and the most symptomatic one of this sporting involution is the dragster (and the hot rod), the motto of which could be 'How can I get nowhere, or at least as close to it as possible (400, 200 yards), but with increasing speed?'

The extreme emphasis on this intensive competition may eventually have the finish line and starting line combined in order to pull even with the analogous feat of live television broadcasting. As far as the domestic car is concerned, its development is the same in every respect, for the automobile has a kind of self-sufficiency about it that is developing increasingly into a separate piece of property. Whence this move, this duplication of accessories, furniture, the hi-fi chain, radio, telephone, telex, and videomobile that turn the means of long-haul transport into a means of transport in place, into a vehicle of ecstasy, music, and speed.

If automotive vehicles, that is, all air, land, and sea vehicles are today also less 'riding animals' than frames in the optician's sense, then it is because the self-propelled vehicle is becoming less and less a vector of change in physical location than a means of representation, the channel for an increasingly rapid optical effect of the surrounding space. The more or less distant vision of our travels thereby gradually recedes behind the arrival at the destination, a general arrival of images, of information that henceforth stands for our constant change of location. That is why a secret correspondence between the static structural design of the residential dwelling and the medially conveyed inertia of the audiovisual vehicle becomes established with the emergence of the intelligent dwelling — what am I saying? — with the emergence of the intelligent and interactive city, the teleport instead of the port, instead of the train station and the international airport.

In answer to a journalist's indiscreet question about her address, a well-known actress responded: 'I live everywhere!' Tomorrow, with the aesthetics and logic behind the disappearance of the architectonic, we will live everywhere, that is a promise. All of us, like the animals of the 'video zoo', which are present only by virtue of a single image on a single screen — here and there, yesterday and the day before, images recorded at places of no importance, excessive suburbs of a cinematic development that finally takes audiovisual speed as it relates to the interior design of our dwellings and puts it on the same footing as that which the speed of automobiles has long been for the architecture of our cities and for the layout of our countries.

The 'immobile simulators' will then replace the flight simulators. Behind our cathode glass cases we become tele-actors and tele-actresses of an animated theatre whose recent developments in sound and light shows already herald this, although it is repeatedly used by people ranging from André Malraux and Léotard to Jack Lang only on the pretext of saving our monuments.

It is thus our common destiny to <u>become film</u>. Especially ever since the person responsible for the Cinéscénie du Puy-du-Fou, Philippe de Villiers, became secretary for culture and communication and announced his intent to institute 'scenic walks through areas being preserved as historical sites' in order to enhance the attractiveness of our historical monuments and thereby compete with the imported 'Disneyland' near Paris.

In the footsteps of the theatrical scenography of the agora, forum, and church square as traditional places of urban history there now follows <u>cinescenography</u>, the sequenced mutation of a community, region, or monument in which the participating population momentarily changes into actors of a history intended to be revived. It does not matter whether it is the war in Vendée with Philippe de Villiers or the centuries-old services of the city of Lyon with Jean-Michel Jarre. Even the predecessor of the current minister of culture has paid tribute to this phenomenon by tapping into the budget for funds (earmarked 'Salamandar') to finance the production of an interactive videotape of a tour through the chateaux of the Loire. It is 'Light and Sound' at home, and it turns the earlier visitors from a bygone age of tourism into video visitors, 'tele-lovers of old stones', whose record collections and discotheques have not only Mozart and Verdi but Cheverny and Chambord as well.

As noted in a poem entitled 'La Ralentie', by Henri Michaux, 'One does not dream any more; one is dreamed of, silence'. The inversion begins. The film runs in reverse. Water flows back into the bottle. We walk backwards, but faster and faster. The involution leading to inertia accelerates. Up to our desire, which ossifies in the increasingly distinct medical distancing: after the whores of Amsterdam in the display windows, after the striptease of the 1950s and the peepshow of the 1970s, we have now arrived at videopornography. The list of mortal sins in the Rue Saint-Denis is confined to the names of the new image technologies like BETACAM, VHS, and VIDEO 2000 in the expectation of erotic automatism, of the vision machine.

The same is happening with military confrontation. After the home trainer for the pilots in World War I, the swivel chair for training pilots in World War II, and NASA's centrifuge for future astronauts, which is a reality test for the ability or

inability to become accustomed to weightlessness, we have for ten years been witnessing the development of increasingly sophisticated and powerful simulators for the advocates of supersonic flight. Projection domes up to nine yards in diameter and more; a geode for a single man, the most developed of which will have a field of vision of up to almost three hundred degrees because the pilot's helmet will comprise an optical system for expanding the retina. To enhance realism even more, the person who practices here will don inflatable overalls that simulate the acceleration pressure related to the earth's gravity.

The essential is yet to come, though, for tests are being run on a simulation system that is derived from the oculometer and that will finally liberate us from the spheric video screen. The presentation of the images from aerial combat will be projected directly into the pilot's eyeballs with the aid of a helmet fitted with optic fibres. This phenomenon of hallucination approaches that of drugs, meaning that this practice material denotes the future disappearance of every scene, every video screen, to the advantage of a single 'seat' [siège], in this case, though, a trap [siège/piège] for an individual whose perception is programmed in advance by the computing capabilities of a computer's motor of inference. Before this future model of a static vehicle is invented, I think it would be appropriate to reconsider the concept of energy and the engine. Even though physicists still distinguish between two aspects of energetics — potential and kinetic energy, with the latter setting off motion — one should, eighty years after the invention of the travelling shot in the movies, perhaps add a third, the kinematic energy resulting from the effect that motion and its more or less great velocity has on ocular, optic, and optoelectronic perception.

In this sense, the contemporary industry of simulation seems like a realisation of this latter energy source. The computational speed of the most recent generation of computers approximates a final type of engine: the cinematic engine.

But the essential would not yet be said if we did not return to the primacy of time over space, a primacy best expressed today by the primacy of arrival (which is momentary) over departure. If the profundity of time is greater today than that of the field, then it means that earlier notions of time have changed considerably. Here, as elsewhere, in our daily and banal life, we are in fact switching from the extensive time of history to the intensive time of momentariness without history — with the aid of contemporary technologies. These automotive, audiovisual and informatic technologies all operate on the same restriction, the same contraction of duration. This earthly contraction questions not only the extension of the countries but also the architecture of the house and the furniture.

If time is history, then velocity is only its hallucination that ruins any expansion, extension, or chronology. This spatial and temporal hallucination, which is the apparent result of the intensive development of cinematic energy — of which the audiovisual vehicle would be for the motor today just as the mobile vehicle and, later, the automotive vehicle were for kinetic energy yesterday — these synthetic images, ultimately displacing the energies of the same name that were invented in the previous century.

Let us not trust it. The third dimension is

LA Freeway Interchange

The beauty of these vast motion sculptures, and their intimate involvement with our daily lives and dreams, may be one reason why the visual arts have faltered in the second half of the twentieth century. No painter or sculptor could hope to match the heroic significance of freeway interchanges.

In many ways they also threaten the novel, their linear codes inscribing a graphic narrative across the landscapes of our lives that no fiction could rival.— JG Ballard

Monorail, Sydney

Peter Sloterdijk
Modernity as Mobilisation

Only now a new perspective opens up for seeing mobilisation as the fundamental process of modernity — not because hitherto no-one has been more intelligent than the social theorists of previous centuries, but because today the 'situation itself' has reached the stage where it can be recognised with open eyes. In the face of the late-modern effects of acceleration it is only today that we can experience and observe the phenomenon of pure mobility. At the end of the twentieth century, in analogy to the Marxist vision of the Grundrisse, *a new category of phenomenon for diagnosing the times arises: 'mobility in its totality', 'self-movement'. This presumes not only the third industrial revolution with everything that electronics, nuclear technology and information science have made out of the reality of modern living, but also modern politics with its arms race, its mass social movements, and its top-down and bottom-up initiatives. It also presumes modern tourism, and its conception of the world as a check-in hall and runway, as well as the cable-linked screens, the new erotic disorder with its urban theatre of diversion, the midnight discotheques, the computer play things in the children's bedrooms, jogging in the park and the cult of athletics in the stadiums, the throw-away bottle, Andy Warhol's Factory and* Captured Music.... *Only since self-movement as, a category of the reality of life has penetrated directly into everybody's lives, can the dynamic motif of a society of self-mobilising subjects be named in a critical but relaxed tone of voice — that is, without the diagnosing critics having to present themselves as larger-than-life prophets. Only now are we compelled in a philosophical sense to notice that Marx and Nietzsche have said the same thing: the will to the self-appropriated production of the self, and the will to power (as the initiative to assert an interpretation of the world) are two alternative formulations for the same creative offensive of the working spirit against 'matter'. They share the same kinetic nihilism which takes the being as nothing but a source of energy and a construction site.*

Within the fundamental modern process of mobilisation — having by now drawn the entire course of the world into itself — three elementary trends can be distinguished. Firstly, the great self-movement towards surplus-movement leads to a tendency towards motorisation, towards the installation of automatic process units and their continual acceleration (tachocracy). Secondly, it

'Return to Muroc' 1997
Edwardes Air Force Base,
California

John McCracken
<u>Mach 2</u> 1992
Polyester resin, fibreglass
and wood
23 x 305 x 41cm
Lisson Gallery, London

Theo Baart
Highway 1996

Theo Baart
Highway 1996

*no longer the measure of expansion; relief, no
longer the reality. From now on the latter is
concealed in the flatness of pictures, the transferred
representation. It conditions the return to the
house's state of siege, to the cadaver-like inertia of
the interactive dwelling, this residential cell that has
left the extension of the habitat behind it and whose
most important piece of furniture is the <u>seat</u> [siège],
the ergonomic arm-chair of the handicapped's motor,
and — who knows? — the bed, a canopy bed for the
infirm voyeur, a divan for being dreamt of without
dreaming, a bench for being circulated without
circulating.* End

Ilya Chasnik
<u>*Design for a Suprematist Architectonic Composition*</u> *c.1923*
Watercolour, gouache and pencil on paper
16.6 x 22cm
Private collection

develops into the tendency towards the expulsion, the anaethetising and the switching off of subject-functions that are too sensitive, too slow and too oriented towards truth (automation through desensitising or cutting out of context). Thirdly, it works itself out through the progressive elimination of distances and imponderables that come with the strategic appropriation of things alien (logistics). In these three complexes of development, the world, as a hitherto inert resource, is prepared, coded and made ready for consumption and developed for auto-mobile system-subjects. The making of un-reality is the psycho-social result of a systematic 'self-realisation' whereby the outmoded concept of 'reality' shrinks logically to a remainder function of what has not yet been mobilised. American 'deconstructionists' have been whispering for some years about the new gospel: 'there is nothing outside the text'; only the naive still cling to the antediluvian fiction of 'external referents'. Epistemologically too, the short-circuit between kinetics and semiotics is in sight — logically speaking the world is ripe for evaporation.

Against the reality of an omnipresent mobilisation only one kind of critique is appropriate, a critique which advances through a pervasive awareness of mobility. Such a formulation is again prone to misunderstanding, however, since the direction of such a consciousness-raising process is not a forward movement, but a step back, a disconnection that distances us from the process of acceleration. Only hesitantly do we name the critical aspect of the mobilisation theory after a classical model: a critique of political kinetics.

Through this critique, the ugly, seemingly merely physical and sub-human topic of mobility is reclaimed for the sciences of humanity, for society and for historical foundations. If one recalls the gestures and arguments with which the impudent Marxist claim to accept the concept of labour as the basic category of an historical anthropology was received by the Beautiful Souls of the nineteenth century, then it can be imagined what kind of reception a critique of political kinetics can expect. The difference is that this time the Marxists are standing shoulder to shoulder with the Beautiful Souls and the bourgeois pragmatists in a Great Coalition, mobilisers against a critique of kinetics. The Marxists stand opposed because they are the first to notice that a critique of kinetics is only possible from a post-Marxist standpoint from where one has an overview of 'dialectical materialism' as a particularly wilted form of modern mobilisation folklore. The Beautiful Souls are in the opposition because, in their favourite preoccupation with the Human Potential Movement and the coming of a New Age, they are, to say the least, not amused by such an ugly theory. And the pragmatists belong to the Great Coalition because they never allow a thought to occur which even remotely puts their axiom of three percent annual economic growth into question. Now nobody can have any illusions about the fact that a critique of political kinetics puts more into question than merely the growth rates of an industrial civilisation which is racing into uncertainty with the momentum of a train that has been accelerating for centuries. Those who raise the kinetic question bring nothing less into play than the question of whether and how this night-train could be brought to a standstill — or at least whether there is a detour spur for it. It is not the question of whether individuals can leave this train (of course the right individuals can), but whether the

Ilya Chasnik
<u>*Horizontal Composition*</u> *c.1921*
Watercolour, gouache and pencil on heavy paper
17.5 x 28.5cm (excluding frame)
Private collection

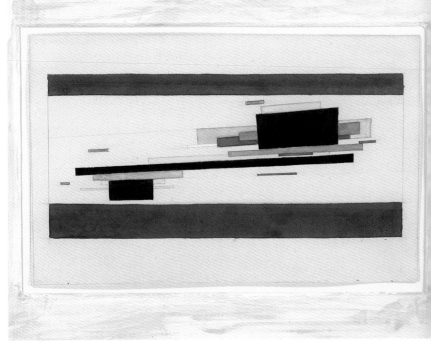

'Colossus' Computer,
Bletchly Park, England
1943

*Have computers already
evolved themselves into
a Darwinian cul-de-sac?
Enthusiastically carrying
out what they do best
and we do worst —
high-speed mathematical
computation — they may
have overshot the mark
and will soon find that they
are little more than
indentured clerks, endlessly
adding up figures in their
electronic ledgers.
Thirty years from now
they will probably regroup,
slow themselves down
and mount a more subtle
take-over bid. The
totalitarian systems of
the future will be sub-
servient and ingratiating.
— JG Ballard*

Female Motorist 1915

*The motor-car
transformed the twentieth
century, constraining the
aggression of men within
a highly controlled and
elaborately signalled
landscape. The highway
system is now a huge
reticular prison, granting
the illusion of speed,
direction and self-
chosen destiny to
millions of men confined
within their mobile cells.
But for women the car
was an immense force
for liberation, freeing
them from the home and
sending them out to
enjoy the unique social
pleasures of the traffic
jam and the hypermarket
car-park. — JG Ballard*

First BBC TV
transmissions 1929

*Television is the perfect
medium for the age of
paranoia. We can venture
into its simulation of the
world without ever being
seen, and a switch will
turn down those strange
voices inside our heads.
TV domesticates reality,
filters out its harder tones
and shows us only what
the less ambitious of us
want to see and hear. It
has done far more to make
a fairer society than Marx
or American consumerism.
— JG Ballard*

modern totality can free itself of a way of being that ontologically is determined by the formula 'Being-as-Mobility'.

These questions are too fundamental to be left to fundamentalists. The critique of political kinetics thus exposes a working framework for any thinking or praxis that is able to contribute in some way to the study of movement and to the exercising of a true mobility. The critique of political kinetics will be the working title for studies at an interdisciplinary, post-university 'university'. It can take up its exercises at any place where the true nature of human and systemic mobility has to be questioned. Like all university-like structures, the transfaculty for the awareness of movement also needs power-neutral terrains — in the best tradition of the defence of theory, going back to the heydays of the European Middle Ages — where the executives and pressure groups of the mobilisers are barred. But since the operations of almost all of the universities currently active on this Earth have developed into prep schools for mobilisation and into cognitive subcontractors for the 'attack of the present on the rest of time', the critique of political kinetics has to look around for other spaces in which to pursue its studies. Whether that be in the New Social Movements, in the centres of alternative culture, in newly founded, para-academic institutions, all this is — initially — not the main issue, and in any case these are not exclusive alternatives. Rather what is essential is that the transfaculty for the critique of movement develop new, polyvalent, societal brains that embody the knowledge of demobilisation from many fields. For all of us, coming from the mobilisation process, this knowledge will be difficult to handle, implausible, and annoying because the critique of political kinetics can never, under any circumstances, be the theoretical conscience of a practice. Its bizarre (some would say absurd) result is to describe the processes of reality in such a way that at first all that remains is that 'nothing needs to be done' — insofar as all those who are ready to leap into action will make fools of themselves when faced with what has to be done first, namely, to hesitate, to step back into more attentive perception, to cease doing what has always been done in some ways, to become imperceptibly free for the right movement. One can be sure that anything else will result once more in blind mobilisation, no matter how splendid the slogans for action may sound.

From its post-Marxist fundamental assertion one cannot conclude that the critique of political kinetics has a destructive relationship with the insights of the socialist tradition. What tilts the balance in comparison with this tradition is, firstly, the extension of the notion of production to that of mobilisation, and secondly, the change of kinetic disposition. One has to make an effort to study the Communist Manifesto once more in a way which the text has long since deserved: as the Magna Carta of the offensive kinetic nihilism where modernity for the first time openly pronounced what it is and what it wants. A critique of kinetics, however, will no longer be able to participate in the Marxist euphoria in the face of the observation that, in a world that is throbbing with the movement of capital, 'all that is solid melts into air'. In this formula Marx can be heard entirely as the thinker of mobilisation in action, and not merely as a fortuitous provider of rationalisations for making history in half the world. He is also the thinker of mobilisation because his great conceptual machine, particularly the dialectics of productive forces and relations of production, is only constructed with the intention of demonstrating the explosiveness of the slow social relations, those that still resist both the unleashing of productive production and the ultimate evaporation of all that is solid. His Messianic vision of labour is directed at the state of a society in which the activity of productive selves is only involved with itself — with the removal of the resistance of the real, with the total appropriation of everything that is alienated, with twenty-four hours a day of self-appropriating self-creation. In its own way, a critique of political kinetics will know something of 'dialectics', namely, the dialectics of forces of movement and relations of movement. But it will not lament that the social relations of movement 'still' curb the full deployment of forces; at most it will be dryly noted that the forces of movement in any case are no longer very far removed from 'evaporating' all social relations where conventional movements were still possible for us. The critique of kinetics too will point out that there is a growing organic complex of auto-motive masses, and as a consequence also an underlying fall in the benefits of mobility. It will not entertain the idea, however, to pronounce a prognosis of a 'revolutionary situation'. Even catastrophic speculations about interconnections between system collapse and uprisings of the masses remain alien to it. What the critique of kinetics emphasises is nothing more nor less than the crisis-driven opportunity for an evolutionary reduction of false mobilisation dynamics.

Just as in the process of capitalism the proportion of fixed capital grows continually, in the worldwide mobilisation of the systems, the dead automated forward-moving masses swell constantly, and increase their disproportionate weight beyond the gestures of vital mobility into something oppressive. The same holds also for the unleashed scientific research enterprises where the self-movement of the theoretical apparatuses ensures that thinking, in relation to what is thought, no longer plays any appreciable role whatsoever. These extraordinarily eerie processes are only inadequately covered by the concepts of automation or alienation. Our classical vocabulary leaves us empty-handed in view of the most recent processed realities. Mobility is the great un-thought in our languages.

After all this, one can probably surmise the contours of what a critique of political kinetics has to deal with. It is aimed at a critical theory of modernity in which the problematic obliteration of old world conditions could be described in terms of mobility, and criticised by exercises in demobilisation. As we have already said, there are few indications for whether such a project could succeed — short of success itself, for which, in turn, unequivocal criteria cannot be decreed. In any case, the starting point for this critique is the observation that the awakening of modernity to the self-active, conscious living of everybody has largely been lost in a rather blind, kinetic onward-turning mass process. The magnificent profits from the modern possibilities in many areas of self-mobility and self-actualisation are paid for by an incalculable and increasingly unbearable self-surrender to automatic, self-drifting processes of succession. If we are right in imagining the immediate future as a time in which increasing risks of catastrophe are rapidly realised, it is because we can by now formulate the fundamental kinetic schema for all

possible maximum-impact accidents. They will be the heteromobile result of innumerable self-mobilisations. The interaction of countless self-actions leads to a single, dark, self-fulfilling compulsion. From a systemic point of view, as far as our much-conjured future is concerned, its secret lies entirely in the variants of this great compulsion. Two extreme versions among them can be thrown into relief by way of a typology. The first version leads to a relative quieting of total mobilisation through mutual slowing down of partial processes (in praise of impediments?). The other variant drifts off into the exponential multiplication of mobilisations through interaction, right up to an ecological-kinetic inferno. And our consciousness of processes? What is its role in this world theatre — that of the hero, the jester, or merely that of the impotent onlooker? If everything is really heading towards a fatal conclusion, then our conscious self may console itself with the insight that it embodies all the roles in the end-game simultaneously, in that it can observe itself in its dramatic transformation from the hero of mobilisation into the fool of process, up until the moment the curtain falls. In the case of the relatively benign variant, on the other hand, subjects would be confronted with a noteworthy experience with themselves. In a time in which modernity could have saved itself from itself, the subjects would have also ceased to stir as the ontological agents of the movement towards surplus-movement. They would then know from their changed way of being that they are not the perpetrators of mobilisation, but the 'guardians' of a true mobility. End

Bullet Train

The high-speed train is a vehicle that satisfies a special kind of techno-logical nostalgia, along with computer-equipped yachts and man-powered aircraft. All three employ the most up-to-date materials research, advanced alloys and computerised designs, and apply them to anti-quated and inefficient modes of transport. The rail-train, like the wind-powered yacht and pedal-driven glider, should have been abandoned years ago, when advances in technology made possible their evolution into the helicopter, the speed-boat and the supersonic airliner. In technological terms they represent an artificially perpetuated childhood. — JG Ballard

Cockcroft and Walton
Atomic Accelerator 1932

Particle physics has unlocked the secrets of the sun, but the mystery of existence still endures. Colossal intellectual leaps have taken us back to within micro-seconds of the big bang, but a conceptual barrier deep inside our brains may be one door we will never open, at least until homo sapiens makes a significant evolutionary jump, and the processing capacity of our brains allows us to escape from the constraints of space-time. — JG Ballard

Robert Musil
Kakania
Extract from The Man Without Qualities *1930*

At the age when one still attaches great importance to everything connected with tailors and barbers and enjoys looking in the mirror, one often imagines a place where one would like to spend one's life, or at least a place where it would be smart to stay, even though one may not feel any particular inclination to be there. For some time now such a social idée fixe *has been a kind of super-American city where everyone rushed about or stands still, with a stop-watch in his hand. Air and earth from an ant-hill, veined by channels of traffic, rising storey upon storey. Overhead-trains, overground-trains, underground-trains, pneumatic express-mails carrying consignments of human beings, chains of motor-vehicles all racing along horizontally, express lifts vertically pumping crowds from one traffic-level to another At the junctions one leaps from one means of transport to another, is instantly sucked in and snatched away by the rhythm of it, which makes a syncope, a pause, a little gap of twenty seconds between two roaring outbursts of speed, and in these intervals in the general rhythm, one hastily exchanges a few words with others. Questions and answers click into each other like cogs of a machine. Each person has nothing but quite definite tasks. The various professions are concentrated at definite places. One eats while in motion. Amusements are concentrated in other parts of the city. And elsewhere again are the towers to which one returns and finds wife, family, gramophone, and soul. Tension and relaxation, activity and love are meticulously kept separate in time and are weighed out according to formulae arrived at in extensive laboratory work. If during any of these activities one runs up against a difficulty, one simply drops the whole thing; for one will find another thing or perhaps, later on, a better way, or someone else will find the way that one has missed. It does not matter in the least, but nothing wastes so much communal energy as the presumption that one is called upon not to let go of a definite personal aim. In a community with energies constantly flowing through it, every road leads to a good goal, if one does not spend too much time hesitating and thinking it over. The targets are set up at a short distance, but life is short too, and in this way one gets a maximum of achievement out of it. And man needs no more for his happiness; for what one achieves is what moulds the spirit, whereas what one wants, without fulfilment, only warps it. So far as happiness is concerned it*

Mobile Phone

The mobile phone can be seen as a fashion accessory and adult toy as well as a break-through in instant communication, though its use in restaurants, shops and public spaces can be irritating to others. This suggests that its real function is to separate its users from the surrounding world and isolate them within the protective cocoon of an intimate electronic space.

At the same time phone users can discreetly theatricalise themselves, using a body language that is an anthology of presentation techniques and offers to others a tantalising glimpse of their private and intimate lives. — JG Ballard

Facsimile Newspaper 1950s

The fax machine and the e-mail seem to threaten the old-fashioned printed word, at a time when a reader who owns no books has access to an entire university's data-base, and when a diligent browser will hunt out from the world's newspapers and magazines those topics that most keenly interest us. But books and news-papers survive and even prosper, suggesting that we need the fortuitous and contingent, and that our imaginations have evolved to scan the silent margins of our lives for any intriguing visitors or possible prey. — JG Ballard

Modem 1980s

The modem may become our most important interface with external reality. Human intercourse, like the exchange of social signals in the street and office, and even the elaborate cues between mother and baby may one day seem of minor importance when compared with the infinite riches of the virtual reality universes that the modem will bring to us. — JG Ballard

*matters very little what one wants; the main thing is that one should get
it. Besides, zoology makes it clear that a sum of reduced individuals may very well form a totality of genius.*

It is by no means certain that things must turn out this way, but such imaginings are among the travel-fantasies that mirror our awareness of the unresting motion in which we are borne along. These fantasies are superficial, uneasy and short. God only knows how things are really going to turn out. One might think that we have the beginning in our hands at every instant and therefore ought to be making a plan for us all. If we don't like the high-speed thing, all right, then let's have something else! Something, for instance, in slow-motion, in a gauzily billowing, sea-sluggishly mysterious happiness and with that deep co-eyed gaze that long ago so enraptured the Greeks. But that is far from being the way of it: we are in the hands of the thing. We travel in it day and night, and do everything else in it too: shaving, eating, making love, reading books, carrying out our professional duties, as the four walls were standing still: and the uncanny thing about it is merely that the walls are travelling without our noticing it, throwing their rails out ahead like long, gropingly curving antennae, without our knowing where it is all going. And for all that, we like if possible to think of ourselves as being part of the forces controlling the train of events. That is a very vague role to play, and it sometimes happens, when one looks out of the window after a longish interval, that one sees the scene has changed. What is flying past flies past because it can't be otherwise, but for all our resignation we become more and more aware of an unpleasant feeling that we may have overshot our destination or have got on to the wrong line. And one day one suddenly has a wild craving: Get out! Jump clear! It is a nostalgic yearning to be brought to a standstill, to cease evolving, to get stuck, to turn back to a point that lies before the wrong fork. And in the good old days when there was still such a place as Imperial Austria, one could leave the train of events, get into an ordinary train on an ordinary railway-line, and travel back home.

There, in Kakania, that misunderstood State that has since vanished, which was in so many things a model, though all unacknowledged, there was speed too, of course; but not too much speed. Whenever one thought of that country from some place abroad, the memory that hovered before the eyes was of wide, white, prosperous roads dating from the age of foot-travellers and mail-coaches, roads leading in all directions like rivers of established order, streaking the countryside like ribbons of bright military twill, the paper-white arm of government holding the provinces in firm embrace. And what provinces! There were glaciers and the sea, the Carso and the cornfields of Bohemia, nights by the Adriatic restless with the chirping of cicadas, and Slovakian villages where the smoke rose from the chimneys as hills, as though the earth had parted its lips to warm its child between them. Of course cars also drove along those roads — but not too many cars! The conquest of the air had begun here too; but not too intensively. Now and then a ship was sent off to South America or the Far East; but not too often. Here one was in the centre of Europe, at the focal point of the world's old axes; the words 'colony' and 'overseas' had the rings of something as yet utterly untried and remote. There was some display of

Alan Turing 1951

Turing was the first martyr of the computer age, a brilliant visionary and pioneer who was also a persecuted homosexual. He killed himself, apparently from despair. Turing gave his name to a test that he devised, which distinguishes between human and non-human responses to computerised queries. But the distinction is becoming more and more blurred. Many hospital patients prefer computer interrogators to human staff when giving their intimate medical histories, and we feel surprisingly at ease with the synthetic voices used in talking elevators and phone company consumer services, as if alienation is a secretly desired state. — JG Ballard

Autobahn 1937

Hitler, from
Reichsautobahn 1933

Edward Dimendberg
The Will to Motorisation — Cinema and the Autobahn

In a 1982 interview with Michel Foucault published under the title 'Space, Knowledge, and Power', the following exchange took place.[1] Responding to Paul Rabinow's suggestion that 'architects are not necessarily the masters of space that they once were, or believe themselves to be,' Foucault answered, 'That's right. They are not the technicians or engineers of the three great variables — territory, communication, and speed. These escape the domain of the architect.'[2]

I can think of no better preliminary definition of what I will call 'centrifugal space' than these remarks of the philosopher which emphasise the complex imbrication of three factors — territory, communication, and speed — in spatial forms that exceed received understandings of the architectural.[3] A determinant feature of the built environment of modernity, centrifugal space largely defines the geographic arrangement of the United States after 1930 and challenges conventional understandings of the metropolis.

Irreducible to specific urban forms or demographic trends such as suburbanisation, centrifugal space initiates novel perceptual and behavioral practices — new experiences of time, speed and distance — no less than new features of the everyday landscape. While the broad transformations in cities that arose after 1929 have been widely noted, corresponding changes in spatial perception have received far less attention, as has the role of cinema in the promulgation of this new geography.[4]

Characteristics of centrifugal space include the decreased significance of metropolitan density and agglomeration and their replacement by dispersed settlements and a shift from urban verticality to the horizontal sprawl of suburbs and larger territorial units.[5] But one might also discern centrifugal space in the redeployment of surveillance mechanisms away from the body of city dwellers towards the automobile, the proliferation of electronic media, and the collection of traffic statistics as a strategy of control.[6]

Centrifugal spaces include suburban settlements, industrial landscapes and shopping malls, but also urban regions that have lost their former centripetal features (perhaps through renewal projects, suburban exodus, or economic blight) or have become incorporated into conurbations such as Jean Gottmann's eastern seaboard 'Megalopolis' or the type of extended

1 An excerpt of this essay was presented at the 'Cine City: Film and Perceptions of Urban Space 1895–1995' conference organised by the Getty Center for the History of Art and the Humanities, Santa Monica, March 28–30, 1994. The text appearing here is an updated and reworked version of an article first published as 'The Will to Motorisation: Cinema, Highways, and Modernity' by the MIT Press in October 73 (1995). I am grateful to Anton Kaes, Annette Michelson, and Wolfgang Schivelbusch for their helpful comments on an earlier draft. Julian Cox of the Department of Photographs at the J. Paul Getty Museum, Hartmut Bitomsky, and Eric Chaim Klein offered invaluable assistance with photographic research. The Graham Foundation for Advanced Research in the Fine Arts provided a grant that aided my writing and research.
2 Michael Foucault, 'Space, Knowledge, and Power' interview by Paul Rabinow, trans. Christian Hubert, in The Foucault Reader, ed. Rabinow (New York: Pantheon, 1984), p. 244.
3 Descriptions of the spatial environment as exhibiting 'centrifugal' and 'centripetal' tendencies are frequently encountered in the literature of twentieth-century American urban geography and planning. The characterisation of the modern city as 'centripetal' appears throughout Frank Lloyd Wright, The Disappearing City (New York: William Farquhar Payson, 1932). An early attempt to define the conceptual opposition is Charles C. Colby, 'Centrifugal and Centripetal Forces in Urban Geography', Annals of the Association of American Geographers 23 (March 1933), pp. 1–20. A later example is José Luis Sert, Can Our Cities Survive? An ABC of Urban Problems, Their Analysis, Their Solutions, (Cambridge: Harvard University Press, 1947), p. 156. The project of

defining centrifugal space after World War II — and its cultural, political, and cinematic modalities — is one that I undertake at length in my forthcoming book, Film Noir and the Spaces of Modernity. Its completion has been greatly facilitated by receipt of a J. Paul Getty Postdoctoral Fellowship in the History of Art and the Humanities, and a Resident Fellowship at the University of California Humanities Research Institute.
4 Of course, many examples of urban decentralisation and the expansion of the city beyond its traditional boundaries can be supplied for the period prior to 1929. Perhaps the most famous case remains the metropolitan area of Paris that grew from containing seven communes beyond the city boundaries in 1851 to twenty-nine in 1872. Between 1861 and 1872 its ten eccentric arrondissements gained 200,000 inhabitants. The rise of the garden city movement in the early decades of this century is also significant. While attempts to specify the first instance of these tendencies seem unlikely to evade the impasses of historicism, it is worth noting how the proliferation of the automobile, highway construction, radio, and television after 1929 created the conditions of possibility for what I call centrifugal space. What is central to the concept as I understand it is not simply a mutation in urban morphology and geography, but rather fundamental changes in the lived experience of space itself. For a discussion of the history of Paris, see David H. Pinckney, Napoleon III and the Rebuilding of Paris (Princeton: Princeton University Press, 1958), esp. pp. 165–71. The standard text on the garden city movement is Ebenezer Howard, Garden Cities of Tomorrow (1902; reprint, Cambridge: MIT Press, 1965).
5 As one historian notes, 'between 1950 and 1960 urban population grew

by about 45 per cent, but it occupied twice as much land — 12,804 square miles in 1950 compared with 25,554 miles in 1960. The reason, quite simply, is that the outward shift of urban population is also predominantly a shift from multiple to single-family dwellings.' (John B. Rae, The Road and the Car in American Life [Cambridge: MIT Press, 1971], pp. 226–27).
6 A little-known example of this surveillance involves the traffic planning studies conducted in urban areas by the Bureau of Public Roads beginning in the early 1940s. The most popular device for collecting information about driving habits and itineraries was the 'origin and destination survey', in which interviewers stationed at the entry point of a highway into a city would stop motorists to question them about their routes and destinations. Other means of gathering facts involved collecting license plate numbers, distributing travel questionnaires at the workplace, and even enlisting Boy Scouts to assist with the collection of data. As an early instance of the employment of statistical patterns to aid in the planning of roads and highways, these surveys suggest the increasing importance of the driver as the subject of centrifugal space. For a discussion of their practice see John T. Lynch, 'Traffic Planning in American Cities', Public Roads vol 24, no 6 (October–December 1945), pp. 161–78. For an account of the use of television surveillance to manage automobile traffic, see 'Closed-Circuit Television Aids Traffic Survey', The American City (February 1957), p. 155.

Robert Musil
Kakania
Continued

luxury; but it was not, of course, as over-sophisticated as that of the French. One went in for sport; but not in madly Anglo-Saxon fashion. One spent tremendous sums on the army; but only just enough to assure one of remaining the second weakest among the great powers. The capital, too, was somewhat smaller than all the rest of the world's largest cities, but nevertheless quite considerably larger than a mere ordinary large city. And the administration of this country was carried out in an enlightened, hardly perceptible manner, with a cautious clipping of all sharp points, by the best bureaucracy in Europe, which could be accused of only one defect: it could not help regarding genius and enterprise of genius in private persons, unless privileged by high birth or State appointment, as ostentation, indeed presumption. But who would want unqualified persons putting their oar in, anyway? And besides, in Kakania it was only that a genius was always regarded as a lout, but never as sometimes happened elsewhere, that a mere lout was regarded as a genius. End

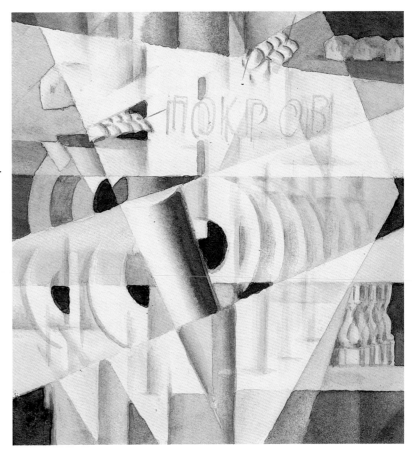

Ivan Kluin
Study for 'Landscape Rushing By'
c.1914–15
Brush and ink wash on paper
16 x 14.8cm
Private collection. Courtesy Julian Barran Ltd., London

Ed Ruscha
Racecar Drivers 1998
Acrylic and ink on paper
76.5 x 101.2cm Courtesy Anthony d'Offay Gallery, London

development prevalent in southern California.[7] They are historically transitional between an older centripetal metropolis of the street and promenade and the emerging electronic cyberspace of virtual reality and the information superhighway of our present fin-de-siècle moment.

Largely ignored by architects, the highway may well be the pre-eminent centrifugal space of the twentieth century.[8] Arguably as significant to post-1930 cinema as the street and the railroad were to those earlier films engaged in charting a centralised and navigable centripetal space, cinematic representations of the motorway remain far less studied than filmic treatments of the metropolis.[9] Precariously situated on the intellectual meridian between the disciplines of architecture, geography, urban planning, landscape design, and traffic management, the freeway occupies an ambiguous status within the branches of knowledge devoted to the study of modern space.[10]

Frequently imagined as a spatial superconductor for transporting vehicular traffic in an unimpeded, frictionless flow, the motorway has become the most extravagantly romanticised structure of the late twentieth-century built environment. As the last refuge for the myth of a pure functionalism long since disavowed by architects, the freeway conveniently evades the faintest hint of contingency; its allegedly utilitarian vocation is imagined as the product of disinterested traffic engineers and transportation planners.

Cultural historians of modernity inevitably recount the encroachment of speed into all areas of life, the heroic conquest of distance and the triumphal elimination of resistance to the technological ordering of time, space, the body, and nature itself. From Marinetti through the European embrace of Taylorism, to the productivism of the Vkhutemas and the Bauhaus, speed, whether dynamising aesthetic perception, augmenting production, or boosting consumption appears as the ubiquitous common term linking modernity to diverse instances of twentieth-century modernism.

Yet an equally compelling history could be written about the malfunction of speed as a chronicle of those breakdowns, disturbances, catastrophes, and delays ranging from train accidents to blackouts to commuter crashes to satellite failures in which our collective dependence upon technological systems and their efficient operation is revealed, often to horrifying effect. Living in our present age, we may well experience our modernity primarily through these slowdowns and crises, revealing as they do perhaps more effectively than any other experience the normally invisible and taken for granted infrastructures of social life.

In her book *Rights of Passage*, the photographer Martha Rosler powerfully demonstrates the dysfunctional character of the centrifugal space of the American motorway.[11] Documenting stretches of the New Jersey Turnpike and the approach routes to New York City, Rosler's images of traffic jams, construction blockages, road obstructions, and automobile accidents effectively refute the myth of frictionless circulation. They provide an apposite starting point for an archaeology of the motorway and the fantasies of spatial control and speed elicited by the German National Socialist construction and cinematic representation of the Autobahn.

Hartmut Bitomsky's 1986 film *Reichsautobahn* skillfully presents the German Autobahn as an ensemble of aesthetic and cultural practices that transcends the dictates of a functional transportation system. Together with his 1983 *Images of Germany* (Deutschlandbilder) and his 1989 *The VW Complex* (Der VW Komplex), Bitomsky's cinematic essay explores the inseparability of landscape, the automobile, and social and political life in twentieth-century Germany.[12]

Through the juxtaposition of excerpts from Autobahn film footage, photographs and paintings from the 1930s, and the director's voice-over narration, *Reichsautobahn* constructs an account of the motorway as a social technology producing new modes of perception and representation. While the film thoroughly implicates the highway within the politics of National Socialism, it no less disturbingly locates its spatial form in relation to broader constellations of modernist culture and modernity.

Reichsautobahn is organised into twenty-four sections that explore the physical fabrication of the German highway system as well as the production of its cultural significance by the National Socialists. These segments feature interviews with surviving workers and engineers of the Autobahn, depiction of the construction of such famous segments as the Mangfall Bridge near Munich, and reflections on the motorway's legacy for contemporary Germany. Neither a labour of documentation that purports to offer a seamless historical narrative of the project's gestation nor an assemblage of cinematic material presented to evoke nostalgia or a carefully orchestrated and legitimated revulsion, Bitomksy's film treats the Autobahn as both a building feat and a labour of representation.[13]

Reichsautobahn pursues a calculatedly open and nondidactic formal strategy. Sections follow one another without immediately discernible motivation; sounds and images from the 1930s are juxtaposed with those from the present. Excerpts from the original Autobahn films frequently produce a comic effect, while Bitomsky's commentary interpolates historical contextualisation and philosophical analysis but eschews the univocal meaning traditionally produced by voice-over narration. Gradually one recognises the film's leitmotifs (labour, the cult of the machine, bridge construction, integrity of German *Lebensraum*, cinematic representation), which recur with a singular persistence.[14]

Beginning with a voice-over quotation from Hitler, 'We will ensure that the work is no longer dissociated from those who created it', the film immediately cuts to images of an army of shovellers and an account of the emergence of the so-called shovel disease that afflicted malnourished and overworked Autobahn workers. Bitomsky reveals the Führer to be a man of his word and demonstrates that rather than detach itself from these labourers the technology of the Autobahn introduced mutations into their bodies while inaugurating a range of no-less-painful social pathologies.

Presented by the National Socialists as the invention of Hitler, allegedly envisioned during his 1924 incarceration, the earliest conceptions of the German Autobahn predate the First World War.[15] During the Weimar Republic, diverse specialist interest groups composed of civic leaders and representatives of industry and finance such as the Automobile Traffic and Training Road Association (AVUS), the Hanseatic Cities-Frankfurt-Basel Lobby (HAFRABA), and the Research Society for German Road Construction (STUFISTRA) promoted the

7 See Jean Gottmann, Megalopolis: The Urbanised Northeastern Seaboard of the United States (Cambridge: MIT Press 1961) and Rob Kling, Spencer Olin, and Mark Poster, eds., Postsuburban California: The Transformation of Orange County Since World War II (Berkeley and Los Angeles: University of California Press, 1990). A helpful overview of contemporary architectural views on centifugal space is found in Architectural Design 108, devoted to 'The Periphery'.

8 Although they seldom (if ever) actually built highways, the principal modernist architects of the early twentieth century frequently wrote about them. Examples of these analyses include Mies van der Rohe, 'Expressways as an Artistic Problem' (1932) in The Artless Word: Mies van der Rohe on the Building Art, trans. Mark Jarzombek, ed. Fritz Neumeyer (Cambridge: MIT Press, 1991); Le Corbusier, The Radiant City (1933), trans. Pamela Knight, Eleanor Levieux, and Derek Coltman (London: Faber and Faber, 1967), pp. 196–97; and Frank Lloyd Wright, The Living City (New York: Horizon Press, 1958), p.116.

9 Two of the more thoughtful recent analyses of film and urban space are Giuliana Bruno, Streetwalking on a Ruined Map (Princeton: Princeton University Press, 1993) and Anne Friedberg, Window Shopping: Cinema and the Postmodern (Berkeley and Los Angeles: University of California Press, 1993). For a discussion of the railroad and cinema, see Junction and Journey: Trains and Film (New York: Museum of Modern Art, 1991). It is revealing to observe that most current research on film and the city neglects the period between 1930 and 1960, precisely the time frame in which centrifugal space rapidly expands.

10 The concept of the freeway, a route free of side-entry access roads, originates around this time with the Norris Freeway built in 1933 by the TVA. See Norman T. Newton, Design on the Land: The Development of Landscape Architecture (Cambridge: Harvard University Press, 1971), p. 617.

11 Martha Rosler, Rights of Passage (1997). The phrase 'traffic jam' apparently was coined by the Saturday Evening Post in 1910. See Clay McShane, Down the Asphalt Path: The Automobile and the American City (New York: Columbia University Press, 1994), p.193.

12 Although not conceived by the filmmaker as a single entry, these three cinematic texts have come to be regarded as constituting his 'German Trilogy'. The scripts of Bitomsky's major films, a complete filmography, and a collection of critical essays on his work can be found in Die Wirklichkeit der Bilder: Der Filmemacher Hartmut Bitomsky, ed. Jutta Pirschtat

(Essen: Edition Filmwerkstatt, 1993). References to the film refer to page numbers in the Reichsautobahn screenplay included in this volume. Unless otherwise noted, all translations from German are mine.

13 An important analogue to Reichsautobahn is the writing of Wolfgang Schivelbusch, especially his classic study The Railway Journey, trans. Anselm Hollo (New York: Urizen Books, 1979). Like Schivelbusch, Bitomsky is also an archaeologist of perception whose work investigates the cultural reception of technology in the industrial age.

14 As Bitomsky notes in his narration, 'Today the Autobahn is so natural, one would have to imagine a world without it. But at the time the Autobahn was so unfamiliar one needed to imagine oneself in it.' (Reichsautobahn, p. 77). Precisely by depicting the highway in its novelty, Reichsautobahn explicates its significance for modernity. The most common technique appropriated by Bitomsky toward this end involves close analysis of single film scenes or photographs and paintings. This is accomplished either by slowing down an Autobahn film (as when it is viewed on an editing table) or by scrutinising frame enlargements. By decomposing cinema into its individual images and constructing a new temporality of analysis, Bitomsky foregrounds both the power of the National Socialist propaganda and the complicity of cinema in the intoxicating speed of the Autobahn films. I am grateful to Thomas Levin for this insight.

15 One of the earliest segments of the Autobahn was actually constructed in 1912 between Berlin Wannsee and Charlottenburg. The best short overview of its history is Thomas Kunze and Rainer Stommer, 'Geschichte der Reichsautobahn', in Reichsautobahn, Pyramiden des dritten Reichs: Analyse zur Äesthetik eines unbewältigen Mythos, ed. Stommer (Marburg: Jonas Verlag, 1982) , pp. 22–48. An insightful discussion of the motorway's popular representations with a useful historical chronology, filmography, and selection of Autobahn poetry is Erhard Schütz, '"Jene blassgrauen Bänder": Die Reichsautobahn in Literatur und anderen Medien des "Dritten Reiches"', Internationales Archiv für Sozialgeschichte der deutschen Literatur vol. 18, no. 2 (1993), pp. 76–120. For a richly illustrated discussion of the myths of the Autobahn see Erhard Schütz and Eckhard Gruber, Mythos Reichsautobahn: Bau und Inszenierung der 'Strassen des Führers' 1933–1941 (Berlin: Ch. Links Verlag, 1996). English-language treatments of German roads include James D. Shand, 'The

Reichsautobahn: Symbol for the Third Reich' in Journal of Contemporary History 19 (1984), pp. 189–200, Wolfgang Sachs, For the Love of the Automobile: Looking Back into the History of Our Desires, trans. Don Reneau (Berkeley and Los Angeles: University of California Press, 1992), and Iain Boyd Whyte, 'National Socialism and Modernism', in Art and Power: Europe under the Dictators 1930–45, compiled and selected by Dawn Ades, Tim Benton, David Elliott, and Iain Boyd Whyte, (London: Hayward Gallery, 1995), pp. 258–269.

Autobahn workers
1930s

Cover of Die Strasse
1930

Autobahn
1930

Autobahn worker
1930s

construction of local segments of the Autobahn, generally with limited success.[16]

Resistance from the German railroad lobby stalled highway development until 1929, when the worldwide economic depression following the American stock market crash provided a boost by making available the labour of Germany's vast army of the unemployed.[17] *The appointment on June 28, 1933, of Fritz Todt as General Inspector of German Highways and the establishment two months later of the Society for the Reichsautobahn removed road building from local jurisdiction and centralised authority for Autobahn construction within the state, which began to implement many of the plans originally conceived by earlier freeway lobbyists.*[18]

Although Hitler and Todt did not invent the Autobahn, they became its consummate salesmen and the principal architects of its aesthetic, a point vividly conveyed by the film footage of Hitler breaking ground on September 23, 1933, for the first segment of the Autobahn, the Frankfurt-Darmstadt-Heidelberg route. Bitomsky analyzes this visual presentation of the German leader on an editing table and notes how the overly energetic worker who threatens to upstage the Führer is quietly removed from the scene.[19]

Yet the limited number of passenger cars in Germany in the early 1930s scarcely sufficed to convince the population of the necessity for its construction.[20]

No less significant than the labour of the highway's physical fabrication was the creation of a requisite social demand and competence accomplished through a flood of photographic, painterly, literary and cinematic documentations.[21]

Representing 'Hitler's road' figured so prominently in National Socialist propaganda that one is tempted to conclude that the Autobahn existed as much to be photographed and filmed as to be driven upon. Facilitating 'communication' in the manner Foucault understands as emblematic of the exercise of modern power, the Autobahn became medium and message in one, a means to conquer spatial distance that also transformed the meaning of the territory it traversed.

The progress of the Autobahn was recorded cinematically with such prodigious enthusiasm that one is led to speculate it may well be the most heavily filmed construction project of the twentieth century. Hitler always found the quantity of Autobahn films deficient and lamented 'it is unfortunately the case that everything great accomplished here [Germany] is not expressed in film'.[22] *Bearing titles such as Bahn Frei! (Open Road), Strassen der Zukunft (Roads of the Future), Auf Deutschlands neuen Autostrassen (On Germany's New Highways), Schnelle Strassen (Fast Roads), and Strassen Machen Freude (Roads Make Happiness), these films were intended for a general non-technical audience and typically depicted the fabrication and dedication of new motorway segments.*

Representation of labour was a key function of Autobahn cinema, whose depiction of workers engaged in construction seemed to confirm Hitler's assertion that his highways would effectively remedy German unemployment, which hovered at about 25.9 percent of the working population (4.8 million people) in 1933.[23] *The first Autobahn film, Strassen ohne Hindernis (Roads Without Obstacles) (1935) released around the time of the completion of the Frankfurt-Darmstadt segment, stresses the project's significance as a means of creating jobs as well as its economic stimulation of the steel,*

Paul Wolff
The New Rhine Bridge, Krefeld
Collection of the J Paul Getty Museum, Malibu, California

16 Much of the preparatory work for the Autobahn had been accomplished by the HAFRABA association, founded in 1926 to build a motorway from northern Germany to Basel. After the National Socialists came to power, the technical personnel and plans of this group came into the control of the party and were renamed GEZUVOR (Gesellschaft zur Vorbereitung des Reichsautobahns), a clever pun on the German phrase for 'go first'. The new regime passed up few opportunities to oppose its successful road building to the Weimar Republic's dearth of highway construction, a consequence, it claimed, of the latter's lack of political unity. This failure to obtain political consensus followed from a widespread perception of the Autobahn as a luxury project of benefit only to a small segment of automobile drivers. Yet the inability to fund its construction was due in large measure to the parliamentary opposition of both National Socialists and Communists to the privatisation of highway construction and the charging of road tolls. After 1933 the National Socialists soon dropped their objection to user fees, which had been the basis for Mussolini's implementation of Pietro Puricelli's influential plan for an Italian Autostrada beginning in 1922. Yet tolls were never implemented on the highway. Two weeks after his election, Hitler began to champion the Autobahn, which the party soon began to present as a panacea for German unemployment. For the official critique of HAFRABA, see Die Plannungsarbeiten für die Reichsautobahnen: Zweieinhalb Jahre GEZUVOR (Berlin: Volk und Reich Verlag, 1937), p. 11. For a discussion of political opposition to the Autobahn during the Weimar period, see Kunze and Stommer, 'Geschichte der Reichsautobahn,' and Christine Uslular-Thiele, 'Autobahnen' in Kunst im 3 Reich: Dokumente der Unterwerfung (Frankfurt: Frankfurter Kunstverein, 1975), pp. 68–70. A useful summary of road-building developments in Europe at this time can be found in M. G. Lay, Ways of the World: A History of the World's Roads and the Vehicles That Used Them (New Brunswick: Rutgers University Press, 1992), pp. 313–22.

17 The excellence and density of Germany's railroad network and poor state of its roads hindered the proliferation of the automobile up to the end of the 1920s. For every 100 square kilometres there were 14.6 kilometres of railway track in Germany, 11.7 in France, 10.6 in Holland, and 7.4 in Italy. See R. J. Overy, 'Cars, Roads and Economic Recovery in Germany: 1932–38', The Economic History Review 2nd ser., vol. 28. no 3 (August 1975), pp. 466–83. From the moment of his announcement to support construction of the

Autobahn, Hitler was forced to placate the leadership of the powerful German Reichsbahn. This was accomplished by initially establishing the Reichsautobahn under the jurisdiction of the railroad, the only governmental authority with the necessary expertise to built the highway system. In 1936, three years after the enabling law that established the Reichsautobahn, its practical control was removed from the railroad and vested in the General Inspector of German Highways, Fritz Todt. See Franz W. Seidler, Fritz Todt: Baumeister des Dritten Reiches (Munich and Berlin: Hebrig, 1986), pp. 98, 144–45. It is perhaps not coincidental that trains frequently appear in Autobahn films, the spectre of an earlier technological form in eclipse.

18 Fritz Todt (1891–1942) was trained as an engineer and worked for the Munich construction firm Sager & Worner as chief technical adviser. He joined the party in 1923, and in 1932 he published a treatise on roads and technology that attracted the notice of the party leadership, including Hitler. On November 30, 1933, he was named General Inspector of German Highways and thereby attained primary responsibility for coordinating the labour and construction plan for the Autobahn. After 1938 he supervised the building of the Westwall fortification along Germany's borders with France, Switzerland and Luxembourg. Todt was one of Hitler's most respected advisers on technical and engineering matters and enjoyed unrestricted access to the Führer and sweeping authority in all matters relating to construction. On February 8, 1942, he died in an airplane accident of suspicious origin at Rasterburg, Hitler's headquarters on the eastern front. For a critical account of Todt's role in the Autobahn, see Franz W. Seidler, Fritz Todt: Baumeister des Dritten Reiches. The standard encomium is Fritz Todt: Der Mensch, Der Ingenieur, Der Nationalsozialist: Ein Bericht über sein Leben und Werk (Oldenburg: Verlag Gerhard Stalling, 1943).

19 Bitomsky notes in Deutschland Bilder that Hitler claimed to have completed 1.25 million kilometres of automobile travel through Germany during his rise to political power. The excerpts in Reichsautobahn of newsreel footage depicting motorcades and the dedication of new highway segments underscore the practical value of the Autobahn in the constitution of the National Socialist public sphere. As Hitler remarked, 'Without automobile, airplane, and loudspeaker, the conquest of power would not have been possible'.

20 The number of automobiles in Germany rose as follows: 1925: 425,790; 1930: 1,419,870;

1935: 2,157,811; 1939: 3,894,588 (Karl Heinz Ludwig, Technik und Ingenieure im Dritten Reich Düsseldorf, Droste Verlag, 1974), pp. 304–5. Yet as late as 1935, there were 16.1 cars for every 1,000 inhabitants of Germany, compared to 204.5 vehicles for every 1,000 inhabitants of the United States (Overy, 'Cars, Roads, and Economic Recovery', p. 470).

21 Images of the Autobahn and models of its bridges appeared prominently in the two 1937 exhibitions 'Gebt Mir Vier Jahre Zeit' (Grant Me Four Years Time) and 'Schaffendes Volk' (A Productive People) held to mark the fourth anniversary of the National Socialist state. See 'Strassenwesen und Reichsautobahn auf der Reichsausstellung "Schaffendes Volk"' and 'Die Reichsausstellung "Gebt Mir Vier Jahre Zeit"' in Die Strasse 10 May (May 1937), pp. 285–86.

22 Bitomsky, Reichsautobahn, p. 71.

23 The funding for the construction of the Autobahn derived in part from gasoline taxes, but principally from monies designated for relief and social security payments. Even here the National Socialists were scarcely innovators, for as early as 1926 road construction constituted 60 per cent of unemployment projects supported by the Länder. Peter Reichel claims that in 1936, at the height of the building of the Autobahn, no more than 250,000 were employed by its construction or in support industries. Fritz Todt had earlier predicted that 600,000 people (less than 13 percent of Germany's unemployed) would be provided work through the Autobahn. Peter Reichel, Der schöne Schein des Dritten Reiches: Faszination und Gewalt des Faschismus (Munich: Carl Hanser Verlag, 1991) p.279. As late as 1939 Todt asserted that 400,000 people were engaged by Autobahn construction. See Dr. Fritz Todt, Die Strassen Adolf Hitlers, ed. Dr. Otto Neismann (Berlin and Leipzig: Hermann Hillger Verlag, 1939), p.25. All of these figure are only approximations, for it is not clear how many Autobahn workers actually were unemployed before they began to labour on the motorway. In 1933 the population of Germany was approximately 66 million. For useful statistical information on unemployment and demography, see V. R. Berghahn, Modern Germany: Society, Economy, and Politics in the Twentieth Century (Cambridge and New York: Cambridge University Press, 1982), pp. 251–89. For a presentation of the profound economic recovery produced by Hitler's work creation programs, see Dan P. Silverman, Hitler's Economy: Nazi Work Creation Programs, 1933–1936 (Cambridge: Harvard University Press, 1998).

German Troop 1937

Albert Renger-Patzsch
Iron Girders
Collection of the J Paul Getty Museum,
Malibu, California

cement, and lumber industries. From the delivery of raw materials to the meticulous finishing of the road surface, the building of the thoroughfare appears as a meticulously choreographed act of cooperation between energetic workers and the state.[24]

Yet the actual predicament the National Socialist regime faced in conscripting labourers willing to accept poor wages, backbreaking toil, and life in a distant work camp apart from their families is never mentioned in a film such as <u>Bilder der Aufbau der Reichsautobahn</u> (Images of Construction of the Reichsautobahn), in which a benevolent foreman resolves petty conflicts among workers who are later driven triumphantly along the stretch of highway they have built. In the 1939 UFA feature film <u>Mann für Mann</u> (Man for Man), a Berlin Autobahn project functions as the site for resolving male subjectivity in crisis. By the start of the war the labour shortage became so acute that prisoners of war and Jews were forced into Autobahn construction, a situation scarcely conveyed by the appearance of cheerful workers in these films.[25]

Autobahn documentaries sought to depict a unified territory of the German nation. Through their persistent deployment of maps (as in the scene in which Todt describes the future routes of the network) and emphasis on the increased ease of travel, they convey the impression of a gradual shrinking of distances between German cities and the advent of the Reich as a consolidated geographical entity.[26] Radio coverage and weekly newsreel reports reinforced this experience of spatial compression. Territorial integrity and national boundaries also are highlighted in these films by the recurrent appearance of foreigners eager to praise the significance of Germany's accomplishments.[27]

Advertising the features of the motorways and instructing Germans in their practical use was no less important a task of Autobahn cinema. Coinciding with Hitler's promotion of <u>Autowandern</u> as a leisure activity and the advent of the first Volkswagen marketing campaign in 1938, these films promoted a new automotive-oriented lifestyle, a desirable image of social prosperity, and novel spatial distractions, as exemplified by the Autobahn film sequence in which three women drive to the country for a picnic.[28] Modern economic life was becoming inconceivable without the automobile, as Hitler noted in his address to the 1933 Berlin Automobile Show, which bore the foreboding title that year of 'The Will to Motorisation':

'The motor vehicle has become, next to the aeroplane, one of humanity's most ingenious means of transportation. The German nation can be proud in its knowledge that it has taken a major part in the design and development of this great instrument Just as horse-drawn vehicles once had to create paths and the railroad had to build lines, so must motorised transportation be granted the streets it needs. If in earlier times one attempted to measure people's relative standard of living according to kilometres of railway track, in the future one will have to plot the kilometres of streets suited to motor traffic.'[29]

Yet the most profound consequence of the Autobahn and German motorisation may have been less its short-term stimulation of the pre-war economy or alleged military significance than a quieter if more insidious transformation of everyday life.[30] One sees this in the film <u>Bahn Frei!</u> (Open

[24] Construction sequences in Autobahn documentaries were often filmed with a moving camera and convey a technical virtuosity and smoothness that was no doubt intended as a comment on the roads themselves. Rarely do workers appear as specific individuals, nor do these films generally depict building firms, authority figures, or government agencies. Their ultimate effect is to suggest a giant highway system that magically fabricates itself. One might also note the frequent appearance of workers carrying heavy logs or building materials; the symmetrical deployment of their muscled bodies suggest the ordered balance of a bridge.

[25] For a discussion of the use of conscripted labour in the constuction of the Autobahn, see Seidler, <u>Fritz Todt</u>, p. 105

[26] As one commentator noted in 1936, 'The contradiction that appeared between the technical development of the motor and the very limited realities of the street — a result of insufficient attention in previous decades — is now being cast aside. The roads of the Führer will be developed into great traffic arteries, which not only will contribute to the melding of the German people into a stronger political and economic unit, but will also put an end to the last remnants of particularistic thinking'. Quoted from 'National Highways — The Sign of Our Times', <u>Die Strasse</u>, 1936, no 1, p.8 ff. in Wolfgang Sachs, <u>For the Love of the Automobile: Looking Back into the History of Our Desires</u>, p. 51. Yet the line between the triumph over particularistic thinking and the imperialistic expansion of German <u>Lebensraum</u> was frequently imperceptible. On March 13, 1938, seven days after the Austrian Anschluss, the first Autobahn exhibition opened in Vienna. A month later, construction of the first segment in Austria commenced. In December 1938, building of an Autobahn began in the newly annexed Sudetenland. For a discussion of Todt's thinking about expansion of highways into Eastern Europe and German colonies in Africa, see Seidler, <u>Fritz Todt</u>, pp. 137–43.

[27] Representative of this tendency is the film <u>Schnelle Strassen</u> (Fast Roads) in which the German actors posing as English tourists take a test drive on the Autobahn. Bitomsky notes that the film was produced in English and other foreign languages, suggesting the circulation of Autobahn films abroad. Foreign engineers — including Thomas MacDonald, chief engineer of the American Bureau of Public Roads, and Piero Puricelli, Mussolini's road architect — also visited the German motorways as did British Prime Minister Lloyd

George, who came with his own measuring stick to ascertain that the Autobahn was actually 25 centimetres thick. For an account of the influence and reception of the Autobahn abroad, see Seidler, <u>Fritz Todt</u>, pp. 124–26, and 'Deutscher Autostrassenfilm vor USA — Srassenbauleuten', <u>Die Strasse 7</u> (April 1938), p. 225.

[28] The significance of the Volkswagen to the German economy and the National Socialist military effort is discussed in Bitomsky's film <u>The VW Complex</u>. The most thorough historical treatment of these issues is the monumental study by Hans Mommsen with Manfred Grieger, <u>Das Volkswagenwerk und seine Arbeiter im Dritten Reich</u> (Düsseldorf: Econ Verlag, 1996).

[29] Adolf Hitler, in <u>Die Strasse 20</u>, p. 242, quoted in Sachs, <u>For Love of the Automobile</u>, pp. 47–48. Hitler did make good on his promise during his speech to lower automobile taxes, deregulate the car industry and support road construction.

30 While National Socialist discussions of the Autobahn generally downplay its military significance, this appears a rare instance of the regime actually revealing the truth. Only after 1938 did Todt construct Autobahn segments for the invasion of Poland and Czechoslovakia. Most evidence overwhelmingly suggests that during the early years of the Autobahn's construction tactical concerns did not decisively influence its planning or utilisation. The leadership of the German army thought the Autobahn too vulnerable to attack or appropriation by the enemy and preferred the railroad for transporting men and war material. And as the engineer interviewed in Reichsautobahn clearly notes, the roadway surface of the Autobahn was designed for passenger vehicles and could not withstand the weight of the heavy trucks that came into service after 1937. Most of the motorways constructed, such as the Cologne–Frankfurt–Stuttgart–Munich–Salzburg and the Berlin–Leipzig–Nuremberg–Munich segments were north–south routes without military value. The east–west Autobahn line toward Berlin and Stettin was completed with extensive delays, and by the start of the Second World War only the north–south routes were operational. That the construction of the Westwall and the outbreak of the war virtually brought the building of the highway system to a standstill in 1942 suggests the relatively minor strategic role played by the Autobahn. For a discussion of these issues, see Seidler, Fritz Todt, pp. 136–43 and Ludwig, Technik und Ingenieure, pp. 319–23. A dissenting interpretation that stresses the military significance of the Autobahn is Karl Lärmer, Autobahn bau in Deutschland: Zu den Hintergründen (Berlin: Akademie-Verlag, 1975).
31 Bitomksy, Reichsautobahn, p. 73
32 Thomas Mann, 'Deutschland und die Deutschen', in Essays vol 2 (Frankfurt: S. Fischer Verlag), p. 294, quoted in Jeffrey Herf, Reactionary Modernism: Technology, Culture and Politics in Weimar and the Third Reich (New York: Cambridge University Pres, 1984). Herf's book remains the standard discussion of reactionary modernism. While recognising the importance of its overall argument, I do not share all of its conclusions, especially the crticism of the Frankfurt School analysis of National Socialism. Other helpful discussions are found in Peter Reichel, Der Schöne Schein des Dritten Reiches, pp. 101–13 and George L. Mosse, 'Fascism and the Avant-Garde' in Masses and Man: Nationalist and Fascist Perceptions of Reality (Detroit: Wayne State University Press, 1987), pp. 229–45.
33 Herf, Reactionary Modernism, pp. 1–2

34 Bitomsky suggests that no Autobahn film could end without being crowned by a bridge sequence, an assertion that is scarcely surprising when one considers that between 1933 and 1941 9,000 Autobahn bridges were constructed at a cost of 2 billion Reichsmark, nearly a third of the total 6.5 billion mark expenditure for the highway. The first Autobahn bridges were economically advantageous steel-and-reinforced-concrete structures designed by leading architects such as Paul Bonatz. The functional appearance of such Zweckbauten (functional buildings) displeased party leaders who desired bridges to be 'cultural monuments' (Kulturdenkmal) with the heroic neoclassical demeanor preferred by the regime for public and ceremonial buildings. After 1935, bridges increasingly were built in stone and appropriated designs and motifs from antiquity and the Middle Ages, partially in response to the rationing of steel after the introduction of the Four Year Plan in 1936. Paradoxically, although many stone bridges actually contained a reinforced concrete core, they required construction workers to relearn forgotten techniques of masonry to fabricate their exterior. A helpful discussion of Autobahn bridges can be found in Rainer Stommer, 'Triumph der Technik: Autobahnbrücke zwischen Ingenieuraufgabe und Kulturdenkmal', in Reichsautobahn, pp. 49–76. The standard work on this architectural history remains Barbara Miller Lane, Architecture and Politics in Germany 1918–1945 (Cambridge: Harvard University Press, 1965).
35 Bitomsky, Reichsautobahn, pp. 68–69

Petrol Station 1937

Road!) in which poor driving conditions on German surface roads delay the leisure outing of a young couple. Concerns about loss of time and the pressure to arrive quickly at a destination introduce a new lifestyle. As Bitomsky notes, 'The pleasure trip is calculated on an eight-hour day, as if it were work or a business venture'.[31] Presented as an innovation that yields greater freedom and leisure, the Autobahn and motorisation are shown by Reichsautobahn to initiate a new temporal economy and regimentation.

As a technique for acclimatising the sensorium of the average German to new experiences of speed, time, and mobility, these films advance the ideological program of reactionary modernism, effectively defined by Thomas Mann as 'the really characteristic and dangerous aspect of National Socialism … its mixture of robust modernity and an affirmative stance towards progress combined with dreams of the past: a highly technological romanticism'.[32] Or in the words of Jeffrey Herf:

'Before and after the Nazi seizure of power, an important current within conservative and subsequently Nazi ideology was a reconciliation between the antimodernist, romantic, and irrationalist ideas present in German nationalism and the most obvious manifestation of means-end rationality, that is, modern technology. Reactionary modernism is an ideal typical construct …. The reactionary modernists were nationalists who turned the romantic anticapitalism of the German Right away from backward-looking pastoralism, pointing instead to the outlines of a beautiful new order replacing the formless chaos due to capitalism in a united, technologically advanced nation.'[33]

Technological romanticism permeated Autobahn discourse and presented the German highways not simply as an engineering achievement but as an aesthetic and pedagogical enterprise. No mere transportation system, the motorway was to be a cultural monument that fostered the citizen's experience of belonging to the German nation. From the construction of imposing bridges modelled after Roman monuments to the adorning of gasoline stations in the style of regional Heimatkunst, no detail of the visual appearance of the Autobahn was relegated to chance.

Particular care was devoted to Autobahn bridges, the prestige projects of the highway system frequently represented in film.[34] The construction of the Mangfall Bridge near Munich and Salzburg between December 1934 and August 1935 was a favourite topic of documentaries; its simplicity and lengthy span composed of a steel base and reinforced concrete pillars seemed a perfect architectural expression of the National Socialist concentration of power. Constructors freely acknowledged the authority of their monumental projects: 'If one wants to represent the will to form [Formwillen] of the present, one would have to choose a technical building or a bridge.' As the most compelling architectural and ideological metaphor of the Autobahn, the bridge tangibly represents the ideal of a social order in which 'Everything is subjugated to the whole without force' and 'all structures would fit together as individual links in a chain spanning the Reich'.[35]

Proponents of the motorway never tired of emphasising its proximity to nature and its role in making the landscape accessible to the average German. No less than an appearance of technological grandeur, the insertion of the Autobahn in the countryside was intended to elicit

a socially desirable aesthetic experience.[36] As one commentator observed:
'They are more than just technical marvels, piercing spacelike arrows and ignoring the obstacles the ruthless landscape rears against them in their course; for technology itself, however highly we may esteem it as our handmaid and instrument in the fostering and development of life, does not possess a living soul These roads bear witness to the mighty unity of the Reich that has made it possible for the human beings travelling upon them to speed ceaselessly along in glorious rhythm to the song of the motor from east to west, from north to south, over heath and moor, up hill and down dale, leaving towns and villages behindThey are understood by the whole German people, thus enabling us to share anew together, in a national community of art, experience such as had for generations been lost to usThey open up to Germans wide areas of their homeland of which hitherto they had known practically nothing. They educate them to see Mountain range, forest, bush, pastures, mills, lakes, draw into view, fall away, call and beckon to the voyager to stop, to stay a while to rest and think.'[37]

Forbidding billboards and advertisements along the roadside (and even at its service stations), the Autobahn creators envisioned an aestheticised space, a theme park for the automobilised subject, in which nothing would come between drivers and the experience of the German landscape. In the words of the commentator, 'We live in a technological age and the more we take possession of it, the more we strive to return toward nature'.[38] Yet the paradox of constructing a technologically mediated experience of the natural environment did not appear to trouble observers at the time.

For the pastoral landscape experienced by German drivers was no less elaborately constructed than the road itself. Autobahn routes were carefully selected for their physical beauty through a system of ground surveying and aerial reconnaissance. Monotony was eliminated by rolling curves built so that no straight segment of the roadway was longer than eight kilometres.[39] Distractions from other buildings were kept to a minimum.[40]

In the case of the Munich-Salzburg segment, the highway actually was relocated to Irschenberg, a twenty-kilometer detour, in order to include scenic views of the Alps.[41] Harmonious integration of the Autobahn into the surrounding landscape remained a key concern to its builders, and in the interests of ecology and aesthetics each construction site was assigned a <u>Landschaftsanwalt</u> (landscape attorney) as an advocate for the surrounding flora.[42] Alwin Seifert, a prominent garden architect who understood national identity as 'rooted in the soil' and advocated a purely German natural environment, worked closely with Todt and imparted the ecological concerns of the Autobahn builders with a uniquely <u>völkisch</u> twist.[43]

The highway provides a controlled visual experience analogous to the montage and multiplicity of perspectives afforded by cinema. Speeding down its lanes, 'New images continually reveal themselves to the driver. The driver experiences the spaces of the landscape with its exciting succession of narrow and spacious views'.[44] Seen through the windshield of an automobile, the German countryside reminded many observers of a scene from an aeroplane.[45] Writing about the experience of railway travel,

August Sander
<u>Freeway built under the</u>
<u>Third Reich, Neandertal</u> 1936
Collection of the J Paul Getty
Museum, Malibu, California

Schivelbusch characterises the consequences of mobile vision as follows:

'Panoramic perception, in contrast to traditional perception, no longer belongs to the same space as the perceived objects: the traveler sees the objects, landscapes, etc. through the apparatus which moves him through the world. That machine and the motion it creates become integrated into his visual perception: thus he can only see things in motion.'[46]

Separated from the landscape, the automobile occupant can experience it much the same way as the spectator of the panorama once encountered the countryside. Borrowing a term from Anne Friedberg, one might speak of the Autobahn as facilitating an automobilised 'virtual gaze' that projects driver and passenger alike into an idealised natural environment of an earlier preindustrial German past.[47] The presence of attractions alongside the roadway, such as an eighteenth-century mill converted into a rest stop for motorists, suggests an equally deliberate re-creation of an anterior historical moment.[48]

As Bitomsky suggests, 'the Autobahn introduces perspective into the landscape'.[49] Unfolding fresh vistas for the spectator, the open road becomes a powerful allegory for continuity and progression, a historical teleology and vision of the future projected into the landscape itself. This repetition of endless stretches of (empty!) open highway in many Autobahn films suggests the highway's ability to reassert its context in unfamiliar surroundings yet always harmonise with nature. In the words of Todt:

'Already in the planning stages, the greatest value is placed on the perfect insertion of these roads into the German landscape. It is a pioneering achievement of the road construction of the Third Reich that not only functional but above all beautiful highways have been built The organisation of routes that results in complete adaptation to nature is the best. The beautiful road attracts traffic to it like a magnet. But the new roads, the roads of Adolf Hitler, also express a very new characteristic feature of the German landscape. The open road forces the gaze in its direction. Origin and goal clearly stand out. And over time the German people themselves will be led by means of these grand routes to think in larger spaces and dimensions than they have previously.'[50]

The visual means for directing this automobilised gaze varied considerably, and the National Socialists carefully balanced völkisch and modernist representations of the Autobahn with traditional landscape imagery and monumentalising depictions of the classical architectural vocabulary employed in bridges and construction projects.[51] Just as the highway was carefully implanted into the landscape, the motorist was meticulously interpellated into the Autobahn, even (perhaps especially) when physically separated from it.

In films and photographs of highways and bridges one notices a predilection for vanishing perspectives, aerial and elevated views, vertically or diagonally organised compositions, and an absence of the human figure associated with the Weimar Republic aesthetic of Neue Sachlichkeit.[52] Consequently, it is scarcely surprising to learn that its chief proponent in photography, Albert Renger-Patzsch, published photographs in the Reichsautobahn magazine Die Strasse (The Road).[53]

Perhaps the most common visual strategy

36 The Autobahn was not the first controlled access automobile route that sought to harmonise with the surrounding landscape, a distinction enjoyed by the Bronx River Parkway completed in 1923. See Newton, Design on the Land: The Development of Landscape Architecture, pp. 596–604, and Siegfried Giedion, Space, Time and Architecture: The Growth of a New Tradition, 5th ed., rev. (Cambridge: Harvard University Press, 1982), pp. 823–33. German traffic engineers carefully studied the American parkways, just as their American counterparts later inspected the Autobahn as a prototype for a transcontinental highway system.

37 Georg Fritz, Strassen und Bauten Adolf Hitlers (Berlin: Verlag der Deutschen Arbeitsfront, 1939), pp. 13–14. I have slightly modified the English translation included in the book. The appearance of this text in three languages (German, English, Italian) suggests that a foreign readership was not least in the minds of its publisher. For an example of German architectural propaganda aimed at an English-language readership, see A Nation Builds: Contemporary German Architecture (New York: German Library of Information, 1940).

38 Reichsautobahn, p.74

39 The first Autobahn engineers brought their experience designing routes for the German railroad to the construction of the highway. Consequently, the earliest segments were roadways of unwavering straightness. Todt endeavoured to introduce more curves into the course of the roads. (Seidler, Fritz Todt, p. 117)

40 'To facilitate the experience of the landscape, the early Autobahn was built at a higher elevation than the surrounding terrain. Only gas stations were permitted next to the roadway to prevent buildings from spoiling the view. All other structures were distanced from the road so that 'one would not take away the most beautiful quality of the Autobahn, direct access to the natural landscape.' Parking areas were located at appealing scenic spots to allow drivers to experience the region, such as the Saale Valley Bridge', Meinhold Lurz, 'Denkmäler an der Autobahn — die Autobahn als Denkmal' (Reichsautobahn, p. 182). The elimination of billboards from the roadside was soon to become a highly charged political issue, with defenders of the German Heimat opposing 'tasteless capitalist advertising techniques' that contaminated the countryside. See 'Kampfwoche gegen die Verchandelung der Heimat', Volkstum und Heimat 1 (April 1934), pp. 36–37.

41 For a discussion of the Irschenberg route, see Meinhold Lurz, 'Denkmäler an der Autobahn', p. 181. This segment of the

Autobahn was particularly well known through its representation in an amateur photograph that won a competition for the most 'beautiful road' of the motorway. See Philipp, 'Die schöne Strasse', pp. 116–18. Todt's surveying of potential sites for the Autobahn is mentioned in Seidler, Fritz Todt, p. 114.

42 For a discussion of the role of the Landschaftsanwalt (landscape attorney), see Seidler, Fritz Todt, p. 116–20.

43 Seifert transposed the Nazi ideology of 'blood and soil' into the category of 'rooted in the soil' (bodenständig). Practically, this entailed a politicisation of the garden through the avoidance of plants foreign to Germany and a critique of 'supranationality' in landscape architecture. See Joachim Wolschke-Bulmahn and Gert Groening, 'The Ideology of the Nature Garden: Nationalistic Trends in Garden Design in Germany in the Early Twentieth Century', Journal of Garden History, vol 12 no 1 (1992), pp. 73–80. For a discussion of the collaboration between Seifert and Todt, see Seidler, Fritz Todt, p. 116–20, and Alwin Seifert, 'Die Wiedergeburt landschaftsgebundenen Bauens', Die Strasse 17 (September 1941), pp. 286–89.

44 Hans Lorenz, 'Die Mitarbeit der lebendigen Natur', Die Strasse 8 (1941), p. 289, quoted in Claudia Gabriele Philipp, 'Die schöne Strasse im Bau und unter Verkehr: Zur konstituierung des Mythos von der Autobahn durch die mediale Verbreitung und Ästhetik der Fotografie', in Reichsautobahn, ed. Stommer, p.114.

45 See Alfons Paquet, 'Die Autobahn in der Landschaft und im Reich', Die Strasse 9 (May 1939, first issue), pp. 274–76.

46 Schivelbusch, The Railway Journey, p.66

47 The gaze from the window of an automobile involves a simultaneous real confinement and mobility. Friedberg usefully proposes the notion of the 'virtual gaze' that is 'not a direct perception but a received perception mediated through representation ... an imaginary flânerie through an imaginary elsewhere and elsewhen.' See Friedberg, Window Shopping: Cinema and the Postmodern, p. 2

48 See Carl Lindner, 'Von neuen Reichsautobahn–Rastanlagen', Die Strasse 7 (April 1940), pp. 138–41, for a discussion of the renovated Old Mill rest station.

49 Bitomsky, Reichsautobahn, p.71

50 Todt, Die Strassen Adolf Hitlers, pp. 30, 32. Italics at end of passage are mine.

51 For a helpful discussion of classicism in architecture during the 1930s, see Franco Borsi, The Monumental Era: European Architecture and Design 1929–1939, trans. Pamela Marwood

(London: Lund Humphries, 1987).

52 While used around the turn of the century by Hermann Muthesius, founder of the German Werkbund, after 1924 the phrase 'New Objectivity' (Neue Sachlichkeit) became a means of distinguishing the new Weimar art from the earlier stylistics of expressionism. For one of its initial uses in the exhibition catalogue of the first major display of the new painting, see Gustav Hartlaub, 'Introduction to "New Objectivity": German Painting Since Expressionism' in The Weimar Republic Sourcebook, ed. Anton Kaes, Martin Jay and Edward Dimendberg (Berkeley and Los Angeles: University of California Press, 1994), pp. 491–93. Herbert Molderings usefully defines its photographic aesthetic as 'clear, sharp, and precise reproduction, shots from unusual angles, close-up or from a great distance, narrowly limited detail instead of an ensemble, isolation of particular features, emphasis on material surface and abstract structure. All this contributed to an aesthetically fragmented perception, less human than technical and mechanical in its effect.' Herbert Molderings, 'Urbanism and Technological Utopianism: Thoughts on the Photography of Neue Sachlichkeit and the Bauhaus' in Germany: The New Photography 1927–33, ed. David Mellor (London: Arts Council of Great Britain, 1978), pp. 93–94.

53 In 'Die schöne Strasse', pp. 116–117, Philipp discusses the publication of photographs by Renger-Patzsch in Die Strasse, an assertion that is difficult to confirm because of the magazine's erratic practice of acknowledging contributors. Other prominent Weimar photographers whose images and names do appear in Die Strasse include Umbo and Paul Wolff.

of the photography of Renger-Patzsch involves the serial repetition of manufactured objects, a practice received with great enthusiasm by advertisers. Widely criticised by commentators such as Walter Benjamin for transforming photography into a barely disguised paean to the commodity form, the immaculate object world of these photographs exemplifies the productivist invocation of the machine aesthetic prevalent during the rationalisation boom of the 1920s.[54] As Anson Rabinbach explains:

'Beauty was identified with a "second nature", with mechanical adequacy and technical form. Especially in the artistic and literary Neue Sachlichkeit, which gained extraordinary popularity in pre-depression Germany, the new aesthetic celebrated "the concrete", the thing, autonomous of all social relations. The mystique of technical rationality, productivity, efficiency, and "romantic faith in the speed and roar of machines all belonged to the cult of the sachlich". Paralleling the intensive rationalisation of German industry, during the "upswing" of German capitalism between 1924 and 1928, everything from frying pans to industrial gears were exhibited for their pious adherence to the principles of economy of form, efficiency of design, and mathematical precision. With the extension of modern design to all aspects of everyday life, social relations became mediated by an image of the world derived from technical rationality.'[55]

Renger-Patzsch exemplified this tendency in much of his photography from the late 1920s throughout the 1930s, which was frequently commissioned by industrial clients.[56] Yet even when representing technological subject matter (such as engine assembly at the Nuremberg Zündapp motorcycle plant), his photographs persistently render mechanical things as animate or organic forms.

Comparisons between manufactured objects and trees and animals abound in his 1928 book Die Welt ist schön. An early admirer recognised the isomorphic relations between animate and inanimate forms recurring in Renger-Patzsch's work and claimed 'this photography reveals nature more intensely than nature reveals herself — precisely because it offers a concentrated selection of what nature withholds by her very abundance'.[57]

Nature as a 'model for the functional' is a recurring aesthetic principle throughout Renger-Patzsch's work of the 1920s and 1930s.[58] One observer noted at the time: 'Lawful order is at the core of the contemporary Kunstwollen. Structure, not mood, is the governing element in a picture.'[59] Writing in Die Form, the journal of the German Werkbund design association, a commentator claimed:

'Nature itself creates art. A will to form rules here that is thoroughly sovereign, self-creation A self-increasing will to form, governing and directing organisms, must be admitted as a fact. It is now necessary to understand more deeply the effect of this "Logos", its artistic principle. To that end I want to contribute the following claim: the same stylistic succession is found in nature as in art; a definite rhythm orders our human cultural creations and the same rhythm is clearly recognisable in the structures of self-advancing nature.'[60]

Commonly understood as promoting an aesthetic of machine production, the photographic practice of Renger-Patzsch is equally characterised by an attention to nature

whose rhythms, essential forms, and logos his photographs calculatedly emulate, as his proponents never tire of reminding us. While organising and animating the reified object world, these images also technologise the natural environment, transforming plants, animals, and landscapes into a visual typology of the 'will to form' of the mechanical age. Technology and nature reinforce and reconcile with each other in the spiral of a self-referential definition through which each term legitimates the other. Nature expresses its will to form: industrial production creates an aesthetically sublime second nature.

Designed to heighten the motorist's experience of the countryside, the Autobahn is no less a second-nature construction, 'history that congealed into nature', than the objects depicted by the photography of the New Objectivity.[61] Reification is systematically effaced in typical photographs of the motorway, as is the historical character and violence of the roadway. Formal relations among the component elements of the highway radiate power and a reassuring solidity that augments their rapturous coexistence with nature. The Autobahn is a transportation machine that aspires to become landscape, a yearning made powerfully evident in August Sander's 1936 photograph of the Neandertal highway route.

Although never proponents of National Socialism, photographers such as Sander and Renger-Patzsch created a photographic aesthetic whose conflation of nature and technology mimics and promotes the blurring between them realised by the Autobahn itself. It is incorrect to understand this visual practice as a product of the coercive pressure of National Socialist cultural policy, for its essential features are evident well before 1933, as is its ubiquity in photographs of architecture and construction projects that circulated during the Third Reich.[62]

If these images are ideally suited to the cultural enterprise of representing technology and highways as vital organisms growing throughout the German landscape, it is not least because they may culminate in an aesthetic experience of identification with a powerful external object. As Donald Kuspit notes about the work of Renger-Patzsch:

'Both the aesthetic moment, a kind of epiphany of the thing, and the perceptual identification with the thing — an identification that occurs in the aesthetic moment, indeed, that the moment exists to facilitate — have the same refreshing point: the sense that the aestheticised object can in its turn aestheticise or transform the subject, inducing a feeling of being renewed or reborn. The object, then, becomes not just a metaphor for self-transformation and re-creation, but their catalyst Thus Renger-Patzsch privileges photographic perception as a way of establishing the thing's constancy. But the photograph does more for him: it offers an empathic rapport, fusion, and finally complete identification with the thing.'[63]

Examining photographs, films, and drawings of the Autobahn from the 1930s, one encounters images of technological splendor that encourage precisely this identification and sense of renewal, an aesthetic response grounded in an orchestrated misrecognition of second nature whose political utility could not have escaped

54 Benjamin's critique of the photography of the Neue Sachlichkeit is specifically directed against Albert Renger-Patzsch's 1928 book Die Welt ist schön (The World is Beautiful). He writes: 'The "creative" principle in photography is its surrender to fashion. Its motto: the world is beautiful. In it is unmasked photography, which raises every tin can into the realm of the All but cannot grasp any of the human connections that it enters into, and which, even in its most dreamy subject, is more a function of its merchandisability than of its discovery. Because, however, the true face of this photographic creativity is advertising or association, therefore its correct opposite is unmasking or construction. For the situation, Brecht says, is complicated by the fact that less than ever does a simple reproduction of reality express something about reality.' (Walter Benjamin, 'A Short History of Photograph' [1931] in Classic Essays on Photography, ed. Alan Trachtenberg, trans. Phil Patton [Hamden, Conn: Leet's Island Books, 1980], p.213).

55 Anson Rabinbach, 'The Aesthetics of Production in the Third Reich' in International Fascism: New Thoughts and New Approaches (London and Beverley Hills: Sage Publications, 1979), p. 203. This article remains among the most perspicacious studies of the National Socialist appropriation of modernism. For recent approaches to the same topic, see the essays collected in Wolfgang Emmerich and Carl Wege, eds. Der Technikdiskurs in der Hitler-Stalin-Ära (Stuttgart and Weimar: Verlag J. B. Metzler, 1995). For approaches to the theme of 'Traffic and Mobility in Modernity', see the special issue of Sozialwissenschaftliche Informationen 4 (October–November–December 1996).

56 These commissions include Wegweisung der Technik Werkbundbücher Bank 1, text by Rudolf Schwarz (Berlin and Potsdam: Müller und Keipenheuer Verlag, 1928); Eisen und Stahl, Werkbundbuch, foreword by Albert Vögler (Berlin: Verlag Hermann Reckendorf, 1930); and Leistungen der Deutschen Technik, text by Albert Lange (Leipzig: Seeman-Verlag, 1935).

57 Hugo Sieker, 'Absolute Realism: On the Photographs of Renger-Patzsch' (1928) trans. Joel Agee, in Photography in the Modern Era, ed. Christopher Phillips (New York: Metropolitan Museum of Art/Aperture, 1989), p.113.

58 Ute Eskildsen, 'Photography and the Neue Sachlichkeit Movement', in Mellor, Germany: The New Photography, p.104.

59 Wolfgang Born, 'Photographic Weltanschauung' (1929), trans. Joel Agee in Phillips,

Photography in the Modern Era, pp. 15–57.

60 Rudolf von Delius, 'Kunstform und Naturform', _Die Form_, vol 1, no. 6 (March 1926), p.110.

61 Russell Jacoby, _Dialectic of Defeat: Contours of Western Marxism_ (Cambridge and New York: Cambridge University Press, 1981), p. 119. The concept of second nature derives from Hegel and was later employed by Georg Lukács in his 1914–15 book, _The Theory of the Novel_, trans. Anna Bostock (Cambridge: MIT Press, 1971), pp. 62–64. For a useful overview of its later appropriation by Theodor Adorno and Walter Benjamin, see Susan Buck-Morss, _The Origin of Negative Dialectics_ (New York: The Free Press, 1977), pp. 52–57.

62 As an instance of the continuity between Weimar artistic practice and the art of National Socialism, one might note the post-1933 paintings of Wilhelm Heise that depict the Autobahn in a style essentially identical with much painting associated with the New Objectivity. A useful discussion of this is found in Kurt. H. Lang and Rainer Stommer, 'Deutsche Künstler — an die Front des Strassenbaues! Fallstudie zur nationalsozialistischen Bildgattung "Autobahnmalerei"' in _Reichsautobahn_, ed. Stommer, pp. 91—110. A photographic example can be found in the remarkable elevated views of Autobahn bridges that appropriate the visual style of Moholy-Nagy's work of the late 1920s. See 'Vom neuen Bauen in der Deutschen Landschaft', _Volk und Reich_, vol 3, no 12 (March 1936), pp. 233–36. That these images are credited to the Wasow Photographic Agency in Munich suggests the continued popularity and acceptability of the earlier photographic aesthetic.

63 Donald Kuspit, 'A Critical Biographical Profile', in _Albert Renger-Patzsch: Joy Before the Object_ (New York: Aperture/J.Paul Getty Museum, 1993), p. 68. My disagreement with Kuspit's formal aestheticist interpretation of Renger-Patzsch along with his excoriation of Benjamin as a 'commissar' guilty of 'political tunnel vision' and 'Marxification' as a result of which he 'forgot that photography had something to do with perception' (66) is severe. Although Kuspit notes that Renger-Patzsch resigned from his position at the Folkwangschule in Essen in 1934 in protest against its takeover by the party, he overlooks the fundamental congruity between his work and the National Socialist visual aesthetic of reactionary modernism. Kuspit seems unwilling to recognise the ways in which Renger-Patzsch's photographs could be useful to the ideology of the regime. He insists instead on defending the person of the photographer as a staunch opponent of its authoritarianism, anti-Semitism, and industrial excesses whose career was damaged by his loss of a job and archives in a bombing raid in 1944. Yet to claim that 'for Benjamin, the point is not to celebrate, with whatever aesthetic subtlety, the ugly and the banal, but to expose why there is so much ugliness and banality in the world' (p. 67) is to misread the social and historical location of the philosopher's critique of Renger-Patzsch, a project in which the exposure of a reified world of second nature was far more than an aesthetic issue. Kuspit's analysis of these photographs refuses to understand the political stakes of the 'unconscious perceptual identification' with the technological object world they effect. The division that he attempts to maintain between the photographer's career before and after their rise to power strikes me as implausible, for it privileges landscapes and ignores the copious industrial commissions and advertising work completed before and after 1933. Like most commentators on Renger-Patzsch, Kuspit remains conspicuously silent about the continuities in the photographer's work after the National Socialist consolidation of power. Similarly unconvincing is his claim that the 'cool, glossy modernity of the thirties things ... bespeaks indifference rather than identification'. Renger-Patzsch rarely came as close to the thirties things as he did to the twenties things' (p. 72). One can easily find examples of images from the 1930s that are photographed in close proximity, such as the tinsmith's tools in _Eisen und Stahl_. Where distances between the photographer and motif do increase, this is generally a consequence of an increase in the size of the represented object.

1 Quoted from Marc Dambre, Roger Nimier: _Hassard di demi-is_, (Paris, 1989)

Kristin Ross
La Belle Américane

Writing in 1963, Roland Barthes commented that only perhaps food had as much place in French discourse of the period as the car. Barthes' own discursive career had begun in the late 1950s with occasional journalistic pieces (assembled in 1957 as _Mythologies_) on such everyday upheavals as the presentation of the new Citroën DS ('Déesse', the divine) on the floors of the 'Salon de l'automobile' or the photos accompanying recipes in _Elle_ magazine. In 1955 a young sociologist who would soon become the leading theorist of French modernisation, Alain Touraine, published his first book: _L'évolution du travail ouvrier aux usines Renault_. Touraine's colleague at Nanterre during the 1960s, Jean Baudrillard, wrote his first book in 1967, _Le système des objets_; it contained a long section entitles 'La voiture, objet sublime'. And in 1960, in an article entitled 'Theses on Traffic' published in _L'Internationale situationniste_, Guy Debord pronounced the automobile to be at once 'the sovereign good of an alienated life and the essential product of the capitalist market'.

But when Barthes refers to the saturation of discursive reflection on the car in the late 1950s and early 1960s, he is thinking less of writers like these — less, that is, of writers like himself: than various friends and colleagues of Henri Lefebvre who, following his lead, had turned their attention to everyday life — and more, I think, of the popular information then readily available from magazines, market research surveys, best-selling novels like those of Françoise Sagan, hit movies, advertisements, even documentaries: that array of prose and images that François Nourissier called 'the beautiful litany of Mercedes, Facel-Vegas, Aston-Martins and Jaguars'.[1] In the early 1950s novelists Boris Vian and Roger Nimier attended the yearly 'Salon de l'automobile' as fans; they published their enthusiastic reviews in magazines like _Elle_ and _Arts_.

Françoise Sagan's 1954 car wreck in her Aston-Martin was a focus of print obsession for months, even years; Nimier's latest car accidents were featured in _Femina illustration_. Testimonies to a particular novelist's bold, risk-taking driving style in turn increased sales of both novels and magazines. In the 1950s, when a newly resuscitated Céline despaired of having sold less than a tenth of of the number of volumes Sagan had sold, Nimier scolded him ironically for having limited himself to war accidents: automobile accidents brought

the National Socialists.[64]

Vastly under-utilised by Germany's scant motorists, the Autobahn needs to be understood not as a response to real transportation needs but, as Bitomsky's film elegantly suggests, as a labour of representation. An ideal aesthetic counterpart to the highway's contradictory double existence as landscape and machine, the depiction of the Autobahn in much German cinema, photography, and painting of the 1930s recalls the stern warning of Adorno to those who repress the historical character of production and essentialise it as a natural process:

'The more relentlessly socialisation commands all moments of human and interhuman immediacy, the smaller the capacity of men to recall that this web has evolved, and the more irresistible its natural appearance. The appearance is reinforced as the distance between human history and nature keeps growing: nature turns into an irresistible parable of imprisonment.'[65] End

64 Nor did it, as a viewing of the Kulturfilm footage included by Bitomsky in his Deutschland-sbilder makes clear. A film such as the 1935 Metall des Himmels (Metal of Heaven), a documentary produced for the steel industry, includes close-up images of steel products whose glistening beauty suggests a popularised imitation of the work of Renger-Patzsch. The film also contains a montage sequence worthy of Ruttmann's Berlin, Symphony of a Great City.

Through his reverent depiction of the tinsmith's tools, one of the final images in his 1931 book Eisen und Stahl, Renger-Patzsch prefigures the visual glorification of labour that would become commonplace in National Socialist culture. That this book was produced for the German Werkbund recalls the National Socialist turn of an influential member such as Wilhelm Lotz, editor of its journal Die Form, and later editor of the Nazi publication Schönheit der Arbeit. See Anson Rabinbach, 'The Aesthetics of Production', pp. 202–5, for a discussion of continuity between the Werkbund and National Socialism.

65 Theodor W. Adorno, Negative Dialectics, trans. E. B. Ashton (New York: Seabury Press, 1979), p. 358. It is telling that Adorno's earliest engagement with the concept of second nature, the domain of reification and false appearances, occurs in his 1932 essay 'Die Idee der Naturgeschichte' (The Idea of History of Nature) written during the National Socialist consolidation of political power. This text is reprinted in Theodor W. Adorno, Gesammelte Schriften (Frankfurt: Suhrkamp, 1973), vol. 1, pp. 345-65.

Crashed Volkswagen Beetle
at side of road 1984

instant publicity. The violent automobile death of Nimier himself and novelist Sunsiaré de Larcone in 1962, along with those of Albert Camus and Michel Gallimard in 1960, Jean-René Huguenin in 1962, the two sons of André Malraux, the Ali Khan, and the near-fatal accident of Johnny Halliday in the surrounding months, each produced a torrent of horrified, lurid articles. Three books came out in France celebrating the myth of speed and risk associated with the figure of James Dean, dead on the desolate road to Paso Robles in 1955. A particular discourse takes place: this is a social fact. The richness of the reflexive discourse surrounding the car, perhaps more than the car's material ubiquity, points to a particular historical situation.

In fact, the centrality of the car in movies, novels, in the print consciousness of the period, to a large extent precedes the car becoming commonplace in French life. As such, the discourse, on the whole, is futuristic: anticipatory and preparatory in nature, fascinated or horrified, but generally permeated with anxiety. In 1961, only 1 in 8 French people (as opposed to 1 in 3 Americans) owned a car. And statistics show that the class breakdown of French who bought cars during the period remains constant; despite the arrival of the mass affordable car, workers, for the most part, went without. But while in the early 1960s the automobile could no longer be considered a luxury item, it was not yet a banality either. It occupied an intermediate status, that of being within the purview of most French. Neither a fantastic, luxurious dream, nor a 'necessary commodity', an element of survival, the car had become a project: what one was going to buy next. And it is at this point, when the car stands on the verge of becoming a universal accessory, that the cinema no longer represents the car as a fabulous or wondrous item, and the traffic accident loses its inevitability as a plot device in French movies and in the movies of virtually all the popular women novelists of the time.

Post-war French movies charted the demonic nature of the first cars and their metamorphosis into the quotidian. The ability of film — foremost among the media — to create the sensation of the mythic, fabulous object has been heavily discussed in film studies. I want here to isolate merely a number of simple tropes or techniques commonly found in European films of the era which serve to underline the car's singularity; the first of these is the ubiquitous 'only car on the road' sequence. Dino Risi's 1962 Il Sorpasso stars Vittorio Gassman as a compulsive hot-rodder who, as he puts it, 'only feels good in a car'; for him speed is the mark of an independent and free spirit. The opening sequences show him whizzing past a number of familiar Italian monuments in a little convertible sports car. The contemporary viewer is astounded: true, it's the early morning, and later we find out it's a religious holiday — nevertheless, his is the only car on the road in Rome! (Gassman's character, by the way, comes to no good in this movie; the film ends with him killing his repressed law-student sidekick, played by Jean-Louis Trintignant, just after Trintignant has awakened to the joys of life on the road, by catapulting both the car and him over a sea cliff). Two extraordinary French films, Dhery's La belle américaine, which I'll talk more about later, and Rosier's Adieu Philippine both deal with ambivalence surrounding private ownership on the part of the first car-owners in small, 'traditional'

John Minton
Composition: The Death of James Dean 1957
Oil on canvas
121.9 x 182.9cm
Tate Gallery, London. Presented by the Trustees of
the Chantrey Bequest, 1957

communities. Both films choose to emphasise the singularity and newness of ownership by an extended 'only car on the road' sequence. That fact that, in each case, half of the village is along for the ride doesn't lessen the sensation of solitude and spatial expansiveness.

Another common film tactic, more associated with comedy or burlesque realism, is the extreme close-up, such that the car, like some enormous insect on a microscopic slide, occupies the whole frame; what little background remains in the frame only heightens the wondrous nature of the object. In the opening sequences of Jacques Demy's <u>Lola</u>, the camera hugs the luxurious movement of the massive white American convertible — referred to by all the characters who see it as a 'voiture de rêve', a 'dream car' — as it rolls along the seedy wharfside road in Nantes.

The greatest analyst of post-war French modernisation, Jacques Tati, is perhaps best remembered for his Busby Berkeley-like pinwheels made of cars doing their intricate synchronised swimming in late movies like <u>Playtime</u> or <u>Traffic</u>; much of Tati's later work does focus on the car as fatal element in a ballet of seriality and repetition. But in an early film like <u>Mon Oncle</u>, the arrival of the fabulous pink and green Chevrolet ('Everything is automatic!') is treated by the camera as a fantastic and singular visitation, as outlandish as the landscape of the house, an autonomous technical object, its garish colours making it a factory of fantastic private illusions in addition to a catalogue of ready-made tastes, values and ideas. The moment of singularity in Tati though is short lived: turn the corner and the car has joined an endless row of vehicles in a traffic jam waiting to drop their children off at school.

In many of these early films American cars help reinforce the idea of singularity — in fact, the most effective way to indicate an 'object from another planet, the effect of intrusion, is to use a foreign, preferably American car. Claude Lelouche's immensely popular <u>A Man and A Woman</u> is in this sense already nostalgic. Made in 1967 when the myths of singularity and speed had been substantially eroded, <u>A Man and a Woman</u> shows that they can be nostalgically revived by a Ford Mustang and an actor — Trintignant again — who is no longer an ignorant, technologically wary law student who perishes in a car crash, but a race car driver, i.e. a man whose <u>métier</u> allows him to place his body in contact with a complex 'souped-up' machine, and by whose effective 'piloting' of said machine, can retrieve the waning provisionary myths of speed and singularity associated only a few years earlier with driving.

The history of driving and the history of movie-going in France and the US suggests several curious overlaps and parallels. The foremost manufacturer of automobiles in the world before World War I was France; similarly, France was the world's biggest supplier of films up to 1914, its leading firms, Gaumont and Pathé dominating the international distribution networks. But the French never recovered from the American jump to superiority in both industries after World War I, a jump in which advances in car production techniques stimulated similar advances in film production. Well-capitalised American studios, in other words, were quick to pick up on the assembly line and scientific marketing techniques worked out in the auto industry. As film historian Victoria de Grazia puts it: 'During the 1920s and 1930s

America's movie industry offered an entirely new paradigm for organising cultural production on industrial lines: what Fordism was to global car manufacturing, the Hollywood studio system was to a mass-produced internationally marketed cultural commodity.'[2] But her analogy is not quite right: for Fordism is not merely a set of rationalised techniques; its major accomplishment is that of transforming its workers into the consumers of the product they make, and this is certainly not the case with film. And while Fordism introduced techniques, management organisation, and the competitive pressure that forced European manufacturers to embark on their own mass-production of autos, in the case of film, the American commodity, for the most part, took the place of the native product. Another way of putting this is that there were very few American cars actually purchased in France in the late 1950s, but there were an enormous number of American movies watched: by virtue of the Franco-American credit agreement signed in 1946, Hollywood and its European affiliates came to exert a virtually total domination of the European movie market after the war.

Film historian Dennis Turner puts it this way: 'Unlike other American industries which stepped into the vacuum created by the war to sell necessities the indigenous manufacturers could not provide, the American film industry stepped into peddle a way of life which the native audiences would never be able to realise.'[3] While the French were more successful than the rest of the world in stemming the tide of the American cinematic invasion, statistics show that even the Nazis were better for the French film industry that the Americans. By 1947, in other words, American films had overrun the country. The leverage and power wielded by the eight Hollywood studios in the post-war period — a moment when the US enjoyed unprecedented political, military, and economic superiority over its trading partners — can be measured less in terms of the industry's corporate success than in terms of its role as semi-official propaganda machine for 'the American Way of Life'. The post-war screens of Europe were filled with an illustrated catalogue of the joys and rewards of American capitalism; all the minutiae of domestic life in the United States, its objects and gadgets and the lifestyle they help produce, was displayed as ordinary — that is, the background or trappings to convincing, realistic narratives. But ordinary or common objects became assertive when they appeared on the European screen. In production, cars had paved the way for film; now, film would help create the conditions for the motorisation of Europe — the two technologies reinforced each other. Their shared qualities — movement, image, mechanisation, standardisation — made movies and cars the key commodity-vehicles of a complete transformation in European consumption patterns and cultural habits.

Much of that transformation involved a change in perception, a change in the way things were seen. Writing about the introduction of railway travel and its effects on everyday life in nineteenth-century Europe, Wolfgang Schivelbusch argues that the train, and the accelerated circulation of commodities it both enabled and represented, altered visual perception.[4] As people became accustomed to train travel, traditional perception was replaced by 'panoramic perception': the kind of perception that prevails when the viewer sees

2 Victoria de Grazia, 'Mass Culture and Sovereignty: The American Challenge to European Cinema, 1920–1960' in <u>Journal of Modern History</u> 61/1989
3 Dennis Turner, 'Made in the USA: Transformation of Genre in the Films of François Truffaunt and Jean-Luc Godard', Ph.D. dissertation, University of Indiana, 1981
4 Wolfgang Schivelbusch, <u>The Railway Journey: Trains and Travel in the Nineteenth Century</u>, (New York, 1979)

5 Georges Perec, Les choses, (Paris, 1965)
6 Karl Marx, Grundrisse: Foundation of the Critique of Political Economy, (London, 1973)

objects and landscapes through the apparatus that moves him or her through the world. Panoramic perception occurs when the viewer no longer belongs to the same space as the perceived object; as such, it pertains as much to the car driver as it does to the railway traveller. But in post-war France the banalisation of car travel coincided with the banalisation of cinema. Georges Perec, for example, locates the historical newness of his young adult characters in the 1960s in terms of their relation to cinema: 'Above all they had the cinema. And this was probably the only area where they had learned everything from their own sensibilities. They owed nothing to models. Their age and education made them members of that first generation for which the cinema was not so much an art as simply a given fact.'[5] Surely the intensification of two burgeoning technologies, acting in tandem, would produce a qualitative acceleration in panoramic perception; for both cars and movies create perception-in-movement. The automobile and the motion it creates become integrated into the driver's perception: he or she can see only things in motion — as in motion pictures. Evanescent reality, the perception of a detached world fleeting by a relatively passive viewer, becomes the norm, and not the exception it still was in the nineteenth century.

Schivelbusch links the emergence of panoramic perception in nineteenth century Europe to the physical speed of the train and to the commodity character of the objects it transported. Transportation, in fact, creates commodities: as Marx pointed out in the Grundrisse, it is precisely the movement between geographical points that makes the object a commodity: 'This locational movement — the bringing of the product to the market, which is a necessary condition of its circulation, except when the point of production is itself a market — could more precisely be regarded as the transformation of the product into a commodity.'[6] That is, the train coincided with a qualitative change in the production/circulation complex in part by bringing a new level of speed to the circulation of goods. Circulation increases the commodity character of goods with a rapidity that is in direct proportion to the physical rapidity of the vehicles. But what about post-war car traffic? In France at least, the car marked the advent of modernisation; it provided both the illustration and the motor of what came to be known as the society of consumption. But passenger cars, unlike trains, rarely transport goods; they transport workers insofar as they themselves constitute commodities. Bicycles were the mode of transportation preferred by workers on the eve of the Popular Front. Post-war modernisation and the monopolistic restructuring of industries created the need for a mobile workforce, a need identical to the one that characterised the period of industrial conquest in the United States thirty years earlier. The popular car was born of that need. The 'moving picture' produced by cars and movies reflects a new acceleration in commodity production and circulation, but it does so, perhaps, through a more thorough and complete commodification of the driver, the worker, through a recasting of his identity by means of continuous displacement; in this way man becomes 'l'homme disponible'. Movable, available man (and woman) is open to the new demands of the market, to the imaginary worlds pictured on the silver screen, and to the lures of the newly commodified leisure of the countryside and the institution of les vacances, access to which is

Mark Gertler
Merry-Go-Round 1916
Oil on canvas
189.2 x 142.2cm
Tate Gallery, London

Peter Wollen
The Crowd Roars – Suspense and the Cinema

In 1959 the psychoanalyst Michael Balint published
a book on the subject of Thrills and Regression
which is of great interest not simply to Freudians
but to film theorists and historians as well. Although
Balint never mentions the cinema as such, his
opening chapter on 'Funfairs and Thrills' covers a
number of different varieties of thrill-laden activities,
including both those in which the thrill is directly
experienced by participants and those in which
thrills are experienced vicariously, as, for instance,
at the circus where professionals entertain
spectators with their feats on the tightrope and the
trapeze or in the lions' den. The cinema is often
discussed in relation to the theatre or the novel
but its kinship to the circus is much less frequently
admitted, even though we are all aware how
important the vicarious enjoyment of thrills has
been throughout the history of film. From the
beginning, the cinema exploited its capacity to
create excitement. The very first films of the
Lumière Brothers had a thrilling effect on their
audiences — there are a number of contemporary
accounts of spectators cowering or fleeing the
cinema as the train approached the station at Le
Ciotat, threatening to run directly off the screen into
the auditorium. Soon afterwards Georges Méliès
was taking spectators on a rocket trip to the moon.
 The very first category of thrill which
Balint mentions is that of thrills 'connected with
high speed, as in all kinds of racing, horse riding
and jumping, motor racing, skating, ski-ing,
tobogganing, sailing, flying, etc.' Essentially, Balint
sees thrills as structured in what he sometimes
describes as three acts: '(a) some amount of
conscious fear, or at least an awareness of real
external danger; (b) a voluntary and intentional
exposing of oneself to this external danger and to
the fear aroused by it; (c) while having the more or
less confident hope that the fear can be tolerated
and mastered, the danger will pass, and that one
will be able to return unharmed to safety. This
mixture of fear, pleasure, and confident hope in
face of an external danger is what constitutes the
fundamental element of all thrills.' In the case of
speed, of course, the danger consists of somehow
losing control and crashing, or, in the particular
instance of a pursuit or chase, of being overtaken
and captured or attacked. Often high speed is
combined with the two other principal kinds of thrill
which Balint mentions — the thrills connected with
'exposed situations', such as rock-climbing, deep-

'… the automobile is a diversion. It is a diversion because it gives us speed, takes us to far places, offers us escape and grants us apparent freedom. It is a distraction. It displaces us. It is useless and superfluous. It makes us do things we would not do without it.'

Jacques Ellul
The Technological Bluff 1990

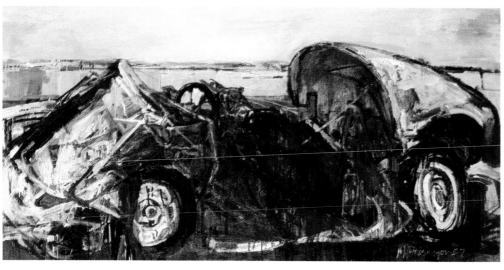

Tony Messenger
30th September 1955 1958
Oil on panel
122 x 244cm
Private collection

Michelangelo Antonioni
L'Aventura 1959
Film still

provided by the family car.

One of the most popular French films of the early 1960s was Jacques Dhery's 1961 comedy La belle américaine. In this film a young working couple in the market for some transportation end up, completely by fluke, with an enormous American luxury convertible on their hands. When they bring it back to their quartier the grotesque car fills the entire tiny square; neighbours gather around, children caress it. But the car unleashes a series of disasters: Marcel, the husband, is fired from his factory job both because the car makes him late for work and because his bosses are envious. The couple then attempt to make use of the car: Marcel's short stint as a chaffeur is disastrous, and when they next enter the car in an upscale competition for 'elegant automobiles' they lose: though they possess the central winning element, they lack the rest of the accoutrements (a well-bred poodle, for instance) with which to ornament the life-style the car represents. In one scene husband and wife burst into tears: their 'trop belle voiture', has ruined their lives. 'I thought I would make all of you happy', says Marcel. 'What bothers me most is that we are alone in having a car like this.' How can they get their old lives back? Only a car crash can save them: inadvertently, the wife backs into the horse-drawn ice-cream cart that provides the livelihood for many of the people in the quartier, crushing the cart and disabling the car. The film concludes with a close-up of the car, newly decked out with banners, paraphenalia and draped with the neighbourhood children: the quartier's new 'modern' ice-cream cart, La belle américaine.

Dhery's film, like Tati's Mon Oncle, depends on spatial devices to stage his conflict: the juxtaposition of two, non-integrated universes. Marcel and his wife live in a traditional, 'artisanal' quartier, almost a village within the city of Paris; what lies beyond their lively quartier is foreign turf, how others live. Everything in the neighbourhood is in immediate proximity; at the centre is the café, with its elegant old, intermittently functional, coffee machine: the space of work (a bicycle-ride away for Marcel), relaxation, meals and informal social contact interpenetrate effortlessly in a still-rural style of life characterised by the integration of the outdoors with inside. The quartier represents a multigenerational social cell more solid and intricate than the nuclear family, a kind of concentric representation of the world, with the 'village' at the centre and the café at the centre of the village. Into this atmosphere descends what the film emphasises to be the object that more than any other at the time connotes inequality, and disaster reigns until some method, albeit regional, of taming or appropriating the foreign intruder — integrating it into the lighthearted workings of the village — can be found. The happiest of all outcomes: one can acquire America's good features while avoiding its corruption, one can modernise without losing the national (or regional) identity.

The optimism of Dhery's film flies in the face of the way in which France's motorisation was already inscribed in the disappearance of a world: the destruction of such 'traditional' societies through the creation of a space/time structured by and for the car. In this regard the distance between French and American experiences of motorisation could not be greater. Motorisation developed in the US at almost the same time as the industrial infrastructure and coincided with twentieth-century urbanisation. French

sea diving or lion-taming, and with 'unfamiliar or even completely new forms of satisfaction', such as new food, new clothes and 'new forms of 'perverse' sexual activities'.

Speed is not only thrilling in itself, once it has been sufficiently accelerated, but it also enables us to enter exposed and unfamiliar situations, far removed from the zones of safety and normality — to travel into space, for instance, beyond the frontiers of the known. Avid thrill-seekers, or 'philobats' as Balint calls them, are often involved, not simply in dangerous but also highly competitive and aggressive activities. Speed is closely connected to various forms of struggle or contest, ranging from races and, more threateningly, chases up to its decisive role in combat, where greater speed gives a clear advantage over an opponent. Balint notes that an 'element of aggressiveness is undoubtedly present in all philobatic activities' but thrills in themselves are not directed against an outside object, but valued for the subjective experience they bring to the thrill-seeker. In amusement parks and cinemas, violence is closely linked to thrill-seeking but the spectator's thrill is, so to speak, intransitive. Speed is enjoyed for its own sake, even though it may lead in the end to a second order enjoyment of vicarious triumph over a villainous enemy. Thrills, Balint concludes, are essentially auto-erotic — they are ways of embarking on adventures which are fundamentally designed to give oneself pleasure just by the activity involved, so that any specific accomplishment which results, like crossing the finish line first or triumphing over an opponent, is really an added benefit, related to aggression rather than to philobatism as such.

In 1936, Alfred Hitchcock wrote a piece for Picturegoer titled 'Why "Thrillers" Thrive'. Hitchcock argued that shocks or thrills are necessary to us as human beings, that 'our nature is such that we must have these "shake-ups", or we grow sluggish and jellified; but, on the other hand, our civilisation has so screened and sheltered us that it isn't practicable to experience sufficient thrills at first hand. So we have to experience them artificially, and the screen is the best medium for this'. Hitchcock argues that in the theatre — or at the circus — the audience simply watches things happening, remote, impersonal and detached, whereas in the cinema 'we don't sit by as spectators; we participate'. Or, at least, he might have said, the effective experience of participation is much stronger. Hitchcock goes on to cite a sequence in Howard Hughes's 1930 air combat film, Hell's Angels, 'in which the British pilot decides to crash his plane into the envelope of the Zeppelin to destroy it, even though this means inevitable death to himself. We see his face—grim, tense, even horror-stricken—as his plane swoops down. Then we are transferred to the pilot's seat, and it is we who are hurtling to death at ninety miles an hour; and at the moment of impact—and blackout—a palpable shuddering runs through the audience. That is good cinema.'

Hitchcock goes on to note that our enjoyment of the sequence as viewers is possible because 'in our subconscious we are aware that we are safe, sitting in a comfortable armchair, watching a screen'. Moreover, Hitchcock added, we are also 'subconsciously' aware that the pilot — or at least the actor who plays the role of pilot — is not really dead, any more than we are, that our vicarious thrill-seeking depends on the cinema's ability to

Jean-Luc Godard
A bout de souffle (Breathless) 1960
Film still

motorisation, interrupted by two world wars, and slowed down by the economic crisis of the 1930s, was too delayed to be organically inscribed into the development of industrialisation and urbanisation. Its effect, abrupt and enormous, was felt most in Paris and its surroundings where the volume of automobile traffic climbed drastically after the war. On the eve of World War II there were 500,000 cars in the Paris region; that number doubled by 1960 and doubled again to two million in 1965 — this in a city whose street surface had increased only 10% since the turn of the century. Paul Delouvrier, Préfect of Paris and the Haussman of his day, continued in the line of thinking dominant in Parisian planning since Haussman according to which the needs of the street circulation takes precedence over all other urban considerations: 'If Paris,' he wrote, 'wants to espouse her century, it is high time that urbanists espouse the automobile.' Delouvrier found a great enthusiasm for his ideas in Georges Pompidou who affirmed: 'Paris must adapt to the automobile. We must renounce an outmoded aesthetic'. The building of the Péripherique, 'the principal and most spectacular innovation realised in Paris in several decades', was begun in 1956; the Right Bank Expressway along the Seine was completed in 1967. By 1972 the Péripherique carried 170,000 vehicles daily and averaged an accident a kilometre a day; it had replaced the old fortifications with a kind of permeable wall of traffic that, for the Parisian inhabiting and working within the charmed 'inner circle', made the suburbs, the banlieues seem some formless magma, a desert of 10 million inhabitants and grey, undifferentiated constructions, a circular Purgatory cordonned off with Paris — Paradise — in the middle. From the perspective within (and the movement inward, inside the French hexagon at the end of empire, inside the newly comfortable domestic interiors, the electric kitchens, the modern bathrooms, inside the new vision of conjugality and an ideology of happiness predicated on the couple, inside the metal enclosures of auto-mobiles) the suburbs were, and remain, that vague terrain 'out there': a décor in perpetual recomposition, a purely provisional space of transient populations, a makeshift world. End

Jean-Luc Godard
Le Weekend 1967
Film stills

trick us into identifying not simply with the feats of an acrobat or a gladiator but with a performance which is itself a construction, a 'trick' as Hitchcock liked to put it. Many years later, in 1949, Hitchcock wrote another piece, this time for <u>Good Housekeeping</u>, in which he discussed 'The Enjoyment of Fear'. The examples Hitchcock gives are those of enjoyable activities such as riding a roller coaster, climbing a mountain, taking a midnight stroll through a graveyard, speedboat racing, steeplechasing, big-game hunting and so on. For that, Hitchcock says, 'is only the beginning. For every person who seeks fear in the real or personal sense, millions seek it vicariously, in the theatre and in the cinema'. The audience experiences the same sensations as the real-world philobat ('the quickened pulse, the alternately dry and damp palm, etc') but without, as Hitchcock puts it, 'paying the price'. In other words, the spectator's confident hope that the danger will pass is considerably stronger than that of the professional. (A confident hope that Hitchcock was to shatter in <u>Psycho</u>, although there too the spectators were returned unharmed to safety).

It was at this point that Hitchcock introduced the distinction he often made subsequently, between suspense and terror. 'On the screen' according to Hitchcock, 'terror is induced by surprise; suspense by forewarning'. Suspense, like all thrills, depends on our anticipation of an impending threat, whether or not it is actually realised. The closer the threat, the greater the suspense. Thus Hitchcock's example is of the stroller in a dark street who hears footsteps behind. 'The walker stops, the footsteps are not heard; the pace is increased, so also the tempo of the thin sounds coming out of the night'. What interests me about this particular example is Hitchcock's allusion to 'tempo'. In 1950 Hitchcock gave an interview to the <u>New York Times Magazine</u>, which was entitled 'Core of the Movie—The Chase'. 'Well, essentially' he observed, 'the chase is someone running towards a goal, often with the antiphonal motion of someone fleeing a pursuer'. Flight and pursuit. The chase, in fact, is intimately bound up with suspense. The closer the pursuer, the faster the tempo, the greater the suspense, the more powerful the thrill. Hitchcock goes on to discuss <u>Strangers On A Train</u>, 'the picture I am working on now', in which he was trying to exploit the dramatic possibilities of movement throughout the film, gradually building up the tempo until 'the final, physical chase, which must be short and breathtaking to avoid the error of anticlimax'.

In <u>Strangers on a Train</u>, Hitchcock was particularly proud of the sequence where the hero is playing tennis at Forest Hills while the villain plans his crime. Consequently the hero 'must play as hard and as fast as he can in order to win the match, get off the court, and overtake the villain. The villain, meantime, confident that his victim is tied to the tennis court, is taking his time and being very methodical. The camera cutting alternately from the frenzied hurry of the tennis player to the slow operation of his enemy, creates a kind of counterpoint between two kinds of movement'. Hitchcock describes his own expertise in constructing chase sequences as the result of combining what he had learned from literary sources, which fleshed out the basic chase motif with careful plotting and characterisation, with DW Griffith's pioneering use of the chase (in <u>Birth of a Nation</u>, <u>Intolerance</u>, <u>Way Down East</u> and

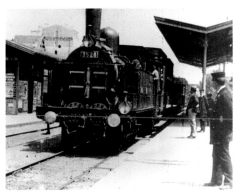

Lumière Brothers
<u>L'entrée d'un train en Gare de la Ciotat</u> 1897
Film still

René Clair
<u>Entr-acte</u> 1924
Film still

Orphans of the Storm) as a physical event, typically a ride to the rescue, in which the spectator's reactions are manipulated by the technique of cross-cutting combined with an ever-accelerating tempo, while the spectator is kept aware of the dreadful threat which still hangs over the potential victim and the ever-shorter amount of time remaining. The closer the threat, of course, the greater the speed required of the rescuer and the more important it is for the potential victim to find ways of decelerating the approach of impending doom.

In the films Hitchcock mentions, Griffith drew on a tradition of races and chases which was almost as old as the cinema itself — Williamson's *Stop Thief!* and *Fire!* date from 1901, Edwin Porter's *Life of an American Fireman* was made in 1902, Cecil Hepworth's *Rescued by Rover* in 1905, although cross-cutting in the fully developed Griffith manner did not appear until 1908. From the very beginning cinema drew on the melodramatic theatre tradition of menace and jeopardy as twin engines of suspense. Griffith's contribution was to establish a style of film-making which accentuated the excitement of chase sequences through control over their tempo. In the second decade of the cinema, as Barry Salt notes, Griffith was already being criticised for the 'rush and turmoil' which characterised his films. Salt believes this was due, partly at least, to Griffith's habit of under-cranking his films, shooting at 14 frames per second or even slower so that the action appeared much faster than normal when it was projected. It is difficult, of course, to quantify the speed of film, beyond noting the now traditional norm of 24 frames per second in projection — the impression of speed is dependent on a number of disparate features. Under-cranking, slow motion, pixillation, jump cuts, rapid camera movement, rapid tempo of editing, rapid movement within the frame, rapid delivery of dialogue, rapid narrative development — all of these can contribute to the impression of speed.

It is true to say, however, that film-makers have continuously sought methods of speeding up the cinematic experience, although the acceleration has not been entirely continuous. In his book, *Film Style and Technology: History and Analysis*, Barry Salt reports on his detailed measurement of cutting rates throughout the history of the feature film. From 1912 to 1917 the longest average shot length (modal length) for a sample of American films was 7 seconds, from 1918 to 1929 it was 5 seconds, but after the coming of sound it lengthened considerably to 9 seconds, where it stayed until 1957. In the period between 1958 and 1963, however, it accelerated again to 6 seconds, where it stayed until 1981, when it accelerated even further, reaching 5 seconds again between 1982 and 1987. Salt's statistical analysis ends at this point, although he notes sourly that in the 1990s an increasing number of movies seem to be 'almost totally made up of tense action scenes', encompassing, I would presume, films such as *Speed* itself. (Hitchcock's films, it is worth remarking in parenthesis, are notable for their early use of the 'shock cut', predecessor of the 'jump cut', for the extremely high proportion of point of view shots in his films and for a pronounced move towards shots of unusually long duration in the post-war period, culminating in his 1948 experimental masterpiece, *Rope*, which consists entirely of ten-minute takes laid end-to-end, in order to achieve a one-to-one ratio between the film footage and the dramatic action. By the end of the 1950s, however,

Hitchcock's films were following the trend in reducing shot lengths again).

Salt makes a number of other interesting points, observing, for example, that there is often a clear correlation between average shot length and directorial ambition. In this connection he cites the average shot lengths of 15 seconds for Jean-Luc Godard's *A Bout de Souffle* (*Breathless*) and of no less than 20 seconds for Joseph Losey's *The Servant*, as well as noting the predilection for long takes of Bob Rafelson, whom he characterises as an American 'art film' director. At the extreme of this tendency to slow down the tempo he also notes Michelangelo Antonioni's use of *temps mort* (dead time). In Antonioni's 1960 *L'Aventura*, for instance, there were an unusual number of scenes which 'appear to have no obvious function in advancing the plot or illuminating the characters'. The extremes of deceleration, however, occur in avant-garde films. Warhol, like Hitchcock before him, strung unedited takes together with no compunction and his 1964 epic, *Empire*, pushed minimalism to the limit with its eerie combination of *temps morts* and continuous time, eight hours of film shot out of the Factory window at night. Michael Snow's 1967 *Wavelength* is in effect a single continuous zoom shot which lasts for over three quarters of an hour and his *La Région Centrale*, filmed in 1971 in an uninhabited wilderness area in the north of Québec, continued for three hours with no cuts and no sign of human involvement except for glimpses of the film-maker's own shadow.

At the other extreme, experimental film-makers also produced films with unusually short shot lengths — Anthony Balch and William Burroughs's *Cut-Ups* in the 1960s or, even more radical, the flicker films of Tony Conrad and Paul Sharits, whose tempo is so accelerated than when exhibited in public they need to carry notices warning of the danger to those viewers susceptible to epileptic episodes. Avant-garde film in the 1960s mounted a kind of pincer movement against the mainstream, accentuating both speed and slowness, trends which persisted in music video, on the one hand, and artists' films, on the other. The turn towards slowness which we see in the work of many avant-garde film-makers — absence of action, absence of editing, absence of camera movement — could best be interpreted as a reaction against the increasing speed of mainstream movies, whether intended as such or not. The *locus classicus* here was Michael Snow's *Wavelength*, the film which, more than any other, opened the door to deceleration. Writing about *Wavelength* in 1982, Nicky Hamlyn made a distinction between what could be called 'interventionist' and 'alternative' films. The 'interventionist' avant-garde retained a narrative format, albeit elliptical, and slowed it down by re-functioning conventional stylistic devices to delay the story rather than to hurry it along. The 'alternative' avant-garde, on the other hand, rejected conventional stylistic devices and looked for completely new ways of structuring a film, which might end up anywhere on the spectrum between ultra-fast and ultra-slow.

The avant-garde had traditionally favoured speed, ever since the Futurists praised it as the core characteristic of the tempo of modern life. Speed became intimately bound up with the idea of modernity — the physical speed of express trains, racing cars, flying machines and the

Michael Snow
Wavelength 1967
Film still

Abel Gance
La Roue 1922
Film still

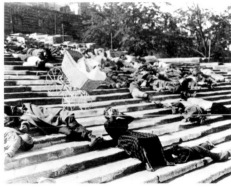

Edwin S Porter
Life of an American Fireman 1902
Film still

Sergei Eisenstein
Battleship Potemkin 1925
Film still

psychological speed of reaction time required by the modern city-dweller, confronted with a dynamic multiplicity of simultaneous events and impressions. René Clair's Dada film Entr'Acte, made in 1924 as an entertainment to fill an intermission between two acts of the Swedish Ballet, was virtually an exercise in the use of speed. Clair gradually increased the tempo of a stately bourgeois funeral cortège, until the procession, including the substantial hearse, is moving at a gallop, finally transferring the momentum, by an editing trick, to a roller-coaster, with the camera mounted in the front of a wagon, swooping at giddying pace down into the abyss. In the Soviet Union, around the same time, Sergei Eisenstein developed his own theories of montage, differentiating metric montage, with its strictly mathematical basis, from rhythmic montage, in which the content of the action was the crucial factor in determining the rhythm: 'Here the actual length does not coincide with the mathematically determined length of the piece according to a metric formula. Here its practical length derives from the specifics of the piece, and from its planned length according to the structure of the sequence'.

In his most celebrated montage experiment, the Odessa Steps sequence in Battleship Potemkin, Eisenstein complicated the rhythm by alternating between strict tempo (soldiers marching down the steps) and chaotic movement (the panic-stricken crowd) as well as between an accelerating rhythm (the 'downward rushing movement of the soldiers') which he contrasted with an abrupt deceleration of the rhythm as a lone figure moves with 'slow solemnity' up the steps, advancing towards the implacable line of soldiers. After this 'caesur' (Eisenstein's term), the tempo is then accelerated even faster as a baby's pram rolls out of control down the steps in front of them. Eisenstein speeded up the action and the rhythm of the editing throughout the sequence, stabilising it and slowing it down at poignant moments, only in order to heighten the impression of speed again as the rout of the protesting crowd continued unabated. His aim was to increase the pathos that we feel for the victims by contrasting moments of solemnity and slowness with the rapid onrush of the soldiers and the panic-stricken crowd. In October, made in 1927, two years later, Eisenstein mimicked the tempo of a machine-gun firing into a crowd by accelerating the tempo of the editing, cutting back and forth between shots which were only two frames in length, a tiny fraction of a second, so that they seemed like flickering superimpositions rather than separate shots.

Perhaps the most influential intervention of the avant-garde however was through Blaise Cendrars' editing of Abel Gance's 1922 film, La Roue, especially his close-up montage sequence of train wheels, which became the model for many subsequent imitations. In this film, Cendrars and Gance used a two-frame shot of the engine's furnace cut between shots of the tracks and the locomotive cab, as well as another two-frame shot of the train's speedometer edited in between shots of the engine-driver. A close connection between the cinema and the locomotive had been established in the very earliest years of film with the Lumière brothers' L'entrée d'un train en Gare de la Ciotat, and it continued on through the so-called Hales' Tours, cinema exhibitions in which the viewer sat in a simulated train carriage to watch footage shot from a locomotive, until shots from speeding trains became a standard feature of the cinema. It

took many years before they eventually gave way to shots from cars, motorbikes and, finally, space vehicles. The avant-garde's fascination with speed thoroughly infiltrated the mainstream cinema, while any countervailing tendencies were marginalised into the emergent art film and a subsidiary sector of the old avant-garde. In fact, during the 1990s, even these surviving pockets of resistance have come under continuous threat as the culture of speed has accelerated its global expansion.

The case against speed was put with great clarity in the early 1950s by the great French critic, André Bazin, in his essay on 'The Evolution of the Language of Cinema', in which he argued against montage and in favour of protracted shots which respected the spatio-temporal unity of events. Bazin welcomed the increased length of shots which had characterised the first decades of sound film. For him, the villains of cinema history, albeit great artists, were Griffith, Eisenstein and Gance. 'In La Roue', Bazin observed, 'Abel Gance created the illusion of the steadily increasing speed of a locomotive without actually using any images of speed (indeed the wheel could have been turning on one spot) simply by a multiplicity of shots of ever-decreasing length'. The key word here is 'illusion' — Bazin was arguing for a cinema that would respect reality, that would not fall back on the manipulative tricks in which Hitchcock delighted. Rather than Griffith, Eisenstein and Gance, Bazin's models were Von Stroheim, Murnau and Flaherty, silent film directors in whose films 'montage plays no part, unless it be the negative one of inevitable elimination where reality superabounds. The camera cannot see everything at once but it makes sure not to lose any part of what it chooses to see'. When Flaherty filmed Nanook of the North hunting seal, Bazin added, what matters to him was 'the actual length of the waiting period ... the actual length of the hunt is the very substance of the image, its true object'. Flaherty filmed the seal hunt in one long, unbroken set-up.

When Michael Snow made Wavelength, he inserted two significant narrative incidents into the otherwise ultra-Bazinian time-space of the loft in which he had set up his camera, where the spectrum of change was restricted to the slow advance of the camera zoom, random changes in the light and the endless glissando of the electronic soundtrack. In one of the incidents a bookcase is carried into the room and deposited there. In the other a man walks in and collapses on the floor, apparently dead. I had always wondered about these incidents and I was delighted to discover that Snow had talked about them in an interview. 'The film events', he said, 'are not hierarchical, but are chosen from a kind of scale of mobility that runs from pure light events, the various perceptions of the room, to the images of moving human beings. The inert: the bookcase that gets carried in, the corpse, as seen, dying being a passage from activity to object. Inertia.' An important element of Snow's project, it seems, was that of breaking down the distinction between action and object, by paying attention to the slow end of the scale of mobility rather than the fast end, the zone in which mobility runs down towards inertia. I was struck by the way in which Snow's ecstatic voyage towards inertia through the deceleration of time, echoed Roland Barthes' remarks on the hyperbolisation of mobility by what he called, in the mid-1950s 'le jet-man'. 'The pilot-hero', he noted, 'was made unique by a whole mythology of speed as an experience, of

Books consulted
Afterimage: Sighting Snow, No. 11, (London, Winter 1982/83).
Michael Balint, *Thrills & Regressions*, (London: Maresfield Library, 1987).
Roland Barthes, *Mythologies*, (St Albans: Paladin, 1973).
André Bazin, *What Is Cinema?*, Volume 1, (Los Angeles: University of California Press, 1974).
Walter Benjamin, *Illuminations*, (New York: Schocken Books, 1969).
Sergei Eisenstein, *Film Form*, (Orlando: Harcourt Brace, 1949).
Gladys C. Fabre, with Marie-Odile Briot and Barbara Rose (editors), *Léger and the Modern Spirit (1918–1931)*, (Paris: Musée d'Art Moderne de la Ville de Paris, 1982).
Sidney Gottlieb (editor), *Hitchcock on Hitchcock*, (London: Faber & Faber, 1995).
Garry Jenkins, *Empire Building: the remarkable real-life story of Star Wars*, (London: Simon & Schuster, 1997).
Lawrence M. Krauss, *The Physics of Star Trek*, (London: Flamingo, 1997).
Ashis Nandy, *The Tao of Cricket*, (New Delhi: Viking and Penguin, 1989).
Dennis Reid, *Exploring Plane and Contour: the drawing, painting, collage, foldage, photo-work, sculpture and film of Michael Snow from 1951 to 1967…* (Toronto: Art Gallery of Ontario, Canada, 1994).
Barry Salt, *Film Style and Technology: History and Analysis*, 2nd Expanded Edition, (London: Starword, 1992).
Bart Testa, *Back and Forth: Early Cinema and the Avant-Garde*, (Toronto: Art Gallery of Ontario, 1992).

space devoured, of intoxicating motion. The jet-man, on the other hand, is defined by a coenaesthesis of motionlessness ('at 2000 km per hour, in level flight, no impression of speed at all'), as if the extravagance of his vocation precisely consisted in overtaking motion, in going faster than speed'. Or, as we might put it, in reaching towards inertia through hyper-acceleration.

In *Thrills & Regressions*, Michael Balint counterposed the 'philobat' against the 'ocnophil', the apparent opposite of the philobat, 'one who cannot stand swings and switchbacks, who prefers to clutch at something firm when his security is in danger', the person who is 'only at ease in the state of stable security'. There is an obvious analogy to be made between the euphoria felt by the philobat who stands on the mountain peak and the joyous sense of security enjoyed by the stay-at-home who feels immune from all possible dangers. On the one hand, we have the action movie, which offers the viewer the vicarious satisfaction of danger triumphantly overcome and, on the other hand, the art film, which offers the satisfaction of danger successfully avoided. At the extreme point of both tendencies, we find the experimental film, Paul Sharits's *Ray Gun Virus* or Douglas Gordon's slowed down staircase scene from *Psycho* further slowed down by step-printing. In the mainstream cinema, however, the battle between fast and slow has become disproportionately one-sided. There is a completely uneven distribution of speeds along the spectrum — one extreme is in constant supply, the other is increasingly hard to find. More than ever before, Hollywood has become a place where philobats abound while ocnophils hardly dare to venture out.

When Marc Hamill, who played Luke Skywalker in the *Star Wars* trilogy, was asked about George Lucas' direction of actors, he replied, 'His biggest direction to me was 'Faster, more intense'. Perhaps it would be better if there were more film-makers whose direction to their actors consisted of saying, on the contrary, 'Slower, less intense. Make it more inert, if you can. I'm really looking for something more like Warhol's *Sleep*'. Or perhaps it might be possible to enjoy the best of both worlds. Chris Marker's 1963 film, *La Jetée*, was composed entirely of still photographs (except for one shot, in which a woman wakes up from her sleep, mobility arising momentarily out of inertia). Marker animated the photo-roman by printing each image in series and then animating the successive sets of static frames by rapid editing. In the final sequence, the central character — a time-traveller — races through Orly airport in Paris, arriving at his destination just in time to watch his own death in a virtual freeze-frame. Inert images are accelerated in a dynamic montage until the momentum finally runs out at the point of death. In Marker's film, speed and stasis co-exist. Bazin and Eisenstein are reconciled at last, outflanking Hollywood at both ends of the scale. There is a poetic justice in Marker's solution. After all, if the cinema ever reached warp speed, like the starship *Enterprise*, it would overtake its own image, visible both as its old static self and as its new ultra-fast double. *End*

Jeremy Millar
Rejectamenta

What does not change
is the will to change

— *Charles Olson, 'The Kingfishers', 1949*

'The history of the arts and sciences could be written in terms of the continuing process by which new technologies create new environments for old technologies.' — *Marshall McLuhan*

While the phrase 'the clockwork Universe' was coined by French philosopher and scientist Nicole d'Oresme in 1377, it was only 500 years later that any attempts were being made to create a universal time. Until the late nineteenth century, most of the world still operated on local times, based on differing astronomical systems and other variations and traditions. It was the railway companies which were the first to call for standardised time systems. The first standard national time was introduced in Britain in 1847, with other countries with rail travel following shortly after (however, even in 1870, a passenger travelling from Washington to San Francisco would have to reset his watch over two hundred times if he were to stay current with all the time systems en route).

Modern dance in America can be seen as part of a larger complex surrounding the movement of the human body in the twentieth century. Influenced by François Delsarte's Cours d'esthétique appliqué, *a series of lectures which he began to deliver in Paris in 1840, and the Harmonic Gymnastics of Steele Mackay, an American who was able to study with Delsarte just before the frenchman's death in 1871, Isadora Duncan, Ted Shawn and Ruth St. Denis began to develop a style of dance in which the body became an instrument of fluid expression rather than a display of the rigid grand manners of formal ballet. For Duncan, the movement of the whole body was to be elaborated from the solar plexus, the area of the lower torso which was seen as the spiritual, as well as physical, centre of the body. Here was a form of dance which allowed a degree of spontaneity and fluidity between a full range of expressive movements, rather than the demonstration of elegant postures; it worked with, if not emphasised, the force of gravity upon the body, rather than the fantasy of balletic flight. As one of the first modern dance*

instructors, Gertrude Colby, was to write, 'The arm positions grow out of the body movements and follow the life and sway of the body. They do not move independently but grow out of and continue the trunk movements.'

'One of the most advanced and complicated uses of the wheel occurs in the movie camera and in the movie projector. It is significant that this most subtle and complex grouping of wheels should have been invented in order to win a bet that all four feet of a running horse were sometimes off the ground simultaneously. This bet was made between the pioneer photographer Edward Muybridge [sic] and horse-owner Leland Stanford, in 1889. At first, a series of cameras were set up side by side, each to snap an arrested movement of the horse's hooves in action. The movie camera and the projector were evolved from the idea of reconstructing mechanically the movement of the feet. The wheel, that began as extended feet, took a great evolutionary step into the movie theatre.' — *Marshall McLuhan,* Understanding Media: the extensions of man, *1964*

The man who has had arguably the greatest influence upon this century was born on 20 March 1856 in Germantown, Pennsylvania. Although gaining admittance to Harvard, Frederick Winslow Taylor instead joined a small machine shop owned by a friend of his family and learned to use a lathe. He moved, at the age of twenty two, to Midvale Iron Works, to take up a clerical post, although before long he was operating the lathe there also. An insomniac, he worked long hours while also following an engineering course (he also won the National Doubles Championship in tennis with a spoon-shaped racket of his own design, which he claimed improved efficiency). Within six years he was chief engineer. He was known as 'Speedy Taylor'.

'Yes, this Taylor was, beyond a doubt, the greatest genius the ancients had. True, he had not attained the final concept of extending his method until it took in the entire life-span, every step, and both night and day — he had not been able to integrate his system from the first hour to the twenty-fourth. But just the same, how could the ancients have written whole libraries about some Kant or other, and yet barely noticed Taylor, the prophet who had been able to look ten centuries ahead?' — *Yevgeny Zamyatin,* We, *1920*

The Canadian engineer Sanford Fleming was one of the most vigorous supporters of a world standard time in the late nineteenth century. As well as simplifying legal disputes, he thought that standard time would engender international co-operation and world peace. He sent a copy of a speech by another famous supporter of world time, Count Helmuth von Moltke, to the editor of The Empire *for publication. Little did he know that Moltke's interests lay more in the co-ordination of military planning than in anything more benign. His experience lay in the German victories against France in 1870, where efficient German railways enabled them to outnumber the French at the frontier by 130,000 troops. 'Build no more fortresses, build railways,' Moltke had then ordered. The standard time for which he had so strongly campaigned enabled Moltke, in 1914, to put into effect a war-plan which demanded that each man be in exactly the right place at the right time. The*

wristwatch, previously thought unmanly, became standard military equipment. As Stephen Kern has remarked, it is one of the ironies of the period that world war only became possible after the world had become so highly united.

'As a piece of technology, the clock is a machine that produces uniform seconds, minutes and hours on an assembly-line pattern. Processed in this uniform way, time is separated from the rhythms of human experience. The mechanical clock, in short, helps to create the image of a numerically quantified and mechanically powered universe. It was in the world of the medieval monasteries, with their need for a rule and for synchronised order to guide communal life, that the clock got started on its modern developments. Time measured not by the uniqueness of private experience but by abstract uniform units gradually pervades all sense life, much as does the technology of writing and printing. Not only work, but also eating and sleeping, came to accommodate themselves to the clock rather than to organic needs. As the pattern of arbitrary and uniform measurement of time extended itself across society, even clothing began to undergo annual alteration in a convenient way for industry. At that point, of course, mechanical measurement of time as a principle of applied knowledge joined forces with printing and assembly line as a means of uniform fragmentation of processes.' — Marshall McLuhan, Understanding Media: the extensions of man, 1964

A growing interest in graphology, the study of handwriting, began to develop in the late nineteenth and early twentieth century. Through the work of Jean-Hippolyte Michon, Jules Crépieux-Jamin and Alfred Binet, it was believed that handwriting could reveal psychological truths about the writer. (It was at about this time that Etienne-Jules Marey, amongst others, was developing means to measure the internal movements of the body, developments which led to the polygraph, or 'lie-detector', a device predicated upon the veracity of bodily movement.) The German graphologist, Ludwig Klages, looked beyond the areas considered by his predecessors and considered the whole motion of handwriting which, he believed, was the clearest record available of the relationship between the restraint of cultural knowledge and the liberation of free expression.

'We all (and perhaps all of you also) have read as schoolchildren the greatest of all the monuments of ancient literature which have come down to us: Time-Tables of All the Railroads. But place even that classic side by side with The Tables of Hourly Commandments and you will see, side by side, graphite and diamond. Both contain the one and the same element — C, carbon: yet how eternal, how transparent the diamond, and how refulgent! Who can help but catch his breath as he thunders and races headlong through the pages of the Time-Tables? The Tables of Hourly Commandments, however, really does transform each one of us into the six-wheeled steel hero of a great poem. Each morning, with six-wheeled precision, at the very same minute and the very same second we, in our millions, arise as one. At the very same hour we mono-millionedly begin work — and, when we finish it, we do so mono-millionedly. And, merging into but one body with multi-millioned hands, at the very second designated by The Tables of Hourly

Nancy Campbell and Judith Nasby
Qamanittuaq

Speed is relative — nowhere more so than in the northern regions of Canada. The Inuit of Canada's North have in the last decades experienced rapid cultural change, perhaps more than any other ethnic group within North America. Until mid-century the indigenous peoples of Canada's Arctic lived a semi-nomadic lifestyle, not unlike that of their ancestors for millennia past. And even as the twenty-first century approaches, it is still difficult for us not to feel that we are slowing down as our journey to the North begins.

We start on a jet in the mid-western city of Winnipeg; via remote settlements such as Arviat and the Rankin Inlet, and through a series of transfers to smaller aircraft (which ironically seem to go faster), we arrive eight hours later at our destination of Qamanittuaq, or Baker Lake. At the airport, a small house in the middle of the tundra, we are met by what appears to be half the community. The plane from the South has landed. We are shuttled to our lodge in the back of a pick-up. We have arrived.

The Inuit too have arrived in the twentieth century, although not necessarily by choice. In the 1950s, a number of circumstances, particularly the depletion of caribou herds, necessitated the nomadic Inuit to move into government settlements. They were suddenly brought into contact with modern technological society. The evolving interface between traditional life and Western culture that the Inuit experienced is reflected in their art. Inuit artists record the rapid adaptations to Southern contemporary society, while maintaining a sense of the timelessness of traditional life and spirituality.

The days are long in August, with the sun setting around midnight. For us, travellers from the South, time in the North seems skewed. Our internal timeclocks have forgotten their schedules and are now ruled by the stars. After dinner (a North-South medley of sweet and sour caribou meatballs) we walk along the dirt road in sunlight. The huskies can be heard in the distance, conjuring up images of the hunts of yesteryear.

Senior Inuit artists like Marion Tuu'luq and Pudlo Pudlat began to make art in their fifties, drawing from their experiences of living on the land and their rich heritage of traditional stories and mythology. Marion Tuu'luq (b. 1910), began documenting the cyclical life of hunting and domesticity that she had practiced for half a

<u>Commandments</u> we bring our spoons up to our mouths; at the very same second, likewise, we set out for a walk, or go to an auditorium, or the Hall of Taylor Exercises, or retire to sleep.' — Yevgeny Zamyatin, <u>We,</u> 1920

Taylor more fully developed what he termed 'Scientific Management' while at the Bethlehem Steel Works in eastern Pennsylvania. 'Taylorism', as it also became known, attempted to improve the productivity of workers by the minute analysis and simplification of their tasks. Combining a slide-rule and a stop-watch — often timing movements down to ten-thousandths of an hour — with guess-work and a great deal of stubbornness, Taylor aimed to extract the maximum benefit from what was Adam Smith's classic industrial principle of the division of labour. At the Bethlehem plant, he managed to get a single labourer, Henry Noll, or Schmidt as he was later known, to move forty-five tons of pig iron a day, rather than the average of twelve-and-a-half. While other workers walked out, too tired to work, or were sacked, Noll reported that he was as good as ever at the end of the day. But Taylor was a difficult man, who found it easy to make enemies. He was fired in May 1901, one month before Charles Schwab, first president of the United States Steel Corporation, bought the company.

The development of cinema allowed time to be experienced in a number of novel ways. A pioneer of French cinema, Georges Méliès, had an accident during filming in Paris which would prove highly influential. While filming a street scene at the <u>Place de l'Opéra</u> in 1896, Méliès' camera jammed; he managed to free the mechanism moments later and continued filming. It was only later, when he projected the entire sequence, that the illusion was revealed of an omnibus which had suddenly, and unexpectedly, turned into a hearse. He utilised, and reversed, this leap in time in <u>The Vanishing Lady</u>, made the same year, in which a skeleton suddenly becomes a living woman.

Although it was the railway companies that introduced standardised national time systems, soon governments recognised the importance of a Universal time, not only as a means of greatly increasing the efficiency of complex economic planning but also as a means of fostering greater international contact and of making the world a safer place in which to live. In 1884, the International Meridian Conference in Washington voted to make Greenwich zero meridian for world time (as it had long been for navigators). The French opposed this move for twenty-seven years until, at the International Conference on Time held in Paris in 1912, they finally accepted; if the meridian was to be English then the institution of world time was to be French.

The Eiffel Tower was constructed for the 1889 Paris Exposition by Gustave Eiffel, the first large-scale modern monument to be designed by an engineer rather than an architect (he declared that its purpose was 'to raise the glory of modern science, and to the great honour of French industry, an arch of triumph as striking as those that preceding generations had raised to conquerors'). The most striking aspect of its appearance was, and still is, its open structure, an iron lacework of girders and beams and bolts (thirty-five million of them), which stands three-hundred metres high. This structure emerged as a technical solution rather than an

aesthetic declaration, allowing the tower to withstand the force of the wind against its heavy mass by, in effect, virtually eliminating its wind resistance (Eiffel would later conduct experiments in aerodynamics from its summit). Visitors to the tower were both inside and outside its structure. The voids within the structure became as important as the tower itself, an overlapping of open forms within which we may discern the artistic innovations of cubist painting and futurist sculpture.

The 'annihilation of time and space' which characterised the early period of the twentieth century enabled the public to be aware of events over a much broader geographical horizon. Newspapers covered the whole world, and provided a sense of 'the present in its totality', as Paul Claudel wrote in 1904. An editorial in the <u>Paris-Midi</u> in 1914 described the headlines in one daily paper as 'simultaneous poetry', (a belief shared, years later, by Marshall McLuhan who remarked that if you take the date line off a newspaper it becomes an exotic and fascinating surrealist poem). In 1930, the American novelist John Dos Passos, who had himself been a foreign correspondent in Spain and the Near East, would publish the first volume of the <u>USA</u> trilogy which contained 'Newsreel' sections, each consisting of fragmented headlines and sections of newspaper copy collaged together, a technique which looks towards the cut-up experiments of William Burroughs and Brion Gysin.

In marked contrast to his later declarations, the early poetry of FT Marinetti betrays a relationship to the modern world that is ambivalent, at best. In <u>Distruzione</u> (Destruction), written in 1904, we do find some themes which are familiar from his more well-known futurist texts. There is the train, for example, a common symbol of both technological expansion and sexual power, with which the poet identifies himself. Through this identification, the poet hopes to experience liberation through speed and violence, phenomena which clearly anticipate his later writings, yet he cannot, at this time, face these with total optimism. Possessed by the 'demon of speed', the poet finds himself in an urban environment which seems suffocating rather than inspirational, where 'rabid' trams 'bite each other like ogre's biting children's bodies' and:

> Tottering plumes of thick greasy smoke
> cover with an awful slime the crowding mob

The poet fears the loss of identity brought about by not only the mechanisation of modern life but also the irrational 'demon of speed' which has alienated him from himself. The effects of technology are here seen as destructive forces rather than the progressive emblems which they will become in the futurist manifestos.

Taylor often had nightmares that he was surrounded by machinery, unable to escape.

The railway profoundly altered the traveller's experience of the landscape. The smoothness of the ride, when compared with the jolts of a horse-drawn carriage, resulted in an acute sense of disorientation, the traveller unable to perceive curves in the track and thereby unable to make sense of the often fractured landscape which he is able to view through the carriage window. As Marcel Proust remarked of a sunrise viewed during

century after moving to Baker Lake in 1961. Like many of the older generation of Inuit artists, she combines different perspectives to present her narrative. In her wall hanging, she has created a massive hunter and fish, representing the historical importance of the hunt in communal society gone by. The top portion of the wall hanging depicts a traditional camp scene with caribou skin tents and drying arctic char; the lower portion illustrates a dog team hunting winter caribou. The traditional Inuit sense of time is cyclical, the only important measurement being the successful hunt.

 Whilst the blending of real and mythic time appears in many Inuit works, commentary on the accelerated pace of cultural change is also prevalent. Pudlo Pudlat (1916–1992) was a prominent hunter who moved to Cape Dorset, a community on the south shore of Baffin Island, in 1964. His coloured pencil drawing, <u>Flying Figure</u>, depicts bird and fish forms that are transforming into each other. At the same time this powerful image takes on the aggressive characteristics of a jet, streaking across the sky. The drawing, produced late in Pudlo's life, serves as a enigmatic icon of the shaman's power both to transform and to take flight, as well as of the intrusive Southern presence, particularly the military, within the Arctic region.

 As Southerners, we find ourselves at once in the past and the present. Co-op stores, the Church (there are five denominations in Baker Lake alone including Inuit Arctic Fellowship and Ba'hai), the schools and medical centre all have a presence. While many residents have lived over half their lives on the land, their children are now hooked on television. Today, the Inuit landscape is 'up to speed'. The community is online, the schools have computers, and everyone seems to have an all-terrain vehicle.

 Some younger Inuit artists have responded more directly and more critically to the effects of Southern society on Canada's North. Qavavau Manomee (b. 1958) has made a remarkable drawing of the Ascension of Christ, portrayed as an Inuk, who is transforming into a space shuttle. Here, the shaman's power of flight conflates with the most powerful symbol of modern society's technological progress. Manomee cryptically depicts a row of arctic graves as the rocket surges skyward — perhaps the graves of the seven astronauts killed in the Challenger explosion, a form of technological sacrifice. Oviloo Tunnillie (b. 1949), another Cape Dorset artist, takes a more light-hearted view of modern culture and the fascination with unknown nightclub life (which has been experienced only through media) by carving a man's Gucci loafer. Many Inuit artists express a powerful reponse to the rapid cultural changes that have effected Canadian Inuit, dramatically changing their lives during the last half of the twentieth century.

 For us three days in the Arctic seems like three weeks. Perhaps it is the endless hours of daylight, the lack of luxury, or the sheer remoteness of it all. Our return is the inverse of our arrival. We transfer to a series of larger jets (which seem to go slower). The urban centre opens up beneath, calling us back home. The freeways weave, skyscrapers shine — the silence of the North has been broken. End

Pudlo Pudlat
<u>Untitled (flying figure)</u> 1983
coloured pencil on paper
Collection Macdonald Stewart Art Centre
Purchased with funds donated by
Blount Canada Ltd., 1988

Qavavau Manomee
<u>NASA Graveyard</u> 1989
coloured pencil on paper
Collection Macdonald Stewart Art Centre
Purchased with funds donated by
Blount Canada Ltd., 1992

Marion Tuu'luuq
<u>Untitled (giant Inuk, giant fish)</u> 1986
Felt applique on wool duffle with embroidery
Purchased with funds raised by the
Art Centre Volunteers, 1989 Macdonald
Stewart Art Centre Collection.

Walter Richard Sickert
Miss Earhart's Arrival 1932
Oil on canvas
71.7 x 183.2cm
Tate Gallery, London. Purchased 1982

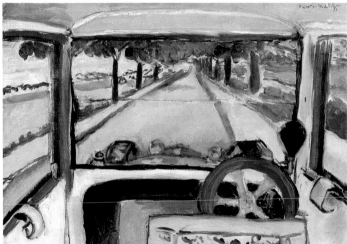

Henri Matisse
The Windshield, On the Villacoublay Road 1917
Oil on canvas
38.2 x 55.2cm
The Cleveland Museum of Art.
Bequest of Lucia McCurdy McBride
in memory of John Harris McBride II,
1972.225

Marcel Duchamp
In Advance of the Broken Arm 1915
Replica by U. Linde, signed by the artist, 1963
Metal spade
109 x 42cm
Moderna Museet, Stockholm

a railway journey: 'I was lamenting the loss of my strip of pink sky when I caught sight of it afresh, but red this time, in the opposite window which it left at a second bend in the line, so that I spent my time running from one window to the other to reassemble, to collect on a single canvas the intermittent antipodean fragments of my fine scarlet ever-changing morning, and to obtain a comprehensive view of it and a continuous picture.' Despite Proust's metaphor, it is not painting, but rather cinema, with its montages across time and space, which most closely resembles this fragmentary experience.

Many artists protested against the building of Eiffel's Tower, seeing it as an industrial monstrosity which would overshadow the artistic delights of Notre Dame or the Louvre. Guy de Maupassant, who with other luminaries such as Dumas fils sent a Protestation des artistes to the Minister of Public Works, was said to have regularly lunched at the restaurant in the tower: 'It's the only place in Paris where I don't have to see it'.

At the same time that time itself was becoming the same around the world, Albert Einstein was developing his Special and General Theories of Relativity (in 1905 and 1916 respectively). While the multiplicity of local times had been replaced with a standard world time (and its national times), Einstein stated that 'every reference body has its own time'. This had the effect, metaphorically, of placing a clock in every gravitational field in the universe, each telling a different correct time. While most people were astonished at the simultaneity of the wireless, which seemed to 'annihilate' time and space, Einstein showed that absolute simultaneity could have no precise meaning. As a phenomenon, simultaneity was to be heralded and denied almost simultaneously.

The toil of Noll became the tale of Schmidt, as Taylor was to tell it, imperfectly, to the many who came to his house. By November 1910, Taylor was famous, mainly through the work of Louis Brandeis, a lawyer and soon-to-be Supreme Court judge, who had challenged the inefficiencies of the American railroad companies in court. Taylor and his devotees gave testimonies and provided evidence against the companies; as a New York Times headline read, they volunteered to show how to save the railroads $300,000,000 a year. With the widespread discussions of 'Scientific Management', Taylor decided to compile his theories into a single volume, The Principles of Scientific Management, published in 1911. Within a few years the book had been translated into Chinese, Italian, Russian, Japanese, French, German and Spanish. Even Esperanto. All over the world, those who ran factories or countries were to read, 'In the past the man has been first. In the future the System must be first.' Hitler was an admirer. So were Eichmann and Mussolini, Lenin and Stalin also.

The use of simultaneity in music was possibly more advanced than in any other art form at the turn of the century. Richard Strauss' Also Sprach Zarathustra of 1896 combined two different keys at the same time (the music is now perhaps most well known from its use in that great film of simultaneity, Kubrick's 2001: A Space Odyssey). Debussey, Bartók and Prokofiev also experimented with the simultaneous use of different keys. Perhaps the

greatest musical scandal of the earliest twentieth century occurred on 28 May 1913, at the opening night of Igor Stravinsky's Le Sacre du printemps. Stravinsky's extensive use of tri-tonal harmonies so shocked the audience that at first they laughed, then began to shout, the noise becoming so loud that the dancers could not hear the music. In the audience was the poet Blaise Cendrars who defended the work so vigorously that a hostile neighbour pushed him through his seat; he wore the seat around his neck like a collar for the rest of the performance.

La Ville charnelle, or Carnal City, a poem written by Marinetti in 1908, also anticipates a number of themes which are more fully developed in the Futurist Manifesto which was to appear the following year. Instead of the fear of the dissolution of the human, a fear Marinetti expressed previously in Distruzione, here we find a rejection of the human, its soft, moist flesh corruptable and destined to rot, for the 'metallic happiness' of a progressive machinic future. The 'demon of speed' is now an inspirational muse which can destroy death in a demonstration of the triumph of the will over time and space. Lust for the carnal city becomes an intoxication with speed, a desire which the title of the poem's Italian translation — Lussaria Velocità — makes all the more explicit.

'The advance of machine-technique must lead ultimately to some of collectivism, but that form need not necessarily be equalitarian; that is, it need not be Socialism. Pace the economists, it is quite easy to imagine a world-society, economically collectivist — that is, with the profit principle eliminated — but with all political, military, and educational power in the hands of a small caste of rulers and their bravos. That or something like it is the objective of Fascism. And that, of course, is the slave-state, or rather the slave-world; it would probably be a stable form of society, and the chances are, considering the enormous wealth of the world if scientifically exploited, that the slaves would be well-fed and contented.' — George Orwell, The Road to Wigan Pier, 1937

It was the wireless telegraph which made a standard world time possible. The US Navy had sent time signals by wireless in 1905 and Paris time had been transmitted from the Eiffel Tower in 1910, before it was even declared the legal time of France. After the declarations of the 1912 conference, it was decided that the Paris Observatory would take readings which would then be relayed to the Eiffel Tower. On 1 July 1913, the first universal time signal was transmitted from the Eiffel Tower to eight stations around the world.

Standardised automated manufacturing processes have been in use since at least the sixteenth century, when their use in Venice's arsenale helped consolidate the domination of the city-state. Such was the sophistication of its methods, it is said that visiting dignitaries were invited to watch raw material being delivered into the arsenale before dining, only to see the completed, fully-armed ship sail away at the end of their meal. The French and then American arsenals continued these developments. The 'American system', as it became known, was initially devised to enable the creation of weapons with perfectly interchangeable parts. Oliver Evans created the first complete production

line with his mechanised mill of 1783; the Victualling Office of the British Navy in Deptford developed an automated production line for biscuits in 1804; Swiss inventor Johann Georg Bodmer developed a number of workshop designs and inventions in order to increase productivity; and the packing houses of Cincinnati used both a division of labour with an overhead rail system on which the carcasses were moved through the different stages of the slaughtering process. Henry Ford introduced the assembly line in his Highland Park factory, Detroit, in 1913, four years after the launch of the Model T and two years after the publication of Taylor's Principles of Scientific Management. Like the American arsenals, here parts were interchangeable; so were the de-skilled workers. Although Ford paid high wages, the labour turnover was even higher. Many workers did not yet want to become a cog in the machine.

'Who can still believe in the opacity of bodies, since our sharpened and multiplied sensitiveness has already penetrated the obscure manifestations of the medium? Why should we forget in our creations the doubled power of our sight, capable of giving results analogous to those of the X-rays?

 'It will be sufficient to cite a few examples, chosen amongst thousands, to prove the truth of our arguments.

 'The sixteen people around you in a rolling motor bus are in turn and at the same time, one, ten, four, three; they are motionless and they change places; they come and go, bound into the street, are suddenly swallowed up by the sunshine, then come back and sit before you, like persistent symbols of universal vibration.

 'How often have we not seen upon the cheek of the person with whom we are talking the horse which passes at the end of the street.

 'Our bodies penetrate the sofas upon which we sit, and the sofas penetrate our bodies. The motor bus rushes into the houses which it passes, and in their turn the houses throw themselves upon the motor bus and are blended with it.' — Umberto Boccioni et alia, 'Futurist Painting: Technical Manifesto', 1910

'It is better to be a first-class engineer than a second-class artist. Engineers can be, after all, important personages. Ettore Bugatti is greater than his brother, the late sculptor Rembrandt Bugatti. But his masterpieces, though perfection today, will be old junk in twenty years, whereas the shattered Parthenon will serenely throne over the ages.' — Amédée Ozenfant, Foundations of Modern Art, 1928

In 1915, Taylor was admitted to a hospital in Philadelphia suffering from a breakdown. Pneumonia developed. Early on the morning of his fifty-ninth birthday, the night-nurse heard him winding his watch. When she went to check on him at four-thirty that morning, she found him lying dead, watch in hand.

 Gong tam-tam zanzibar jungle beast X-rays express scalpel symphony
 You are everything
 Tower
 Ancient god
 Modern beast
 Solarspectrum
 Subject of my poem
 Tower
 Globe-circling tower
 Tower in motion.
— Blaise Cendrars, 'Tour', August 1913

For the philosopher Henri Bergson, the ability to live time was more important than the ability to understand it. This sense of duration — durée, as he termed it — is a source of freedom, a freedom which can be found within the unfolding dynamics of experience. Like the American psychologist William James, who coined the phrase 'stream of consciousness' in 1890, Bergson agreed that consciousness flowed in an ever-changing synthesis of past and future, rather than being composed of discrete elements which were chained together. As Bergson was to write in Creative Evolution in 1907: 'It is into pure duration that we plunge back, a duration in which the past, always moving on, is swelling unceasingly with a present which is absolutely new We must, by a strong recoil of our personality on itself, gather up our past which is slipping away, in order to thrust it, compact and undivided, into a present which it will create by entering.' Graceful movements only occurred as a result of a 'mastering of the flow of time', the future flowing easily from the attitudes of the present, and becoming impossible when the present and future are separated, when movements 'do not announce those to follow'.

'Speed was the first thing the early automobile manufacturers went after. Races advertised the makes of cars.

 'Henry Ford himself hung up several records at the track at Grosse Point and on the ice on Lake St Clair. In his .999 he did the mile in thirtynine and fourfifths seconds.

 'But it has always been his custom to hire others to do the heavy work. The speed he was busy with was speed in production, the records, the records in efficient output. He hired Barney Oldfield, a stunt bicyclerider from Salt Lake City, to do the racing for him.' — John Dos Passos, USA, 1938

In the autumn of 1913, a small press in Paris produced a remarkable publication called La Prose du Transsibérien et de la petite Jehanne de France. This publication was made up of a single sheet of paper, folded down its centre length, and then collapsed like an accordion, into twenty-two panels. La Prose du Transsibérien was published in an edition of 150 copies, with each copy two metres high. If each of the copies were placed vertically, one on top of the other, it would be the same height as the Eiffel Tower. The publication was a collaboration between the painter Sonia Delaunay and the poet Blaise Cendrars, who was also one of the two men who had established the press Les Hommes nouveaux which had published the work. On the left had side of the central crease is Delaunay's painting, a gorgeous swirling mass of colour and shape which at first seems abstract, then a 'landscape rushing by', then the unfolding of an aerial map, then, unmistakably, the Eiffel Tower penetrating the Great Wheel which was built alongside. To the right of the sheet is Cendrars' poem, of a journey as epic as the railway line which lends its name to the piece. The Transsibérien, completed in 1905, linked western Russia with the Pacific coast and was one of the major industrial achievements of the period, like the Trans-African and Trans-Andine railways, which did much to shrink the world.

'If pictorial expression has changed, it is because modern life has necessitated it. The existence of modern creative people is much more intense and

more complex than that of people in earlier centuries. The thing that is imagined is less fixed, the object exposes itself less than it did formerly. When one crosses a landscape by automobile or express train, it becomes fragmented; it loses in descriptive value but gains in synthetic value. The view through the door of the railroad car or the automobile windshield, in combination with the speed, has altered the habitual look of things. A modern man registers a hundred times more sensory impressions than an eighteenth-century artist; so much so that our language, for example, is full of diminuitives and abbreviations. The compression of the modern picture, its variety, its breaking up of forms, are the result of all this. It is certain that the evolution of the means of locomotion and their speed have a great deal to do with the new way of seeing. Many superficial people raise the cry "anarchy" in front of these pictures because they cannot follow the whole evolution of contemporary life that painting records. They believe that painting has abruptly broken the chain of continuity, when, on the contrary, it has never been so truly realistic, so firmly attached to its own period at is today. A kind of painting that is realistic in the highest sense is beginning to appear, and it is here to stay.' — Fernand Léger, 'Contemporary Achievements in Painting', 1914

Einstein's special theory of relativity, which appeared in 1905, destroyed the conventional sense of the stability of forms within the material universe. He argued that a moving body will change its shape with respect to a reference from a stationary body, so that a sphere, when viewed at rest, becomes ellipsoid when viewed at motion. The clear delineations between forms and their surroundings had become blurred; they now interpenetrated, like the words of Joyce, or the sculptures of Boccioni.

For many graphologists, divergence from accepted, standardised letter forms was interpreted as a sign of individuality. While hesitation and unnecessary ornamentation were perceived as 'unnatural' in handwriting, fluidity, rhythm and freedom of expression implied sincerity, vitality and spontaneity, all desirable attributes. The increasing use of the typewriter, with its uni-forms, threatened to obscure these movements, which had always been about more than simply good penmanship. The lectures of Colonel Francis W. Parker, given in 1891 and reprinted as Talks on Pedagogics in 1937, make it plain what was at stake: 'The imperative rule for an adequate act of expression is that the whole body, every muscle and fibre, is concentrated upon the act; a person should sing, write, speak, by means of the freest action of the entire physical organism. When agents are isolated by premature attempts at precision before poise and ease of body become habitual, the inevitable knotting and tension of muscles react, cripple the body, and constrain the mind.'

During the First World War, Ford hired a steamboat, the Oscar II, and filling it with pacifists and social workers sailed to Europe in order to help stop the fighting. He was brought home under wraps. Within two years he was manufacturing munitions and planning one-man tanks and submarines. Soldiers who had lost limbs in the war were encouraged to work in his factories. Special tools were attached to workbenches into which amputees were able to place their residual limbs. The body was becoming the object of increasing mechanisation.

'In an age of accelerated change, the need to perceive the environment becomes urgent. Acceleration also makes such perception of the environment more possible. Was it not Bertrand Russell who said that if the bath water got only half a degree warmer every hour, we would never know when to scream? New environments reset our sensory thresholds. These, in turn, alter our outlook and expectations.' — Marshall McLuhan, Through the Vanishing Point: Space in Poetry and Painting, 1968

'We exclaim the whole brilliant style of modern times — our trousers, jackets, shoes, trolleys, cars, airplanes, railways, grandiose steamships — is fascinating, is a great epoch.' — Mikhail Larionov and Natalya Goncharova, 'Rayonist Manifesto', 1913

Duchamp was very particular about the paints which he used for his works, and it is said that he would scrupulously study their properties before choosing. Eventually, he chose Behrendt, a German brand. While in Munich, during the summer of 1912, Duchamp completed a number of works including a smallish canvas, The Passage from the Virgin to the Bride. He did not use brushes to make this painting, preferring, instead, to model the paint between his fingers, moulding an object rather than staining a canvas (however, he would open a commercial dyeworks in New York ten years later.)

In the multitude of advertisements and leaflets announcing its publication, La Prose du Transsibérien is described as 'le Premier livre simultané', the first simultaneous book. To be simulataneous was to be part of the modern world (even if Einstein's theories of relativity denied the possibility of absolute simultaneity, it was still a phenomenon with which he was engaged). The Futurists embraced it, obviously: 'The simultaneousness of states of mind in the work of art: that is the intoxicating aim of our art', as Boccioni and others wrote the previous year. But while the Futurists intended a synthesis of what one remembers and what one sees, the simultaneity of La Prose du Transsibérien has other, simultaneous meanings. The first is the simultaneity of the colours used in Delaunay's painting, 'couleurs simultanéss', to use her term, in which opposing colours were used in complementarity. The second meaning is that one is to 'take in' the work all at once, image and text together, 'even as one reads with a single glance the plastic elements printed on a poster' as the poet Appollinaire was to write of the work in Les Soirées de Paris the following year. And a third meaning of simultaneity, here, refers to the spatial and temporal compressions which are occur throughout the work, where cities and countries, past and present, are compressed without so much as the arrest of punctuation, where 'the whole of Europe [is] seen through the windcutter of an Express racing ahead at full speed'.

Mindful of the reforms within dance, penmanship, as well as the later reforms within drawing and free play, Ruth Faison Shaw invented children's fingerpaints in 1931, as a means to encourage the free expression of children without the muscle strain associated with the holding of brushes or other implements. Like these earlier reforms, fingerpainting encouraged a coherent sense of movement beyond the area of the body in immediate use. As Shaw was to write in her book Finger Painting: A Perfect Medium for Self-Expression:

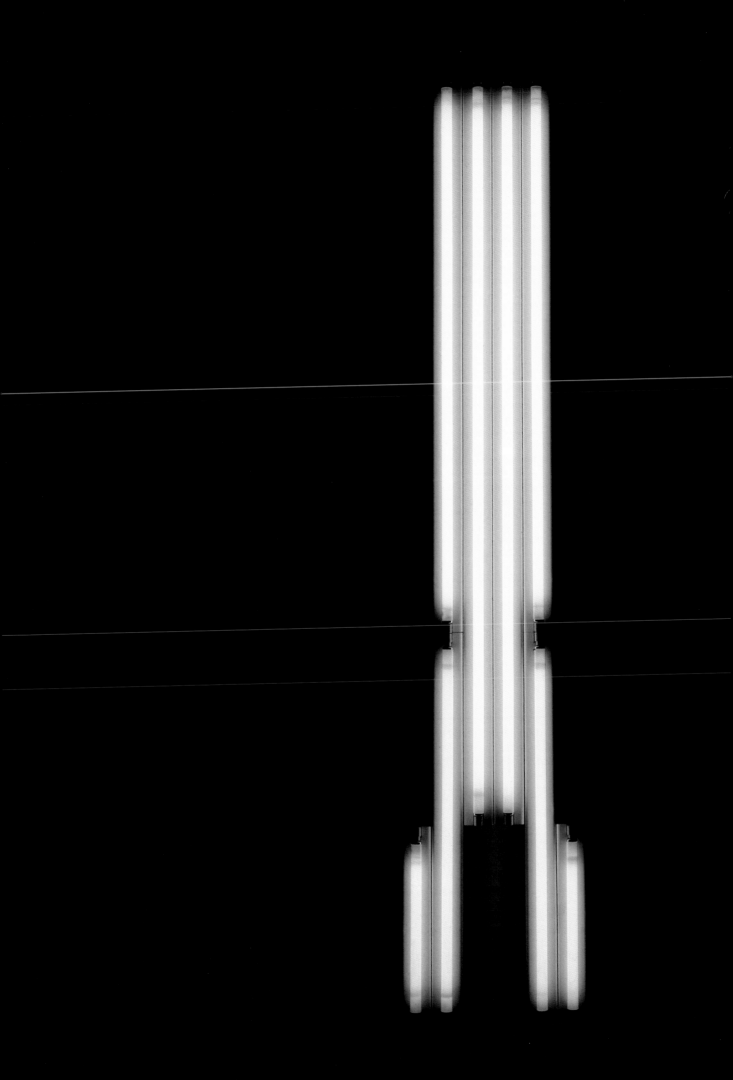

Dan Flavin
Untitled (Monument for Vladimir Tatlin) 1975
304.5 x 61 x 12cm
Fluorescent tubes
Musée d'Art Moderne de Saint-Etienne

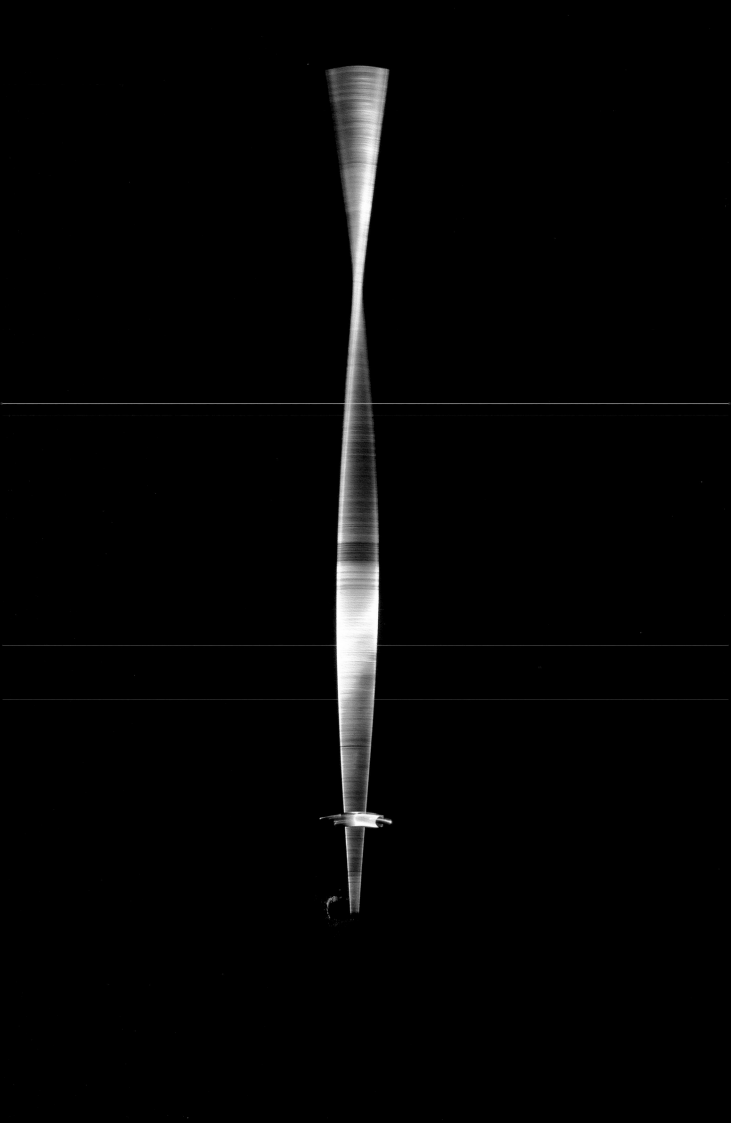

Naum Gabo
Kinetic Construction (Standing Wave)
1919-20, replica 1985
Metal, painted wood and electrical mechanism
61.6 x 24.1 x 19cm
Tate Gallery, London. Presented by the
artist through the American Federation
of the Arts, 1966

'When a child begins to finger paint, his whole body contributes to the rhythmic movements which register characteristic arcs and swirls of extraordinary grace in colour. As one small boy put it, "I paint with the spot in the middle of my back."'

Ford's greatest achievement in terms of manufacturing was that he made his workers his consumers.

With the development of the 'field' theory of physics, the truism that two things cannot occupy the same space at the same time is profoundly false. As the philosopher of science Alfred North Whitehead would make clear, 'with the denial of simple location we must admit that within any region of space-time the innumerable multitude of these physical things are in a sense superimposed.'

Jacob Epstein
Study for 'Rock Drill' 1915
Charcoal on paper
67.5 x 42.5cm
The Garman Ryan Collection,
Walsall Museum and Art Gallery

'Have you ever thought about the sadness that streets, squares, stations, subways, first class hotels, dance halls, movies, dining cars, highways, nature would all exhibit without the innumerable billboards, without show windows (those beautiful brand new toys for thoughtful families), without luminous signboards, without the false blandishments of loudspeakers, and imagine the sadness and monotony of meals and wine without polychrome menus and fancy labels.' — Blaise Cendrars, 'Advertising=Poetry', 1927

Despite Marinetti's intensive identification with the world of machines, it seems that he was, himself, relatively incompetent at using them. As one of his biographers, Gino Agnese, has noted, activities which do not allow for distraction were not suitable for Marinetti, whether it be shaving with a razor or driving a speeding car. In fact, his activities as a driver were brought to an end on 15 October 1908 when he drove of the road, his car coming to rest upside down in a ditch. Its impact was intellectual as well as physical, the incident appearing in the 'Fondazione e Manifesto del Futurismo', the 'Foundation and Manifesto of Futurism' which was published on the front page of the mass-circulation newspaper, Le Figaro, less than four months later. In the text, Marinetti and friends are roused from their bourgeois opulence first by 'the mighty noise of the huge double-decker trams that rumbled by outside', and then 'the famished roar of automobiles'. After going outside to the cars, where they 'lay amorous hands on their torrid breasts', the 'young lions' drove off at speed. It was as they approached two cyclists 'wobbling like two equally convincing but nevertheless contradictory arguments' that Marinetti lost control of his car and rolled into the ditch.

Towards the end of 1912, Marcel Duchamp, Constantin Brancusi and Fernand Léger visited the Salon de la Locomotion aérienne. Once confronted by the displays, Duchamp turned to his friends and said, 'Painting is over and done with. Who could do anything better than this propeller? Look, could you do that?'

By 1926, the complete production cycle for a Model T, from the extraction of ore in Ford's own mines to the car driving away from the factory, had been reduced to eighty one hours.

'The future of America is the future of the world. Material circumstances are driving all nations along the path in which America is going. Living in the contemporary environment, which is everywhere

becoming more and more American, men feel a psychological compulsion to go the American way. Fate acts within and without; there is no resisting. For good or for evil, it seems that the world must be Americanised. America is not unique; she merely leads the way along the which the people of every nation and continent are taking. Studying the good and the evil features in American life, we are studying, in a generally more definite and highly developed form, the good and evil features of the whole world's present and immediately coming civilisation. Speculating on the American future, we are speculating on the future of civilised man.' — Aldous Huxley, 'The Outlook for American Culture: Some Reflections in a Machine Age', Harpers Magazine, August 1927

'If I want to prepare a glass of sugared water, try as I may, I must wait until the sugar melts. This little fact is of great significance.' — Henri Bergson, Creative Evolution, 1907

'At no period in the history of the world have workers had access to plastic beauty, for the reason that they have never had the necessary time and freedom of mind. Free the masses of the people, give them the possibility of thinking, of seeing, of self-cultivation — that is all we ask; they will then be in a position to enjoy to the utmost the plastic novelties which modern art has to offer. The people themselves every day create manufactured objects that are pure in tonal quality, finished in form, exact in their proportions; they have already visualised the real and the potential plastic elements. Hanging on the wall in the popular bals-musettes, you will find aeroplane propellers. They strike everyone as being objects of beauty, and they are very close to certain modern sculptures.' — Fernand Léger, 'The New Realism Goes On', 1937

'We may seek knowledge of an object because we love the object or because we wish to have power over it The scientific society of the future ... is one in which the power impulse has completely overwhelmed the impulse of love The scientific society in its pure form ... is incompatible with the pursuit of truth, with love, with art, with spontaneous delight, with every ideal that men have hitherto cherished.' — Bertrand Russell, The Scientific Outlook, 1931

The sudden shifts in Cendrars' poem owes much to the formal qualities of cinema (after the First World War, in which he lost his right arm, Cendrars would work as a film editor for Abel Gance). We are cut along the track from time to time, from place to place, in an instant, as quickly as splices on a length of film:

> All the faces glimpsed in stations
> All the clocks
> The time in Paris the time in Berlin the time in Saint Petersburg and the time in all the stations...
> And the continuous rushing of the train
> Every morning all the clocks are set
> The train is set forward and the sun is set back

'The new life of iron and the machine, the roar of automobiles, the glitter of electric lights, the whirring of propellers, have awoken the soul, which was stifling in the catacombs of ancient reason and has emerged on the roads woven between earth and sky.
'If all artists could see the crossroads of these celestial paths, if they could comprehend these monstrous runways and the weaving of our bodies with the clouds in the sky, then they would not paint chrysanthemums.' — Kasimir Malevich, From Cubism and Futurism to Suprematism: The New Realism in Painting, 1916

The uneasy relationship between fluid movement and mechanical jolts was central to the tragedies which darkened, and then ended, the life of Isadora Duncan. The first occurred on a drive which her two children were taking with their nurse. While crossing a bridge, the car in which they were travelling stalled; the chauffeur stepped out to crank the engine with the starting handle, forgetting that he had left the car in gear. As soon as the engine started, the car leapt forward, killing the chauffeur before plunging into the river Seine below, drowning its remaining passengers. The second incident occured in Nice, in September 1927, where Duncan was about to test drive a Bugatti which she planned to buy. The silk scarf which she was wearing (Hermès? God of Speed?) was caught first by the wind, and then in the rear wheel of the car. As she drove off the first revolution broke her neck.

'I'm interested in truth. I like science. But truth's a menace, science is a public danger. As dangerous as it's beneficent But we can't allow science to undo its own good work. That's why we so carefully limit the scope of its researches We don't allow it to deal with any but the most immediate problems of the moment. All other inquiries are most sedulously discouraged. It's curious ... to read what most people in the time of Our Ford used to write about scientific progress. They seem to have imagined that it could be allowed to go on indefinitely, regardless of everything else. Knowledge was the highest good, truth the supreme value; all the rest was secondary and subordinate. True, ideas were beginning to change even then. Our Ford himself did a great deal to shift the emphasis from truth and beauty to comfort and happiness. Mass production demanded the shift. Universal happiness keeps the wheels steadily turning; truth and beauty can't. And, of course, whenever the masses seized political power, then it was happiness rather than truth and beauty that mattered. Still, in spite of everything, unrestricted scientific research was still permitted. People still went on talking about truth and beauty as though they were the sovereign goods. Right up to the time of the Nine Years' War. That made them change their tune all right. What's the point of truth or beauty or knowledge when the anthrax bombs are popping all around you?' — Aldous Huxley, Brave New World, 1932

'O maternal ditch, almost full of muddy water! Fair factory drain! I gulped down your nourishing sludge; and I remembered the blessed black breast of my Sudanese nurse When I came up — torn, filthy and stinking — from under the capsized car, I felt the white-hot iron of joy deliciously pass through my heart!' Marinetti's accident, as he relates it, becomes a technological rebirth, the industrial products into which he is thrown providing a surrogate source of nourishment, like the wet-nurse's breast. The natural, and in particular the feminine, is introduced in order that it can be more completely replaced by the masculine order of the industrial age, a desire which appears in his novel Mafarka il futurista (1910) and throughout his writings: 'In the name of the human Pride that we

Richard Hamilton
Hommage à Chrysler Corp 1957
Oil, metal foil and collage on wood
122 x 81cm
Tate Gallery, London.
Purchased with assistance from the
National Art Collection Fund and the
Friends of the Tate Gallery, 1995

worship, I announce to you the coming hour in which men with wide temples and steel jaws will prodigiously give birth, only with their exorbitant willpower to infallible giants ... I announce to you that man's spirit is an untrained ovary ... And we are the first to fecundate it!'

In 1928, the American Amelia Earhart became the first woman, and only the third person, to cross the Atlantic by plane. Four years later she would by the first woman to cross it in a solo flight, landing in Ireland on 21 May 1932. On descending from the plane on the outskirts of London a day later, Miss Earhart was greeted by a party which included the United States Ambassador, with whom she stayed while in London, and the Master of Sempill, who read her a message of congratulations from the Prime Minister. It was this celebratory arrival that was to become the subject of a painting by Walter Sickert. It is unlikely that Sickert was himself one of the welcoming party as his painting is based, instead, upon the largest of the five photographs published on the front page of the Daily Sketch of 23 May 1932, albeit heavily cropped. Sickert rejected the static nature of the studio photograph, preferring, instead, the immediacy of the amateur or the news picture. In working with such material, Sickert looked forward to the use of such imagery by later artists (as three of the five photographs of the newspaper's front page were of reporters killed after their plane crashed while covering the story, the relationship to Warhol's front page declaring '129 DIE' is particularly strong). Yet Sickert appropriated not only the imagery of the mass media but also their rapidity of turnover — the painting was exhibited only seven days after the publication of the newspaper, although it appeared in the New York Times a day earlier than that.

For the artists of early modernism, artistic production was increasingly a process of choosing industrial products. 'What is making? Making something is choosing a tube of blue, a tube of red, and putting some of it on the palette, and always choosing the quality of the blue, the quality of the red, and always choosing the place to put it on the canvas, it is always choosing,' said Marcel Duchamp. 'Since the tubes of paint used by the artist are manufactured and ready-made products, we must conclude that all the paintings in the world are "readymades aided" and also works of assemblage.' As art historian Thierry de Duve has noted, the tube of paint is the missing historical link that connects the readymade to the pictorial tradition.

'The aim of the Communist Revolution in Russia was to deprive the individual of every right, every vestige of personal liberty ... and transform him into a component cell of the great "Collective Man" — that single mechanical monster who ... is to take the place of the unregimented hordes of "soul-encumbered" individuals who now inhabit the earth. To the Bolshevik, there is something hideous and unseemly about the spectacle of anything so "chaotically vital", so "mystically organic" as an individual with a soul, with personal tastes, with special talents. Individuals must be organised out of existence; the communist state requires, not men, but cogs and rachets in the huge "collective mechanism". To the Bolshevik idealist, Utopia is indistinguishable from one of Mr Henry Ford's factories. It is not enough, in their eyes, that men should spend only eight hours a day under the

workshop discipline. Life outside the factory must be exactly like life inside. Leisure must be as highly organised as toil. Into the Christian Kingdom of Heaven men may only enter if they have become like little children. The condition of their entry into the Bolsheviks' Earthly Paradise is that they shall have become like machines.' — Aldous Huxley, 'The New Romanticism', in Music at Night, 1931

'[M]en have always been the sex organs of the technological world.' — Marshall McLuhan, Understanding Media: the extensions of man, 1964

Alfred North Whitehead was an English mathematician who, having never formally studied philosophy in his life, at the age of sixty-three agreed to become professor of philosophy at Harvard University. It was during this period at Harvard, where he developed a metaphysical system based on Einstein's new physics known as 'process' philosophy, that his ideas began to influence the writers and artists of the American avant-garde. Rather than the classical physics of Newton, whereby an electromagnetic field was defined as a collection of discrete charged particles, the modern physics of Einstein inverted this concept; here the energy field itself was seen as primary, with the 'particles' no more than peturbations of that field. It was this idea of the energy field as a model of human experience which Whitehead developed and which influenced artists and writers to develop 'composition by field', whether it be the projective verse of Charles Olsen or the 'all-over' painting of Pollock. The relationship becomes apparent when we consider a section from Olsen's essay 'Projective Verse' and replace the 'poem' and 'poet' with 'painting' and 'painter', particularly Pollock. Both artists employ a method which emphasise 'the kinetics of the thing. A poem is energy transferred from where the poet got it (he will have some several causations), by way of the poem itself to ... the reader. Okay. Then the poem itself must, at all points, be a high energy-construct and, at all points, an energy-discharge.'

With his Futurist writings, Marinetti attempted to institute a 'cult of speed' as a guarantee of a liberating, progressive future. It is in 'La nuova religione-morale della velocità' (The New Religion-Morality of Speed), written in 1916, that the attempt to create a new religion of speed is most explicit. According to Marinetti, speed gives man victory over time and space, thereby realising the Absolute in life, rather than in the Christian after-life. Instead of the protection of sensual excess, which the Christian faith provided, the futurist creed would instead protect man from 'the decay brought about by slowness, memory, analysis, repose and habit', invigorating his progress through the world. Slowness is 'naturally foul', a description which is reminiscent of those which Marinetti the poet made in La Ville charnelle, whereas speed, 'the intuitive synthesis of all forces in movement', is, by its very nature 'pure'. Futurism attempts to replace Christianity with a new morality, one which provides 'a new good: speed, and a new evil: slowness'.

For all the modernising of his youth, as an old man, Ford was a passionate antiquarian. He rebuilt his father's farmhouse exactly as he had remembered it as a boy; he renovated the laboratories of his early hero, Thomas Edison; he created a village of museums to the horse-drawn carriage, the buggy,

the sleigh and the plough. And when he bought the Wayside Inn near Sudbury, Massachusetts, he had the new roadway removed and replaced with a simple dirt track

 'so that everything might be
 the way it used to be,
 in the days of horses and buggies.'
(Dos Passos)

The rulers of Brave New World had chosen the introduction of 'Our Ford's Model T' as the opening date of a new era. Its inhabitants, like ourselves, live After Ford, AF. Ford himself wanted to live BF, Before Ford.

'Tomorrow,' said Gumbril, at last, meditatively. 'Tomorrow,' Mrs Viveash interrupted him, 'will be as awful as today.' — Aldous Huxley, Antic Hay, 1923

 'Futurism opened the "new" in modern life: the beauty of speed.
 'And through speed we move more swiftly.
 'And we who only yesterday were Futurists, arrived through speed at new forms, at new relationships with nature and things.
 'We arrived at Suprematism, leaving Futurism as a loop-hole through which those left behind will pass.
 'We have abandoned Futurism; and we, the most daring, have spat on the altar of its art.
 'The dynamic of movement has directed thought to produce the dynamic of plastic painting.
 'But the efforts of the Futurists to produce purely plastic painting as such, were not crowned with success.
 'They could not abandon subject-matter, which would have made their task easier.
 'When they had driven halfway off the surface of the picture (the old callouse of habit that sees everything naturalistically), they were able to make a picture of the new life, of new things, but only this.' — Kasimir Malevich, From Cubism and Futurism to Suprematism: The New Realism in Painting, 1916

'Modern physics has abandoned the doctrine of Simple Location. The physical things which we term stars, planets, lumps of matter, molecules, electrons, protons, quanta of energy, are each to be conceived as modifications of conditions within space-time, extending throughout its whole range. There is a focal region, which in common speech is where the thing is. But its influence streams away from it with finite velocity throughout the utmost recesses of space and time.' — Alfred North Whitehead, Adventures of Ideas, 1933

In 1946, a young art student was walking through the Tate Gallery with his tutor. The student seemed dissatisfied with painting, David Bomberg remarked, and asked what sort of painting it was that he was after. Gustav Metzger was unable to give a coherent answer, although he knew that the painting had to be intense, and extremely fast. It was ten years later, when he first saw the drip paintings of Jackson Pollock, that Metzger recognised work which came closest to what he had attempted to describe that day.

'Realise that this age is a difficult one to please: it demands from art products potent to overcome and stabilise the feverishness of today. Production results from convergence. The focal point of convergence must be our own ideal, placed so high that nothing can ever reach it or put a bound to our climbing. Some find attempts at breaking records stupid. If speed has a limit, it would interest us little: but speed has no limit other than that of light, and from us to that Ideal speed will never be attained, but the impulse towards that infinite constitutes a lever that can never exert its full power. Men, like civilisations, enter on Decadence not when they have lost but GAINED their ideal.' — Amédée Ozenfant, Foundations of Modern Art, 1928

The montage techniques of Ulysses, which allow the reader to witness activities of Dublin in a vast expanded present, were improvised from Joyce's profound admiration for cinematic editing (in 1909, Joyce was instrumental in introducing the first cinema to Dublin).

'An ordinary man can in a day's time travel by train from a little dead town of empty squares, where the sun, the dust, and the wind amuse themselves in silence, to a great capital city bristling with lights, gestures, and street cries. By reading a newspaper the inhabitant of a mountain village can tremble each day with anxiety, following insurrection in China, the London and New York suffragettes, Doctor Carrel, and the heroic dog-sleds of the polar explorers. The timid, sedentary inhabitant of any provincial town can indulge in the intoxication of danger by going to the cinema and watching a great hunt in the Congo Then back in his bourgeois bed, he can enjoy the distant, expressive voice of a Caruso or a Burzio.' — FT Marinetti, Destruction of Syntax — Wireless Imagination — Words-in-Freedom, 1913

In his essay 'Merce Cunningham and the Politics of Perception', dance critic Roger Copeland described Hans Namuth's film of Jackson Pollock as 'one of the world's most significant dance films' which showed that the fundamental impulse behind abstract expressionism was the desire to transform painting into dancing. Perhaps it was dance instructor Gertrude Colby who has provided us with the most accurate description of Pollock's painting: 'The arm positions grow out of the body movements and follow the line and sway of the body. They do not move independently but grow out of and continue the trunk movements.'

'To say "I accept" in an age like our own is to say that you accept concentration camps, rubber truncheons, Hitler, Stalin, bombs, aeroplanes, tinned food, machine-guns, putsches, purges, slogans, Bedaux belts, gas-masks, submarines, spies, provocateurs, press censorship, secret prisons, aspirins, Hollywood films and political murders.' — George Orwell, Inside the Whale, 1940

For the American poet Charles Olsen, spontaneous composition offered a means of engaging politically with a culture which was saturated with advertising and the mass media. Drawing on the writings of psychologist Carl Jung, who believed that the conscious mind was keeper of social proprieties and that alternatives must therefore be found at the unconscious level, Olsen believed that the spontaneous compositions of the unconscious mind created the potential for authentic forms of human relations. To achieve this end, the poet must let the words flow automatically rather than search them out. As he wrote in his essay 'Projective Verse' of 1950: 'It is spontaneous, this way [A]t all points (even, I

Marcel Breuer
Club Armchair, 'Wassily'
1927–28

Francis Picabia
Portrait of Alfred Stieglitz
Front cover, *291 Journal*,
issues 5 & 6, July-August, 1915
Ink on paper
44 x 29cm
The Board of Trustees of the
Victoria & Albert Museum,
London

Fernand Léger
Hommage à la Danse 1925
Oil on canvas
159 x 121cm
Collection Paule and Adrien Maeght,
Paris

should say, of our management of daily reality as of the daily work) get on with it, keep moving, keep in speed, the nerves, their speed, the perceptions, theirs, the acts, the split second acts, the whole business, keep it moving as fast as you can, citizen.'

'Plasticity … means the possession of a structure weak enough to yield to an influence, but strong enough not to yield all at once .… The material in question opposes a certain resistance to the modifying cause, which it takes time to overcome .… [W]hen the structure has yielded, the same inertia becomes a condition of its comparative permanence in the new form, and of the habits the body then manifests.'
— William James, Principles of Psychology, 1890

In 1943, Peggy Guggenheim commissioned a large scale mural from Jackson Pollock. Pollock contemplated the one-hundred-and-sixty square feet of empty canvas for weeks on end without marking a mark. Then, in an overnight burst of activity, Pollock completed the entire canvas.

'The human body is indubitably a complex of occasions which are part of spatial nature.'
— Alfred North Whitehead, Adventures of Ideas, 1933

By the 1930s, streamlining of manufactured objects had become a style which denoted both modernity and speed (for many, they meant the same thing). Smooth, clean lines were to be admired everywhere. Bodies became elegantly curved, whether those of luxurious American saloons or American women, the latter shaped by a whole array of girdles and garments which 'actually streamline the figure, transforming wayward curves and bulges into smart and flattering lines', as one advertisement put it. These bodies become more completely overlaid in Richard Hamilton's painting Hommage à Chrysler Corp from 1957. Here the car is implied rather than demonstrated, a loose arrangement of shapes taken from magazine advertisements for Chrysler as well as General Motors and Pontiac. A woman's body is also to be found within the fused forms, a shape of a bra and a pair of curved lips, cut from a magazine. Here is the car as a sex object, indeed the woman as a sex object, both themes which were as familiar to Marinetti as they are to contemporary advertisers.

If the twentieth century has allowed its inhabitants to live faster than ever before, it has also allowed them to die faster. Before August 1945 death, like life, had a duration. People passed away, slipped away, they moved over, they left us. And then, two flashes over two Japanese cities changed that. The scientific developments which allowed some to ponder travel at the speed of light also made it possible for others to die at it.

'Speed leads to complication: everything becomes clockwork: and a speck of dust can stop the miracle.' — Amédée Ozenfant, Foundations of Modern Art, 1928

To say that the way in which an artist makes work is integral to that finished work is to say a very dull thing. Nonetheless, it is an importance consideration, particularly when we are considering the paintings of Jackson Pollock. Although these works are often described as the epitome 'abstract expressionism', it is an unfortunate description, the paintings themselves being neither abstract nor expressionist. Instead, these are the most concrete of works, in

possession of an absolute materiality, from the wrinkled skin of the enamel paint, to the pins, or glass, or cigarettes embedded within their surfaces. This physicality derives, of course, from the body of the painter himself, as Hans Namuth's film famously demonstrates. Here the artist moves rhythmically around the horizontal canvas, his body reacting not only to itself, to its own weight, balance and movement, but also the weight, balance and movement of the paint itself. The French nicknamed Pollock 'Le Duco', after the name of the industrial enamel paint which he used. The artist himself has become part of the medium which he uses within his work.

> An American
> is a complex of occasions,
> themselves a geometry
> of spatial nature.
> I have this sense,
> that I am one
> with my skin
> Plus this — plus this

— Charles Olson, extract from 'The Ridge', 1954

In April 1951, while high on Benzedrine, the twenty-nine year old 'Beat' writer Jack Kerouac inserted a continuous roll of paper into his typewriter and over the next three weeks produced the language and basic structure of his novel On the Road in a 120-foot scroll of single-spaced typescript.

Mr Pollock, there's been a good deal of controversy and a great many comments have been made regarding your method of painting. Is there something you'd like to tell us about that?
Jackson Pollock: My opinion is that new needs need new techniques. And the modern artists have found new ways and new means of making their statements. It seems to me that the modern painter cannot express this age, the airplane, the atom bomb, the radio, in the old forms of the Renaissance or of any other past culture. Each age finds its own technique.

'When I was teaching at Cooper Union in the first year or two of the fifties, someone told me how I could get on to the unfinished New Jersey Turnpike. I took three students and drove from somewhere in the Meadows to New Brunswick. It was a dark night and there were no lights or shoulder markers, lines, railings, or anything at all except the dark pavement moving through the landscape of the flats, rimmed by hills in the distance, but punctuated by stacks, towers, fumes, and coloured lights. This drive was a revealing experience. The road and much of the landscape was artificial, and yet it couldn't be called a work of art. On the other hand, it did something for me that art had never done. At first I didn't know what it was, but its effect was to liberate me from many of the views I had had about art. It seemed that there had been a reality there which had not had any expression in art.
'The experience on the road was something mapped out but not socially recognised. I thought to myself, it ought to be clear that's the end of art. Most painting looks pretty pictorial after that. There is no way you can frame it, you just have to experience it. Later I discovered some abandoned airstrips in Europe — abandoned works, Surrealist landscapes, something that had nothing to do with any function, created worlds without tradition. Artificial landscape without any cultural precedent began to dawn on me. There

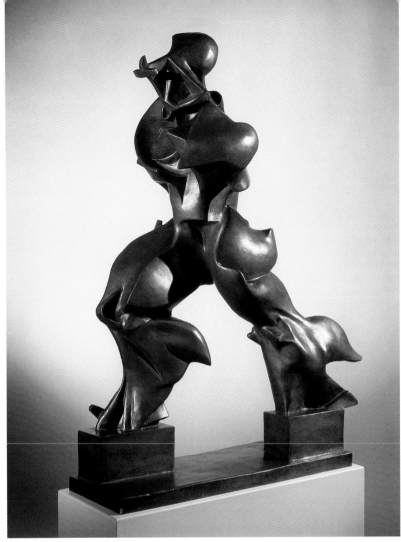

Umberto Boccioni
Unique Forms of Continuity in Space 1913
Cast 1972
Bronze
117.5 x 87.6 x 36.8cm
Tate Gallery, London. Purchased 1972

Le Corbusier
Automaxima Car
1928/1989
Wood
140 x 360 x 180cm
Design Museum, London

is a drill ground in Nuremberg, large enough to accommodate two million men. The entire field is enclosed with high embankments and towers. The concrete approach is three sixteen-inch high steps, one above the other, stretching for a mile or so.' — Tony Smith, 'Talking with Tony Smith', <u>Artforum</u>, *1966*

'We are primitives of an unknown culture.' — Umberto Boccioni, 1911

The development of entropy, particularly in the mid-nineteenth century, strengthened the element of time within the physical sciences. As a measure of disorder, it is often seen as part of an ongoing process, of an increasing disintegration within the universe, leading, inexorably towards its celebrated (if that's the word) heat-death. The idea of entropy fascinated Robert Smithson, to the extent that it is a word which appears in almost all his writings. It is also a phenomenon which appears in most of his works. To explain what he means by entropy, he asks us to imagine a sandpit that has been divided in half; one half contains black sand, the other white. A boy begins to run around the sandpit in a clockwise direction, kicking up the sand as he goes. After some time, the boy reverses his direction and kicks the sand around in an anti-clockwise direction. Rather than undoing the mixing which took place under the initial clockwise movement, the counter direction further intensifies the disorder.

If Pollock's canvases were perceived as 'arenas' for a performative event, then this is a perception shared by Andy Warhol. In 1962, Warhol exhibited his <u>Dance Diagram</u> paintings at the Stable Gallery; however, whereas Pollock's canvases were created on the floor, Warhol's were displayed on the floor. Their surfaces, too, could hardly be more different, with Pollock's scabby enamel paint contrasting with the smooth acrylic of Warhol. The homage (and Warhol's career is full of homages to Pollock) is in the images themselves, cool diagrams of the correct placement of feet, with arrows showing the direction of movement, dotted lines sweeping around its area. We can see Namuth's photographs of Pollock standing on the canvas, dots and lines sweeping in front of him and hear the sneer of <u>Time</u> magazine in the accompanying text: 'All it says, in effect, is that Jack the Dripper, 44, still stands on his work.'

'Instead of causing us to remember the past like the old monuments, the new monuments seem to cause us to forget the future. Instead of being made of natural materials, such as marble, granite, or other kinds of rock, the new monuments are made of artificial materials, plastic, chrome, and electric light. They are not built for the ages, but rather against the ages. They are involved in a systematic reduction of time down to fractions of seconds, rather than in representing the long spaces of centuries. Both past and future are placed into an objective present. This kind of time has little or no space; it is stationary and without movement, it is going nowhere, it is anti-Newtonian, as well as being instant, and is against the wheels of the time-clock. Flavin makes "instant-monuments"; parts for <u>Monument 7 for V. Tatlin</u> were purchased at the Radar Fluorescent Company. The "instant" makes Flavin's work a part of time rather than space.' — Robert Smithson, 'Entropy and the New Monuments', 1966

'It is the Playboy "Playmate of the Month" pull-out pin-up which provides us with the closest

Wyndham Lewis
<u>*Futurist Figure*</u> *1912*
Pencil, pen, ink and watercolour
26.4 x 18.3cm
Private collection, London

contemporary equivalent of the odalisque in painting. Automobile body stylists have absorbed the symbolism of the space age more successfully than any artist. Social comment is left to TV and comic strip. Epic has now become synonymous with a certain kind of film and the heroic archetype is now buried deep in movie lore. If the artist is not to lose much of his ancient purpose he may have to plunder the popular arts to recover the imagery which is his rightful inheritance.' — Richard Hamilton, 'For the Finest Art, Try Pop', 1961

'There was a little alley in San Francisco back of the Southern Pacific station at Third and Townsend in redbrick of drowsy lazy afternoons with everybody at work in offices in the air you feel the impending rush of their commuter frenzy as soon they'll be charging en masse from Market and Sansome buildings on foot and in buses … not even enough time to be disdainful, they've got to catch 130, 132, 134, 136 all the way up to 146 till the time of evening supper in homes of the railroad earth when high in the sky the magic stars ride above the following hotshot freight trains.' — Jack Kerouac, 'The Railroad Earth', 1960

Smithson's description of the entropic process of the boy and the sandpit bears an interesting relationship to Pollock's drip paintings. The sandpit, of course, is spread along the horizontal, and in this it mirrors Pollock's canvases as they were being painted. Its contents are also black and white, Pollock's 'primary' colours. More than this, there is the content of the pit, which reminds us of the sand paintings made by Native American artists, which were so admired by Pollock and others at the time. Both areas have also become 'arenas', if we consider critic Harold Rosenberg's view that Pollock's paintings are less pictures than events. What separates them, then, Pollock's achievement, is that his paintings have not become the entropic grey which we might expect; they have retained movement without being destroyed by it. Is this what was meant when he snapped back after the <u>Time</u> magazine article, 'No chaos, damn it'?

'A news report of March 2, 1950, reported the five-hour flight of a jet Vampire from coast to coast. When the pilot climbed out, he said only that "It was rather boring". For the satiated, both sex and speed are pretty boring until the element of danger and even death is introduced. Sensation and sadism are near twins. And for those for whom the sex act has come to seem mechanical and merely the meeting and manipulation of body parts, there often remains a hunger which can be called metaphysical but which is not recognised as such, and which seeks satisfaction in physical danger, or sometimes in torture, suicide, or murder.' — Marshall McLuhan, <u>The Mechanical Bride: Folklore of Industrial Man,</u> 1951

Jackson Pollock was killed in a car accident in 1956, the year after James Dean died in his Porsche. Warhol was fascinated by both accidents, and the car crash series which he began in 1962 must surely be viewed with this in mind. It was at this time that Warhol would also seek out Ruth Kligman, Pollock's mistress and the 'death car girl', in order that they might hang out around the art world together. Years later when Kligman published her account of her time with Pollock, Warhol even considered making it into a movie; Jack Nicholson would have played the doomed artist.

El Lazar Lissitzky
<u>Composition No. 9</u> c.1920
Watercolour and gouache over pencil
18 x 24cm
Private collection.
Courtesy Julian Barran Ltd., London

'You all remember,' said the Controller, in his strong deep voice, 'you all remember, I suppose, that beautiful and inspired saying of Our Ford's: History is bunk. History,' he repeated slowly, 'is bunk.'
— Aldous Huxley, <u>Brave New World</u>, 1932

'You know, one pebble moving one foot in two million years is enough action to keep me really excited.' — Robert Smithson

'The narrative historian always has the privilege of deciding that continuity cuts better into certain lengths than into others. He never is required to defend his cut, because history cuts anywhere with equal ease, and a good story can begin anywhere the teller chooses.' — George Kubler, <u>The Shape of Time,</u> 1962 End

Alfons Schilling in his studio
Rue de la Glacière, Paris 1962

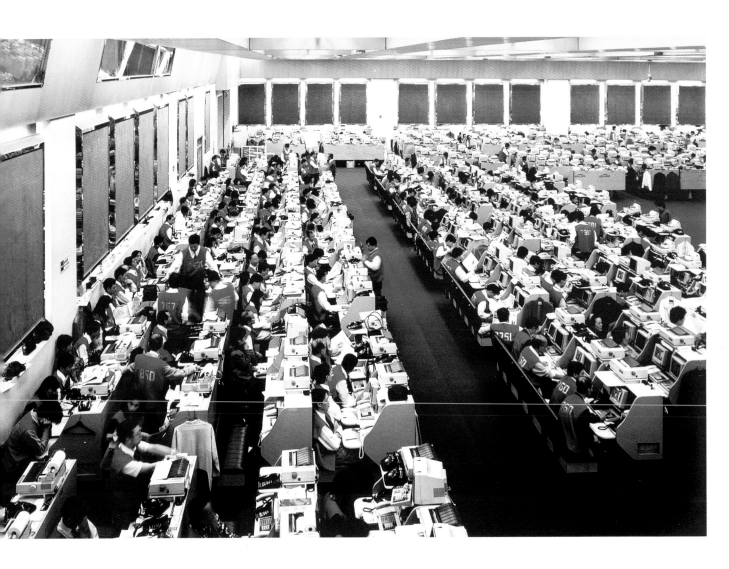

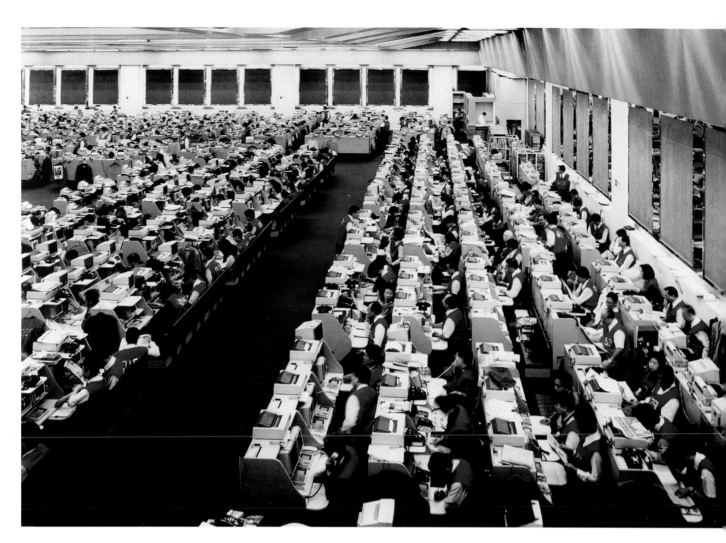

Andreas Gursky
<u>Hong Kong Stock Exchange</u> 1994
C-print
Diptych: each 180 x 250cm
Saatchi collection, London

RA Bertelli
Continuous Profile of Mussolini *1933*
34 x 28cm
Terracotta with black glaze
Collection Imperial War Museum, London

Susan George
Fast Castes

When I was growing up in the United States there
was a comedy team on the radio called Bob and Ray.
They had the same sense of the absurd as the later
Monty Pythons in England. One of their sketches began
like this: 'A … warm … welcome … to … the …
annual … meeting … of … the … Slow … Talkers …
of … America', and so on. Try talking that slowly for
any length of time and you'll reduce your audience,
as Bob and Ray did, to helpless laughter. Ifltalklike
thisyou'llhaveahardtimeunderstandingespeciallyifyo
u'renotanativeEnglishspeakerandyou'llthinkI'mrude.

What I'm trying to say is that we have a natural
sense of appropriate speeds in human communication
and outside those parameters the reaction is likely
to be one of hilarity or irritation. The human body
too has its proper speed limits — Tachycardia or
accelerated heartbeat is bad news and cancer is
characterised by too rapid cell division. Natural
processes cannot be hurried and the natural world
relies on appropriate spans of time to absorb our
wastes among other things. If we accelerate the
speed with which we discharge them, it is at our
peril (for example, carbon dioxide). And thank
heaven, literally, for the moon. If it weren't there
supplying the gravity to slow down the earth's
rotation, our days would last only about four hours,
with constant gale-force winds. Such a rate of
rotation would be much too rapid to support
advanced forms of life. Nature seems to know what
it's doing in the velocity department and clearly
doesn't work on the principle that faster is better.
 So it is perhaps somewhat mysterious
that society — not just ours, but all societies, at
least Indo-European ones — appears to work on a
completely different basis from nature and to have
accorded the greatest prestige, the greatest wealth,
the greatest power and usually all three to their
swiftest components, to those I will call the Fast
Castes. The traditional division of Indo-European
civilisations was based on castes of Agriculturalists,
Warriors and Priests, which can all be analysed in
terms of speed.
 Farmers are, of course, the slowest and
the least prestigious everywhere. They are rooted in
a particular place and work with the seasons which
are by definition slow. Watching grass or any other
plant grow is a metaphor for utter boredom. It
makes no difference that none of us could live
without the patience and nurturing capacity of the
peasantry. Peasants are always at the bottom of the

prestige ladder and one is hard pressed to think of any time in history when the food producers were also the rulers for more than a few days or months.

Mid-way in the speed sweepstakes are the warriors, who are certainly more mobile than agriculturalists, although they may still be bound to some degree by the seasons. It's better by far to make war in the summer, as Napoleon learned to his cost in Russia where he was beaten by 'General Winter'. Warriors at least get out of the house part of the year, and they keep moving, since winning wars requires moving faster than your enemy. As Paul Virilio has so often shown, speed is the definitive advantage. Within the warrior caste, the bowmen beat the club-wielders, the horsemen beat the foot-soldiers and the tank and the aeroplane beat them all, just as the electronic battlefield now prevails.

Fastest of all, and first in the hierarchy, are the priests who I would argue are at the top because of their symbolic speed, even if they remain physically in the same spot most of the time. Communication with the gods has to be instantaneous. Part of being divine is having the gift of ubiquity. To be in several places at once is the epitome of speed. Priests call on and interpret these divine beings who can be everywhere, anywhere at once. They often officiate on behalf of a divine ruler, like the Pharaoh who holds the whip to urge on the horses of the sun's chariot and the hook to hold them back. He is defined by his mastery of speed, just as social status for the less exalted is defined by their faster or slower pace.

Tearing Speed
In the same way that too great physical speed could make the earth uninhabitable, excessive social speed could tear society apart. This may be why great organising principles, particularly religions, have served to prevent this. The best known example in the West is Christianity, which obliged all castes, whatever their relative speeds, to live within the same regulating liturgical calendar. This calendar had its long periods of slowness, of waiting, like Advent and Lent; its normal, pedestrian rhythms as in the long period after Pentecost; and its exciting, festive and accelerating movements of Christmas and especially Easter when Death itself is conquered between Friday afternoon and Sunday morning.

In other societies, rhythms of the seasons and religions are used in similar ways to civilise the polity. The modern or post modern world, no longer ruled by religion but by the market and capitalism, provides no such unifying, restraining principle. In rich, industrialised countries, the seasons have virtually disappeared, anything is available at any time. Capitalism has, historically, presented a parallel structure in time to that of Indo-European societies and their castes in space. We find once more a triad of successively different forms of capital: initially agricultural, then industrial and, finally, financial.

First came the domination of agricultural capital with wealth in the hands of landowners. Basically, agricultural capitalists are, speedwise, the same as peasants even though they're richer-rooted, fixed to a single spot, slow. They hang onto their base wealth forever. There is no velocity to their lives or their money. Selling land in many societies would be akin to selling one's mother.

Today, land is depleted, forests are razed,

aquifers are dried up, and this devastation is counted not as the destruction and depletion it is but as income. Environmental, or natural capital is not even dignified by figuring properly in our national accounts or in those of the World Bank's projects. Nature is just there to be used up.

Agricultural capitalists lost out in the nineteenth century to industrial capitalists who can be compared to the warrior caste. They, too, are more mobile, they fight, that is compete, and those who move fastest also win. Their speedy methods like Taylorism and 'Just in Time' procedures have become watchwords of productivity — one must always be light on inventories and keep the goods moving fast through efficient transport and information networks. These capitalists are, of course, more modern than the traditional warrior caste in the sense that they fight in all seasons, not just summer. But industrial capital is also to some degree archaic because it cannot turn a profit unless it stays put somewhere for a while.

Industrial capital can be removed from one place and reinvested in another, but not instantaneously. It, too, is grounded. Marx told us that Money must go via Commodities to make a profit, accumulate and become Money again (M→C→M→ etc.). No such constraints apply to Financial Capital which, like the priests of old, enjoys instantaneous communication with the divine, or in this case, with profit.

More than $1 trillion is now hurtling around the globe daily. It has no roots and almost no connection to the production and distribution of actual goods and services. Probably less than five percent is used for economic purposes other than the sheer manipulation of money. In Marx's formula, we no longer need C (the Commodity phase) for M (Money) to accumulate: we can go straight from M→M→M→ ad infinitum.

Financial capital is pure speed and pure, immaterial profit. It makes instantaneous judgements on the values of national policies. If it doesn't like what it sees, it leaves, at the speed of bytes, leaving catastrophic consequences in its wake. In December 1994, billions of dollars were removed from Mexico in a matter of hours. The peso collapsed, interest rates were put sky high, over a million small businesses failed, unemployment became rampant, widespread hunger and malnutrition have returned, crime rates soared alarmingly and kidnappings for ransom became routine.

It can happen in rich countries too. George Soros made a billion dollars in a couple of days speculating against the British pound. In July 1993 the French Central Bank lost the totality of its foreign currency reserves overnight in a desperate attempt to prop up the franc against the onslaught of speculators. Like a supersonic fighter plane, financial capital can accelerate from zero to Mach 3 in a matter of seconds.

Meanwhile, Third world countries still compete for Foreign Direct Investment, or industrial, medium speed capital. But more and more the World Bank and the International Monetary Fund encourage them to seek to attract Portfolio Equity Funds (PEF), or foreign purchases of local stocks and bonds. PEFs are volatile, hot money; they make your country vulnerable, as Mexico proved. But when your society can attract this Speed Money, it also means you've arrived: you are henceforth proudly termed an 'Emerging Market'.

Christian Nicolas
Eyal Weizman
Random Walk 1998

World Time

What about those who can't keep up with Mach 3 investment funds, the people who get swept away by tornado capitalism? Karl Polanyi explained 50 years ago that the market is incapable of self-regulation, and that left to itself, it has the capacity to destroy society, and will do so.

Understanding this, nineteenth century England undertook reform to mitigate the manifold evils caused by Mach 2 industrial capitalism. Our problem is to find a way to do the same for Mach 3 financial capitalism. This task is made all the more difficult because it must be undertaken internationally. No unifying religion or moral principle is on hand to provide a slow-down mechanism, or sanity and support.

The acceleration of capital from Agricultural to Industrial to Financial capital is also a form of acceleration and has huge consequences in other areas. The speed of depopulation of the countryside, the huge increase in unemployment in Europe, the tide of immigration, the rate at which all countries have been forcibly integrated into the globalised market, the forced march to NAFTA and the World Trade Organisation — all this has contributed to creating a single 'world time', a single world Fast Caste. This Caste exercises what Virilio calls 'dromocratic power' from dromos, race.

The fastest have, throughout history, been the most powerful. If the rest of us can't organise to slow things down, the <u>dromos</u> will well and truly replace the <u>demos</u> and democracy. Absolute speed is absolute power, which is to say the tyranny of world time. End

Christian Nicolas
Eyal Weizman
<u>Random Walk</u> 1998

Christian Nicolas
Eyal Weizman
Random Walk 1998

Christian Nicolas
Eyal Weizman
Random Walk 1998

Robert Smithson
Trailer with Asphalt 1970
Pencil on paper
48.2 x 61cm
Estate of Robert Smithson,
Courtesy John Weber Gallery,
New York

Wolfgang Sachs
Speed Limits

It was the German aristocrat Friedrich von Raumer who, while travelling in England, mailed back home the first eye-witness report on what amounted to a revolution in the history of mobility: the railway between Liverpool and London.

'The fiery dragon in front,' he wrote in 1835, 'snorting, groaning, and roaring, until the twenty cars are fixed to its tail and it moves them, light as a child, over the level tracks at an extreme rate of speed. A path has been broken through mountains, valleys have been raised; the dragon throws sparks and flames into the night of the arched tunnel. But despite all the violence and despite all the roars, a human being turns the monster to his will with the touch of a finger.'

Raumer's account still betrays the excitement and bewilderment he must have felt watching the train running across valleys and mountains powerfully and incessantly, yet without any sweat and fatigue. Comparing the locomotive with the horse, he and his contemporaries were immediately struck by the effortlessness and apparent tirelessness of the railway. After all, horses as well as humans, when moving fast, are threatened by exhaustion and weakness. It is their bodies which set a limit; they become tired, get hurt, need a rest.

Living beings can be fast only in proportion to their organic powers. Not so the railroad. It bursts the bounds of organic nature, appears to race tirelessly over mountains and through valleys, hindered by neither its metabolism nor the landscape. Energy stored in fuel by far outstrips bodily powers, just as rails made of steel remove most of the resistance offered by the countryside. In the Machine Age, neither the body nor the topography any longer define a natural limit for speed. As a consequence, the modern notion that human motion was set on an infinite path toward ever increasing acceleration could take hold in the popular mind. The rush for higher speeds is a cultural fall-out of the steam engine.

Like a projectile, as nineteenth-century perception saw it, the train shoots through space; the passenger, however, sits calmly as forests and villages are flying by outside, blurring into a stream of fuzzy images. What happens outside is of no concern to him. For the traveller, the space between departure and destination fades into a mere distance to be covered as quickly as possible. The railroad fostered enthusiasm because it brought

distant goals within easy reach; it established in people's minds a map of accessibility which lay over and above that of the muscle-powered world.

In 1843, the German poet Heinrich Heine captured that new experience in his famous remark: 'I feel the mountains and forests of all countries advancing towards Paris. Already, I smell the scent of German lime-trees; the North-Sea breaks on my doorstep.' Thus, he put in a nutshell a sensation of giddiness which was never to leave successive generations up until today; speed makes distant places rush towards you. It abolishes distance and finally annihilates space.

In effect, a new layer of reality, a new perceptual space emerged with the railroad. Consider the famous painting <u>Rain, Steam and Speed — the Great Western Railway</u> of JMW Turner. The railway engine comes toward the viewer like an iron projectile cutting through space. But the surrounding landscape has lost all contours, evaporated into cloudy spots, vanished into flurries of brownish colour. Just the carriers of movement stick conspicuously out: the rails, the locomotive, and a bridge. Only what serves to overcome distance appears to deserve figurative reality.

In fact, the painting depicts two different orders of space, the static one of the fading landscape and the dynamic one of rails and engines, designed to overcome the first. It suggests what indeed happened with the arrival of the railroad: the speed of engines supplanted the speed of bodies, a vehicular space gradually settled upon the natural space.

This was a radical break which inaugurated the age of acceleration. Between Caesar and Napoleon there had not been much progress in speed. Only from the very moment the fossil reserves deep down under the surface of the earth were tapped in order to obtain fuel for the propulsion of vehicles have the gates to the new age been thrown open.

The combustion engine allowed the transformation of the earth's treasures into vehicle speed. In subsequent decades, innumerable railways, automobiles and airplanes along with huge infrastructures of rails, highways and airports have been lined up against the resistance offered by time and space.

While in the natural space, movement is constrained by fixed duration and fixed distance, in the vehicular space duration and distance turn into variables which can be manipulated. In that sense, the mission of successive armies of transport technologies has been nothing else than the reduction and gradual abolition of duration and distance. However, it was the mobilisation of carbon, iron and then oil which made the mobilisation of time and space possible.

A Waste of Time

For the modern mind, as the philosopher Gunter Anders once suggested in ironic allusion to Kant's 'forms of apperception', space and time are the basic forms of hindrance. Anything that is away is too far-away. The fact that places are separated by distances is seen as a bother. And anything that lasts, lasts simply too long. The fact that activities require time is seen as a waste. As a consequence, a continuous battle is waged against the constraints of space and time; acceleration is therefore the imperative which rules technological innovation as well as the little gestures of everyday life.

However, any social system can be

Opposite page
Los Angeles Freeway,
1998

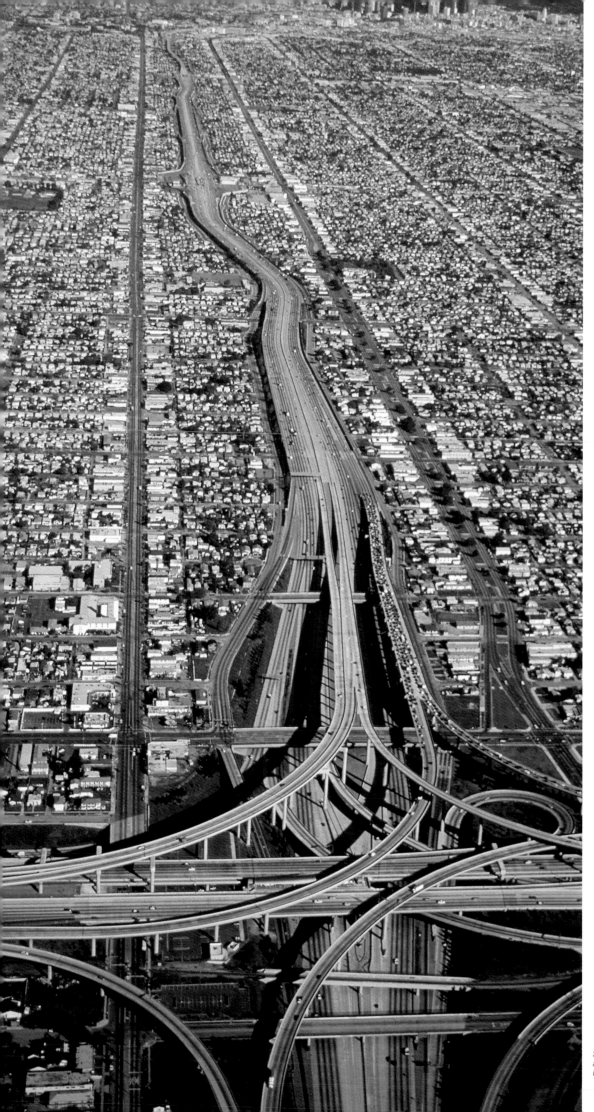

likened to a body which is sustained by a metabolism that makes it dependent on the environment. No living body can exist without consumption of nature and the elimination of residues. Neither a body nor a social system is isolated from nature; both are linked into the biosphere and the geosphere.

Modern society, as everybody knows, weighs very heavily on nature; its metabolism has reached a volume and a velocity which threatens to throw into disorder the very ecosystems it depends upon. In that secular predicament, what matters is less the fact that nature is utilised, but how much is used in what way and — above all — at what speed. Generally speaking, the ecological crisis can be read as a clash of different time scales; the time scale of modernity collides with the time scale which governs life and the earth.

Consider, for instance, a rather simple example of the depletion of non-renewable resources. Every year, the industrial system burns as much fossil fuel as the earth has stored up in a period of nearly a million years. Within a second, in terms of geological time, the planet's reserves are about to vanish in the fireworks of the industrial age.

It is obvious that the rate of exploitation of non-renewable resources is infinitely faster than the processes of sedimentation and melting in the earth's crust. Industrial time is squarely at odds with geological time. It is probably not exaggerated to say that the time gained through fuel-driven acceleration is in reality time transferred from the time stock accumulated in fossil reserves to the engines of our vehicles.

Global warming is another example. The transport of carbon dioxide (CO_2) from the surface of the earth up into the atmosphere and back is part of the global carbon cycle. Under natural conditions, CO_2 is absorbed through respiration and decomposition. But with the additional production of carbon dioxide through the burning of fossil fuels, the absorption capacity is overstressed. Too much CO_2 remains in the atmosphere, threatening warming on a global scale. In other words, the faster speed of industrial emissions outstrips the slower speed of assimilation.

Should the greenhouse effect occur, nature will become a further victim of acceleration. For instance, certain types of trees along the US-Canadian border — though they had slowly migrated for millennia as they followed the shifting temperature zones after the most recent ice-age — will be outrun by the speed of global warming. While the trees are capable of moving at a speed of about a half kilometre a year, a rise in atmospheric temperature of 1–2 degrees within 30 years would require them to run at a speed of 5 km a year in order to follow the advancing climatic zone. Not having enough time for adaptation, they will perish. Out-distanced, exhausted and finally defeated, they are condemned to become victims in the unequal race between industrial and biological time.

The collision between industrial and biological time is most tangible in animal raising and in plant cultivation. It is often the same story over and over again: the natural rhythms of growth and maturation are considered much too slow by the industrial (and post-industrial) mind.

Enormous resources and great ingenuity are brought to bear against the time inherent to organic beings in order to squeeze out more output in shorter periods. Cows and chickens or rice and

wheat are selected, bred, chemically treated, and genetically modified in order to accelerate their yield.

However, the imposition of industrial time on natural rhythms cannot be achieved without a staggering price. Animals are kept in appalling conditions, disease spreads, pollution advances, soils degenerate, the diversity of species is narrowed down, and evolution is not given enough time to adapt. A host of ecological problems in the area of agriculture derives from the fact that the rhythms of nature have been taken hostage by the high-speed economy of our time.

These examples are sufficient to suggest that speed is a critical factor in environmental destruction. The speed regime of modern society drives up the rate by which nature is being used as a mine and as a dumping ground. The throughput of energy and materials occurs at a speed that often leaves no breathing space for nature's ability to react to the recurrent attacks.

Natural systems change according to inherent time scales. Processes like growth and decay, formation and erosion, assimilation and regeneration, selection and adaptation, follow rhythms of their own. Pushed along under the fast beat of industrial time, they are driven into turbulence or destabilised. The speed of capital accumulating is at variance with the speed of nature regenerating.

The Abolition of Man

Speed is fascinating because it confers power. The pleasure to feel like a master over time and space — driving a fast car or sending electronic impulses around the globe — is one way in which Descartes' affirmation of man as the master and possessor of nature has been turned into reality.

This power, however, is deeply ambiguous. The writer CS Lewis, in his 1947 essay ominously titled 'The Abolition of Man', called attention to the seamy side of this power. Speaking about the bomb and the radio, he writes man is as much victim as possessor of power, since he is not just its master, but also its target. 'Man's power over Nature turns out to be a power exercised by some men over other men with Nature as its instrument Each new power won by man is a power over man as well.' And that power is wielded in two directions. On the one hand, each generation exercises power over the following generations, conditioning the shape of future lives, and on the other, the possessors of power will exert their influence on those who don't have it, conditioning the shape of present lives. Power always throws up questions of justice with respect to present as well as to future generations.

Without doubt, the power gained through speed today will most likely leave less power for the generations to come. For it is the generations of the twentieth century who corner a great deal of the resources for power that might be indispensable for steering the boat of mankind through the rapids of the next centuries. The excitement about speed tends to lessen future chances of leading flourishing, let alone high-powered, lives.

What is true with regard to future generations also holds with regard to present generations. The power over nature amassed by the high-speed population of the globe forecloses opportunities for a large majority of their contemporaries. After all, just about 8 percent of the world population have a car at their disposal and presently only around 3 percent have access to a personal computer.

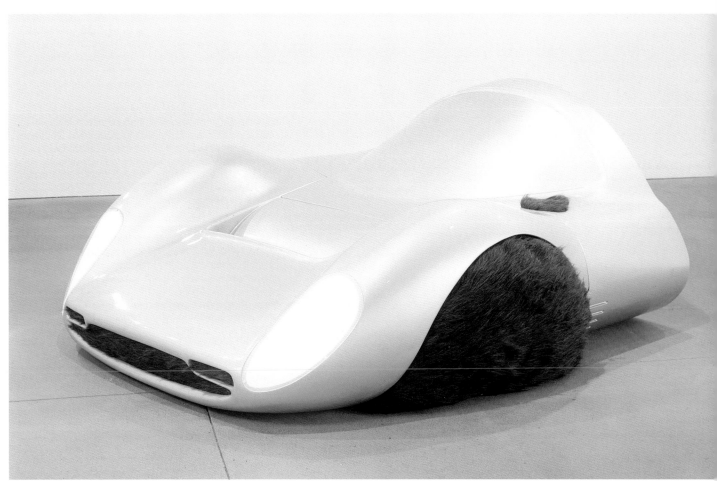

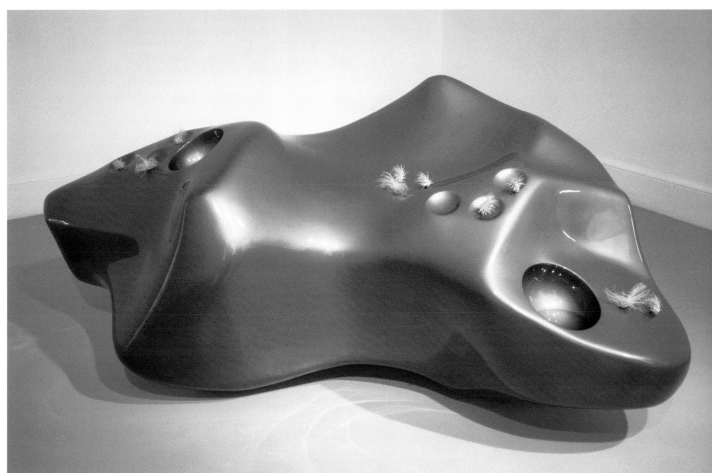

A tiny, privileged fraction enjoys a level of speed which contributes to depriving most of the world's people of their fair share of the world's resources. The conclusion is inevitable: Whatever virtues justice might require in the world of today, the search for selective slowness surely figures among them.

From this point of view, the victory against distance and duration carries a heavy cost. Speed does not come gratuitously. Obviously enough, the mobilisation of space and time requires the mobilisation of nature. Fuels and vehicles, roads and runways, electricity and electronic equipment, satellites and relay stations, call for a gigantic flow of energy and materials.

On the one side, the earth is cut open to obtain resources like oil, gas, carbon, iron, zinc, magnesium, silicon, bauxite, while on the other it is used as a refuse dump where polluted waters, broken rocks, oil spills, toxic substances and greenhouse gases are left behind.

Certainly, this throughput can be reduced through technologies and innovative design strategies which aim at minimising the use of nature at each step along this cycle. But gains in eco-efficiency will never cancel out the basic law which governs the physics of speed: To beat friction and air resistance requires a disproportionately growing amount of energy.

An average car, for example, which consumes 5 litres of petrol at a speed of 80 km/h, will not just need 10 litres when it runs up to 160 km/h, but 20 litres. The high-speed French TGV train and the German ICE consume not fifty-percent but one-hundred-percent more energy when they jump from 200 to 300 km/h. Generally speaking, the more speed outdoes natural time scales, the more environmental resources — at a rather exponential rate — have to be expended.

The Eco-costs of Cyberspace

Some hope that, with the advent of electronic communication, the era of resource-heavy speed has been surpassed. Indeed, quite a few champions of the information society proclaim that electronic impulses, travelling at the speed of light, will finally square the circle: Simultaneity and ubiquity can be achieved without any cost to nature.

They are, more likely than not, mistaken. To be sure, the data highway can be travelled without noise and exhaust fumes, but the electronic networks require quite a lot of equipment. Preliminary results of a study undertaken by the Wuppertal Institute on the resources used by desktop computers show that electronic equipment is environmentally much more expensive than usually assumed.

What counts is not the electricity used, as one would expect at first glance, but the amount of nature to be moved for the production of the hardware. In particular, numerous components require the use of an array of high-grade minerals which can only be obtained through major mining operations and energy-intensive transformation processes.

As it turns out, no less than 15–19 tons of energy and materials — calculated over the entire life-cycle — are consumed by the fabrication of one computer. Comparing that figure to the one of an average car, whose production requires about 25 tons, reveals that the ecological optimism which surrounds the online future is misplaced. On the contrary, there is no reason to believe that mass computerisation will weigh drastically less heavily on nature than mass motorisation.

Silicon Wafer 1998

Losing Time

Looking back into the history of transport and telecommunication one remains uncertain as to whether the Herculean battle against the shackles of time and space was really worth the noble effort. True, nothing is more frustrating than waiting in the slow line, but is faster always better? Does more acceleration make our lives richer?

There is obviously no straightforward answer to this kind of question, but it would be a possible point of departure to wonder why it is that despite the ever expanding number of time-saving machines we feel more pressured and driven by the lack of time than ever before. The automobile can serve as a case in point. Right from the beginning, it had been hailed as the ultimate time saver, marvellously shortening the time to reach a desired destination. What has happened to that promise?

Indeed, contrary to popular belief car drivers do not spend less time in transit than non-drivers. Nor are drivers more frequently on the move: They leave the house slightly less often than non-drivers.

Where has the time gained been lost? Those who buy a car don't take a deep breath and rejoice in extra hours of leisure. They travel to more distant destinations. The powers of speed are converted not in less time on the road but in more kilometres travelled. The time gained is reinvested into longer distances. And as time goes by, the spatial distribution of places changes and long distances become the norm. People still go to school, to work, to the cinema, but are obliged to travel longer routes. As a consequence, the average German citizen today travels 15,000 kilometres a year as opposed to only 2,000 kilometres in 1950.

The automobile is not a special case. Across the board, from mobility to communication, from production to entertainment, time saved has been turned into more distance, more output, more appointments, more activities. The hours saved are eaten up by new growth. And, after a while, the expansion of activities generates new pressure for time-saving devices — starting the cycle all over again. Time gains offer only transitory relief, because they encourage further growth of all kinds. Acceleration is therefore the surest way to the next congestion.

Harried Classes

As acceleration drives growth and growth in turn drives acceleration, speed permeates society. Speed impulses have an epidemic effect; they spread across all social worlds and into the individual sphere. Under the beat of acceleration, social and individual time scales begin to tremble, just as industrial time collides with biophysical times on the macro level.

All social worlds, particular situations and individuals have a time of their own. Different rhythms and tempi coexist in any society.

The spread of speed unsettles these time scales. Children have to hurry up. Students are expected to learn faster. No breaks are allowed during work. Sickness has to be suppressed until the time clock runs out. Even orchestras are supposed to condense their performance.

Most conspicuously, the gap between the so-called productive sectors on the one side and the reproductive sectors on the other widens. The times inherent to activities like studying and researching, caring and hoping, growing up and growing old, cultivating friendships and doing art,

Mark Edelman Boren
Budgie stuffed with JG Ballard's 'Crash' 1991
Mixed media (bird, book, wood)
33 x 21 x 13cm
Collection Mark Edelman Boren

Ed Ruscha
Standard Gas Station (Study) 1963
Tempera and ink on paper
28 x 45.7cm
Courtesy Anthony d'Offay Gallery, London

Wolfgang Sachs
Speed Limits
Continued

1 Wolfgang Sachs,
Reinhard Loske, Manfred
Linz, et alia, <u>Greening the
North — A Post-Indrustrial
Blueprint for Ecology and
Equity,</u> (London: Zed Books,
1997).

are at odds with the speed of the economy.
Acceleration thus enhances and undermines the
good life at the same time.

On the level of personal experience,
the shady side of acceleration makes itself felt. If
pursued thoroughly enough, acceleration will cancel
itself out. One arrives faster and faster at places
where one stays for ever shorter periods of time.
With all the effort concentrated on quick arrival and
departure, we are tempted to devalue the stay. The
attention devoted to moving reduces the attention
devoted to staying.

The more people are on the move, the
more difficult it becomes to meet them. Great
efforts at scheduling and synchronisation come in
the wake of increased circulation. Especially for
the harried classes in society, acceleration beyond
a certain threshold generates counter-productive
effects which undermine the very goal to be
achieved. The goal — coming together — is
threatened with being overwhelmed by the means
of acceleration; so whoever wishes to protect that
goal, will have to opt for selective slowness.

Slow Down
In the nineteenth century, as society still was slow
paced and settled, it was only natural that speed
and acceleration appeared as the promise
of a bright future. At the end of the twentieth
century, however, as society has become restless
and high speed, utopia changes its colour.

Desires are cropping up which define
themselves in contrast to the dominating model
of time. Where hustling mobility rules, a taste for
slowness grows. Who hasn't dreamed of quitting
the 'rat race'?

Where acceleration is the everyday norm,
slowness becomes a non-conformist adventure.
Gradually there will come a change in what had
long been taken to be the logic of progress: that
improvement always means reducing the resistance
of duration and distance.

The suspicion is growing that it is unlikely
that a society which always moves in the fast lane
can ever be environmentally or even socially
sustainable. Perhaps progress could thus also
imply deliberately leaving the resistance of time
and space unchanged, or even increasing it?
Such a change would prove that our society has
outgrown the compulsion to carry the nineteenth-
century world of desires into the twenty first century.

In our recent study from the Wuppertal
Institute, <u>Greening the North,</u>[1] we have called
attention to the need to consider a reduction in
speed levels and traffic if one wants to move
toward a sustainable future. Given the fact that
peak levels of speed consume a disproportionate
amount of energy, we suggest that cars and trains
which are deliberately designed for a lower top
speed. More specifically, we envisage a moderately
motorised automobile fleet where no car can go
faster than 120 km/h. As materials, weight, comfort
and design would follow this criteria of construction,
a new generation of 'gentle cars' would be in
the offing.

A similar logic holds for trains. We
propose to design fast trains for speeds no
higher than 200 km/h, a limit beyond which the
disadvantages of speed accumulate much faster
than its advantages. Reduced speed levels for
physical transport could be an example of a politics
of selective slowness, which is born out of an
appreciation for a plurality of social times and

aims at a lean consumption of resources.

The twenty-first-century utopia of living
with elegance inside limits finds its technical
expression in the design of moderately motorised
engines. Above all, well-measured speeds for
physical transport are the condition for a
sustainable information society.

True, electronic transmission will some-
times become a substitute for physical transport,
but the high-flying hopes that online communication
will eventually solve the transportation problem are
probably illusions. One is well advised to expect
ambivalent effects.

As the history of the telephone
demonstrates, technical communication becomes a
substitute for traffic on the one hand, but stimulates
new traffic resulting from the extended network of
contacts on the other.

It will not be different with the telematic
infrastructure; both effects, substitution and
expansion, are to be expected. The latter, however,
will wildly outrun the former, as long as high speed
remains an unquestioned dogma. It can be taken
for granted that electronic interactions in real time
across the globe will, on balance, sooner or later
lead to an explosion in physical traffic as closer
electronic contacts extend the radius of action
and evoke the desire to meet face to face. In
short, without the deliberate design of a plurality
of time scales, the online society will turn into a
traffic nightmare.

Slow, it turns out, is not just beautiful,
but often also reasonable. Even we as users of the
Internet would be well advised to join an association
which has been recently founded in Austria,
the Association for the Deceleration of Time. End

Vija Celmins
<u>Untitled (Large Desert)</u> 1974–75
Graphite on acrylic ground on paper
48.3 x 36.2cm
Collection The Chase Manhattan Bank, New York

Caesium atomic clock 1955

Helga Nowotny
Time – The Longing for the Moment

Time is always also a strategic concept. There is timing in everything, even if the verb 'to time' is not to be found in the German language. In the conflicts between the super-powers, in the international rivalry of firms and nations, in the chronogram of every organisation which has to decide whether it should expand or not, the choice of the 'right' moment is important. Learning to handle one's own reserves of time better in the face of a limited term of life, resisting the pressure of time, presupposes an appreciative openness towards the strategically playful aspect in time. It seems important to me to learn to understand the temporal frameworks and rhythms of the social background, the rules to which timing is subject in each society. Only against the background of speed can slowness be determined and learnt. Only against the background of temporal limitation can the latter be surpassed.

The previous history of the Western linear system of time is closely connected with industrialisation and the brutal adaptation of human labour and life to the machine. The exploitation of the resources of time which had been made scarce led first to painful wear and tear — in the hope of a better future. Today the future has caught up with the present, but time, individually and collectively, has remained limited. New resources of time are in demand. They are opening up through the extension of time in the present and through the availability at all times which technologies make possible. But the latter in their turn demand a temporal availability of human beings. So where is the time to be found?

Time is made by human beings and has to do with the power which they exercise over one another with the aid of strategies of time. Time unites and separates — combatants as well as lovers. As with every form of power, there is a counter-power; every strategy finds its counter-strategy. Time is in everything, as Shinmen Musashi, a famous Japanese warrior, sums up the strategies of his art of war (<u>Go Rin No Sho</u>) in 1645; time is important in dancing and in music, since rhythms exist only when the time is right. But there is also time in all skills, and equally in the void. Time determines the life of the warrior, his rise and decline, his harmonies and discords. In order to be able to think and act strategically, one has to know which time is to be used, and when it is not to be used ... from the small to the big, from the fast to the slow, from the time of the distance to the time

Jan Dibbets
The Shortest Day at the Van Abbemuseum 1970
Coloured photo panel
177 x 171cm
Stedelijk Van Abbemuseum Eindhoven

of the background. Without knowing the time of the background, every strategy becomes uncertain in its outcome. It is a book, incidentally, which became almost compulsory reading for American managers in view of the challenge of Japanese economic power.[1]

The strategic use of time as a central aspect in the emergence of power — and for the purpose of maintaining it — runs throughout the whole of social life, from interpersonal relations to the big institutions and their built-in tendencies to persist.

In the development of societies, the territorial rule which was exercised by means of the spatial concept of 'order' is followed by that which has devoted itself to the dynamised concept of motion, 'progress', progress through acceleration. Acceleration uses time as motion for strategic goals. Deadly in battle, quickness, i.e. being quicker than the others, has been preserved in competition and is being cultivated in increasingly sophisticated form. Economic competition, now spread throughout the world and functioning as a driving force of world economic events, remains ultimately rooted in that development which uses the acceleration of the machines to increase productivity. Laboratory time, which is inherent in the new communication technologies is employed to economic advantage to transfer information to other areas of production and of services, to create additional infrastructures, and for the purpose of continued accelerated scientific and technological innovation. Acceleration facilitates mobility, and mobility promises further mobilisation. Even sport, the institutionalised competition of bodies in aggressive conflicts, prepared in a way united to the media between nations and regions, towns and districts, ultimately appears as an appendage to the extra-somatically accelerated body-machine. In the struggle for, and the cult surrounding, the proverbial tenths of a second, scientifically based training methods are used which are able to take into account the bodily functions of athletes dependent on their biorhythms, as well as the smallest advantages which technological equipment has to offer. A gigantic machinery of innovation has been set in motion here, leading to a powerfully growing branch of industry that ranges from the solitary sport of body-building to the frenzied stages of experimentation by industry in motor racing. In view of this collective culture of speed, from which no nation is exempt, the strategies of slowing down look really pathetic and defensive: cycleways are set up in towns, speed limits introduced on the motorways, and for his novel The Discovery of Slowness the author Sten Nadolny needed a historical figure who, in his strange habits of thought and perception, seemed eerie even to his contemporaries. The braking experiments will undoubtedly be continued and in part even institutionalised — but is not a well-functioning braking device part of every decently constructed machine? Must not everyone who operates a machine know in what circumstances it is to be slowed down? Thus slowness is ultimately cancelled out in the continued acceleration; the latter relativised itself through the former. Social development does not proceed totally in conformity with machines, of course, but the interdependencies are irreversibly aimed at acceleration. The Stone Age reflex of quickness in flight and in battle has developed through social evolution into a scientific and technological civilisation which is continuing to

1 Miyamoto Musaki, Book of Five Rings, (London: Allison & Busby, 1974).

Rodney Graham
School of Velocity 1993
Yamaha disklavier piano, 1443 framed pages of musical score
Scores: each 32.5 x 45.5cm
Private collection, London

accelerate. This is the time of the background which is of central importance for every other temporal strategy to recognise.

Sociologists and anthropologists long ago referred to the symbolic, time-setting and structuring process by means of which 'social time' is created by human beings and between them. For Norbert Elias, a glance back at Galileo's experiments show in vivo, as it were, the departure of the concept of time in physics from the matrix of social time centred on human beings, which was linked with a corresponding change in the concept of nature.[2] For him, the division into a time of physics and a social time is closely connected with the rise of physics and the natural sciences in general, which led to a conceptual dualism. In this respect, scientists have superseded priests in establishing the 'right' moment which signifies rise or decline and is the decisive factor for chaos and order, no matter whether it is derived from the detected correspondence with the happenings of the gods or from the scientifically based investigation of nature and its processes. Elias gives a detailed account of the contents of the novel by an African author, Chinua Achebe, which focuses on a conflict over determining time. It concerns a first-hand report of life in an Ibo village in Eastern Nigeria during the period in which the old way of life was just beginning to change under the influence of colonial power. The focal point of the novel is the high priest who serves the god of six villages, and one of whose most important functions is to proclaim the right moment. This was indicated by the arrival of the new moon, for which the had to be on the look-out and which was to be greeted as a welcome guest. People's business was dependent on the arrival of the new moon, as well as the festivals and the beginning of harvest time with which the New Year was inaugurated. Achebe and Elias sympathetically describe what it meant for people to learn the right moment from an authority integrating their activities, and the way in which knowledge of the secrets of determining time represented a source of the priest's power. They give insight into an early form of the experience of time, and demonstrate how important it was for people to hear the proclamation that the time for the harvest had come. For when, after a dramatic worsening of the conflict with colonial administration, the priest falls silent and does not proclaim harvest time, people begin to starve.

But what does the right moment stand for, and what can it be measured against? The longing for the individual moment can be strategically directed outwards, in order pragmatically to seek knowledge of the 'when' which can be translated into real advantages. It can be the planned or the chance moment, but it is always a question of relating it to human action. Knowing the right moment is useful; determining it confers power and promises control. But the search for the moment can also point inwards, to the unfolding of one's own, temporal self, to the development of an identity repeatedly reassembled from fragments. Then time is made by the flow of time momentarily stopping to let in the unexpected, to break routine, and to be open to the experience of spontaneity and to the 'vicissitudes' of life. Like the playfully and culturally creative transitional space in which the child discovers the transitional object and creates it himself or herself at the same time, a 'time of transition' is discovered and created here. Through the unreal suspension, the

2 Norbert Elias, <u>Über die Zeit</u>, (Frankfurt: Suhrkamp, 1984), pp.91–2.

Quartz clock at Greenwich Observatory 1947

HAVING FROM TIME TO TIME A RELATION TO :

ESCALATED FROM TIME TO TIME

OVERLOADED FROM TIME TO TIME

REVOKED FROM TIME TO TIME

Lawrence Weiner
ESCALATED FROM TIME TO TIME
OVERLOADED FROM TIME TO TIME
REVOKED FROM TIME TO TIME
HAVING FROM TIME TO TIME A RELATION TO
Matt paint
Stedelijk Museum Amsterdam

momentary standstill of a present withdrawn from duration, the time of transition also contributes to the paradox of the real-unreal: for the real becomes real only in a process of reduction and elimination of the possible.[3] In the long run, the moment is not stoppable, it flows back into development. The poetic language of Cacciari, who follows great Hebrew, Christian and Islamic scholasticism, speaks of the nunc instantis, the dimension of a temporary interim period, which in its fullness is so temporary, but also so present, that it can hardly be noticed as an instant of time and yet for this very reason is completely transitory — a dimension of total transitoriness, in which the most temporary instant coincides with the moment that remains and that blows open the continuum. At this moment, which interrupts the flowing of instants, it is possible 'to take to heart' the sparks of hope, and 'to brush history the wrong way'; at this moment it is possible to understand 'how the radical imperfection of the world … is not mere despair on account of the ruins, but is the power which can raise those sparks in things in all their transitoriness. There is the temporary interim period of a Yes which is stronger than catastrophe, that But which unmasks the idolatry of the homogenous and empty continuum.'[4]

But like knowledge that can be a game, playing with the moment also follows rules which can lead from the sphere of the unreal into that of reality. For the psychiatrist DW Winnicott, children discover and invent reality while playing; they play so that they can surprise themselves. In the game, the child discovers the self, which stands separately and differently, but in relation to the reality which it is not. Even for playing, it is central to set, shift and learn to keep to limits. Only because what 'prevails' constantly shifts is insight possible.

Playing time games, shifting limits, trying out 'what prevails' and setting new limits is, as shown above, an essential part of the symbolic power of action between individuals. But the search for the moment goes on, not least in the sciences. Knowledge of the strategic moment seems imperative for practical application, and even Nietzsche suspected that fear of the unpredictable was the ulterior instinct of science. But the search for the moment can be interpreted in another sense: an an inquiry into the first moment, the origin, in which the universe could have arisen and time along with it. The time of physics, which with the advance of the natural sciences separated from the matrix of social time and which in the machine age became the ideologically linear guide rail for progress, to which all other time had to submit in the name of its external, objective reality, is beginning to approach the social conception of time again. Not just because the intensified study of the possible origins of the universe, and particularly of the question of whether it was a unique event from the point of view of physics, can be interpreted as a kind of time game on the part of physicists. Prigogine and Stengers speak of a new coherence which is beginning to emerge between different scientific disciplines, and which is beginning to open up the 'problem of development' in general. The concept of the 'event', for instance, has changed in that it is now the event which accounts for the difference between past and future, whereas whenever the arrow of time is denied in physics, past and future are regarded as equivalent.[5] What physics has recently discovered is that most, if not all, cyclical phenomena can be 'chaotic' and vice versa. Transitions between the

time of the 'unreproducible' and the time of the 'reproducible' phenomena thus become possible in both directions. For the time of reproducible phenomena, we can therefore speak of a reversal of time, since the flow of events can be reversed, i.e. without the observed events changing the development already completed can be retraced. For chaotic phenomena, however, it is possible to reconstruct their past or to reproduce them. Accordingly, there would also be two kinds of evolution.

At the moment, it is not yet certain whether the explosive phenomena which could have occurred with the big bang belong to the sphere of 'reproducible' or 'unreproducible' time. Prigogine and Stengers suspect that the hypothesis of the uniqueness of the cosmological beginning, according to which there must have been a 'zero time', is to be abandoned. They suggest instead that the universe could have arisen, in a kind of 'gratuitous action', from the fluctuations of the vacuum, from the motions of mass and energy which together amount to zero. In the beginning, there would therefore have been no unique event, but a transition between states of entropy stemming from a fluctuation — a fluctuation not unlike that between chaos and order.

Recently, another physicist, Stephen Hawking, has likewise suggested abandoning the hypotheis of the uniqueness of the big bang. Uniqueness would be the state in which the space-time continuum has shrunk to an infinitely dense, infinitely small point, a state which cannot be described in terms of physics and in which time has no significance. Among other things, he tries to answer the question why at least three arrows of time point from the past into the future, even though the laws of physics do not distinguish between the directions pointing forwards and those pointing backwards: the thermodynamic arrow of time, according to which disorder is increasing; the psychological arrow of time, according to which the past and not the future remains in the memory; and the cosmological arrow, according to which the universe is expanding and not shrinking. Hawking now hopes that a new, yet to be discovered, great, uniform theory (quantum gravitation) could lead to the conclusion that the space-time continuum does not represent a 'line' which begins with the big bang and ends with the great collapse, but is a 'loop' without beginning or end. According to his proposal, the space-time continuum would admittedly be boundless, but not infinite, just as the earth appears boundless to a stroller, even though it is finitely vast. But human beings, and hence knowledge of the universe and time, could only exist in the expanding phase. They represent a tiny fraction of order within an increasingly disorderly universe [6] — enough, however, to lead the social matrix back into nature.

What do such 'time games' on the part of the natural scientists mean for people today, for their desire for proper time, for their longings to escape the constraint of time, and for the ability to structure time differently? How can the complex balancing acts in the daily juxtaposition of times be better accomplished, and how will a society within the accelerated present cope with the current problems of rapid innovation, increasing routine, and growing waste? Having time to play with the moment, being able to plunge into the interim period of transitions, presupposes a recognition of how this time is constituted and how it can be

3 Henri Atlan, *A Tort et à Raison: Intercritique de la science et du mythe*, (Paris: Editionsdu Seuil, 1986(, p. 286.
4 Massimo Cacciari, *Zeit ohne Kronos*, (Klagenfurt: Ritter Verlag, 1986), pp. 138–9.
5 Ilya Prigogine and Isabelle Sprengers, *Entre le temps et l'eternité* (Paris: Fayard, 1988),
6 Stephen Hawking, *A Brief History of Time: From the Big Bang to Black Holes*, (London: Bantham Press, 1988).

created. The 'this way and no other' which scientific knowledge has to offer includes the 'now this way' and 'now the other' as a possibility of being able to intervene and structure things, at least under certain conditions. The glance behind the mask in which time appears in social life makes it possible to stage the game differently as well, starting from a changed sense of time which, like every feeling, is itself the result of history, of experience.

Chronos' fear which caused him to consume his stock, his children, has not been able to hold back the new age with its activities spewing forth innovations. With machines, other motions and speeds entered social life and changed people's perceptive faculty. An even more accelerated, yet more diffuse quality of time, because pressing for constant availability, adheres to today's machines. Machines and people are forming new temporal combinations, just as the relations between people, mediated with one another via machines, are assuming a different shape. The social arrow of time also points forwards. The constraints which seem to emanate from time have not been broken, but the game, the team-game, may perhaps be loosening up. The longing for proper time has become publicly communicable, but proper time is made possible only by others. It is up to the children of Chronos to seize the moment which presents itself to them from so many sides. It is not a question of the unique first moment, but of the socially perceptible one. It is necessary to discover and to shape it — as a repeatable moment which fluctuates to and fro between social chaos and social order, between the self of proper time and the time of society.

It will then become apparent whether the children of Chronos have emancipated themselves. End

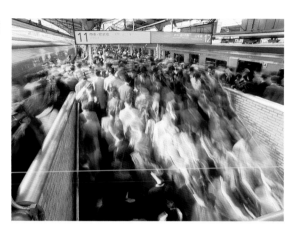

Tokyo Subway 1997

Mark Kingwell
Fast Forward

Speed, according to the physics textbooks we all read in high school, is a function of distance over time: V= d/t. Space divided by time, the three dimensions of extension dissolved into the fourth, mysterious vector of duration. Miles per hour. Feet per second. Bodies rushing through time, into the future. But the indisputable fact that speed measures ground covered during periods of time fails to communicate why we yearn for acceleration, for the sudden enlarging of sensory volume that makes for the feeling of speed. This is a neuro-physiological condition, familiar to most of us, that we might agree to call velocitisation: the adrenal throb of neurons that accompanies large increases in velocity, the electrochemical, brain-fluid high we miss only when it's gone.

That's why coming down a freeway off-ramp finds us an overexcited traffic hazard, a portrait of unwilling deceleration still craving those now impossible seventy miles an hour. Or makes for the night of white-line fever following a daylong drive, the inside of our eyelids relentlessly patterned with oncoming dashes, one after the other, in an insomniac fugue of speed-jockey withdrawal. It is this sensation of speed that we desire, the impressionable meat inside our skulls lit up by that increase in sensory information. We want to be velocitised.

Speed is a drug, and not just in the old-time hepcat high of Dexedrine or bennies, those ingested, on-the-road amphetamines; or even in the newer, hi-tech crystal meth to be found, probably, in some corner of a schoolyard near you. The experience of speed itself releases into the electrochemical soup of our heads a cascade of naturally occurring drugs, not the least of which are epinephrine and norepinephrine, the hormones that course through the brain in the bone-melting, stomach-clenching high of sexual attraction.

I have flown perhaps five or six hundred miles an hour while travelling in a commercial airliner. But the now banal insight about this now banal experience is that ... there is no speed here. A slight pressing into my seat on take-off, insulated from the engine's roar and cloaked in the unreality of carpeting and suit bags and laptops; a brief, fierce application of brakes and a reversal of engines on landing, especially if the airport is old and the runways are short. But otherwise, obviously, nothing. A sense of floating — music in my ears, a drink in my hand, peanut salt on my fingers, and not much in my head. A toboggan ride is faster, and more thrilling.

It would be different in a real plane. I grew up in an air force family. My father, a navigator, pounded around the skies of the Maritimes in big four-prop patrol planes called Arguses, which, like their hundred-eyed namesake in Greek mythology, were ever-vigilant, searching for the conning towers of Soviet submarines or suspicious Grand Banks out of Baltic ports. The base where we lived wasn't home to any really fast planes, but they came through every now and then, hulking F-101s and insectoid F-5s slung with weaponry and wickedly slicked back from their forejutting needlepoints. Top speed: Mach 1.72. We looked at them with awe, the fast planes, observing their promise of barriers broken and limits overcome, the transcendental potential glowing on the matte-painted panels as visibly as the Day-Glo NO STEP and AIR INTAKE warnings. They said: speed transforms, speed kills, speed will make you free. I hung pictures of these jets around my room, glued together miniature simulacra of them, and dreamed of speed, of velocitisation.

I start to read Milan Kundera's novel Slowness one snowy Sunday afternoon. I do it with the television on, a Bulls-Rockets game bounding away in the background. 'A picture-perfect fast break,' Isiah Thomas says to Bob Costas. Like many people, I often read while watching television. I'm not especially proud of this habit, but somehow I'm not appropriately ashamed of it either. Like most of us, I am also capable of simultaneously listening to music, carrying on a conversation, and eating — all while driving fifteen miles above the speed limit, scanning the horizon for signs of authority. Am I the proud owner of a parallel-processing new brain? Could I go even faster with smart drugs?[1]

I have my laptop open to take notes, so I won't have to mark up Kundera's text. The laptop is a PowerBook 5300/100; it runs a 100-megahertz PowerPC 603e chip. This machine was considered pretty fast when I bought it eighteen months ago — not scary fast, just high-end quick. But now it feels slow, because I know there are so many faster machines out there, working at speeds closer to parallel. In fact, my 5300 has been placed in the 'discontinued archive' by the Macintosh product developers, destined for quick-time oblivion in the big boneyard of machine death.

'Speed is the form of ecstasy the technical revolution has bestowed on man,' writes Kundera on his book's second page. He is decrying the false 'ecstatic' speed of the man in a machine — the artificial annihilation of time — as compared with the bodily speed of the runner. The man behind the wheel feels nothing but a mindless, futureless impatience, a desire to go faster that exists only in the present, obliterating all other modalities of temporality in a literal ek-statis. The running man, by contrast, feels the many past, present, and future costs of speed, the burn in his lungs, the fatigue in his legs. Unlike the driver, the runner must resist the constant urge to quit, to slow down and rest. He must play mind games with himself, set intermediate goals, and then set new ones, knowing that eventually he will reach a point where the pain slips away, a fragile, short-lived euphoria of pure human speed.

I look up from Kundera's novel. Whatever the state of their lungs or feet, the Rockets and Bulls are in the dying moments of the fourth quarter and time is now being measured in tenths of a second,

1 Smart drugs have been with us for thousands of years, in the form of caffeine and nicotine, stimulants we use to push our consciousness every day. Who among us is unaware at any given moment, of exactly where he lies on the curve of his daily caffeine regime? Americans spend well over $10 billion on coffee, tea, and their accoutrements every year.

a precise charting that has the irritating effect of slowing it to a stutter. On an inbounds play the ten young giants dash around the court, squeaking and grunting, even as no time at all passes on the game clock. The player with the ball, suspended in this artificial absence of duration, can't find an opening — he can't make time start again — and another time-out is finally called. The last three minutes of the game take twenty-five minutes to play.

'There is a secret bond between slowness and memory, between speed and forgetting,' Kundera says, introducing a figure who captures something essential about the politics of speed. In a world forever overseen by television cameras, a world of instant forgetting, we witness the triumph of a particular character, the dancer. The dancer is that person who, through some expansive moral gesture witnessed by a TV crew, succeeds in putting his rival in an untenable position. The genius of the dancer is knowing when to make bold, skipping maneuvers that seize the political high ground. What is crucial is that the dancer creates an image that instantly defines his opponent; a recent example of the dancer's art is Noel Godin's assault on Bill Gates with twenty-five cream pies, an image that within hours appeared on millions of television screens around the world, where it will be repeated endlessly. By choosing precisely the right moment to attack, Godin permanently inserted the image of Gates with pie on his face into our culture's image reservoir.

The dancer bears some resemblance to another character who was decisively labelled by a Parisian intellectual not long ago. In an essay called 'Sur la télévision', the sociologist Pierre Bourdieu lambasted the media-age creature he called 'le fast-thinker': the person who grinds out what appears to be intellectual discourse under the glare of the klieg lights. Le fast-thinker is not an intellectual, only the simulation of one; he is adept at the snappy phrase, the blustery and authoritative opinion, and, of course, the unanswerable statistical put-down. In the hurly-burly of talk television, on programmes as disparate as Meet the Press and Jenny Jones, the most successful performer is not the person with the truth but the one with the sharpest tongue and the handiest numbers.

Meanwhile, we sit at home and click nervously from one image to another, gazing at the disembodied heads of our televisual oracles as they flash across the screen. The medium, here, is the message, and the rapid-fire jump cuts seem to define not only our politics but our experience as well.

Alexander the Great and Napoleon moved through their respective words of overweening ambition and conquest at precisely the same speed. Top velocity for them, or anyone, was the gallop of a horse.

Machines change everything. Between December 18, 1898, when Comte Gaston de Chasseloup-Laubat set the first land-speed record in an automobile, his 36-horsepower Jeantaud achieving a top speed of 39.24 miles per hour on an open road near Achères, France, and October 15, 1997, when Richard Noble's ThrustSSC jet car broke the sound barrier in a car traveling 763.035 miles per hour (Mach 1.01) in the Nevada desert, the arc of human speed has bent its curve more and more steeply. Millennia of steady-state velocity have passed, and now in this crazy century of upthrust records limits are set and shattered in days, hours, even minutes. Chasseloup-Laubat held his record for less than two months, his Belgian

archrival Camille Jenatzy taking it from him in January of 1899 by hitting 49.92 miles per hour. The Frenchman managed, with some elementary streamlining, to respond by getting his car up to a respectable 57.6 miles per hour. But Jenatzy was more obsessed. He designed a new streamlined electric car, the first expressly built to break record, and shot 65.79 miles per hour that April.

The name of this new car? La Jamais Contente. 'Never happy'. Here we have modernity in a nutshell, the same joyful fascination with speed — the same celebration of the sleek beauty of the machine age and its ceaseless imperatives — to be found a decade later in Emilio Filippo Tommaso Marinetti's orginal Futurist Manifesto, published in Le Figaro in 1909. 'Hoorah!' Marinetti wrote of the speedy machines he loved so much, the race cars and biplanes and swift war machines. 'No more contact with the vile earth!' But Marinetti's happy paean to 'dynamism', his love of machine speed, reached its apotheosis, its own terminal velocity, only when he declared himself a fascist another decade later, in 1919. The speed of modern life had found its perfect political complement. Faster things for faster living. Get with the programme! Right now!

The movement of our century can be plotted on a parabolic curve, a violent calculus of progress and quickness and neuronal excitement that is never, finally, happy, because it still has not achieved the pure limit-speed of infinity over zero. The upgrade imperative of the parabola is buried deep in the logic of speed, where machines not only go faster with each generation but also move from generation to generation at a brisker pace. The speed of personal computers, dutifully conforming to Moore's Law, now doubles in eighteen months or less. Technology's genius is that it plots its upgrade ambition on this striving curve, carrying us ever and ever more sharply upward. When it comes to our machines, nobody has to plan obsolescence. There is no military-industrial conspiracy to keep the eternal light bulb out of your hands, as suggested in a famous riff in the middle of Gravity's Rainbow. Obsolescence just happens.

Why? Well, consider gravity's rainbow itself. It is the other parabola dominating our era's span, the ballistic curve first plotted in the sixteenth century, when mathematicians brought forth the scribbles that could help them deliver cannon payloads more accurately. The two curves of speed and ballistics, the true golden arches, have never been far from the heart of war, our miserable keynote.

'Speed', said Sun Tzu, 'is the essence of war.' 'History progresses at the speed of its weapons systems,' adds the French philosopher Paul Virilio. 'War has always been a worksite of movement, a speed-factory.' It took ancient Greek warriors over a decade to reach, and then destroy, a targeted city; we can now do so, from anywhere, in a few minutes. A single nuclear submarine can quickly reduce dozens of distant cities to molten glass and twisted metal. In the 1940s, the speed of naval 'strike power', still the dominant form of military might, was measured in knots: in nautical miles per hour. By the 1960s, when the astronauts of Apollo 10 achieved a record speed of 24,791 miles per hour, it was measured in Machs: thousands of miles per hour. Now operational velocity inches ever closer to light speed itself. Speed's annihilation of time and place means, finally, speedy annihilation of places — and times.

The inner logic of technology is not technical

Opposite
Ed Ruscha
Miracle # 12 1975
Zinc oxides and pastel on Strathmore paper
98.1 x 74.3cm
Courtesy Anthony d'Offay Gallery, London

2 The urgent apocalypticism of neo-Luddites, members of food co-ops, deep ecologists, quasi-unabombers, and other denizens of the environmental fringe is matched only by the ingenuity with which they design their ever-proliferating Web sites.

3 Those who can pay for the privilege, of course, benefit from T1 lines, cable modems, and high-speed fibre-optic connections. And even in the world envisioned by companies such as Lucent Technologies, which recently announced a new fibre-optic cable that will transmit 10 million calls over a signal fibre, it is probable that our data needs (for video, audio, and as yet unheralded marvels) will simply expand to fill the available bandwidth, in much the same way that the volume of traffic quickly grows to exceed the capacities of newly constructed freeways.

but commercial, and within the logic of commerce location is an increasingly meaningless concept. We confront, now, a new topology, a world of instant and direct contact between every point on the globe. The world's business, the totalising globalisation project, takes place at the speed of light, the speed accommodated by fibre-optic cable. Today there are 228,958 miles of such cable on the ocean floor. By the end of the century that number will almost double. The dominant material of our speedy world is not metal but glass: the glass pulled in phone connections, the silicon of chips and processors, the glass of the screen on which I am typing these words. In this silicon world, money flows ever faster, urged on its way by bulk-trading programs and electronic interfaces that replace the too-slow communication of the human voice. A million transactions a minute now pulse through the New York Stock Exchange alone; in 1900, there were fewer than 2,000 trades per minute. The old-style trader, talking into his headset — or, still more primitively, shouting from the trading floor — is being replaced by a man watching the screen of his computer as representations of wealth and poverty, bar graphs and Cartesian plots, fluctuate up and down, wiping out South Korea's economy in hours or plunging Indonesia into international penury with the press of a key.

Everyone says: go faster. Everyone says: upgrade. Everyone says: be more efficient. We all hang on the curve, afraid to fall off. But the curve itself is not just a parabola; it is a paradox. It can never reach its ultimate goal, can only ever approach it more nearly by minute increments, because the end point of this insistent arch does not really exist. We know that Achilles must catch the tortoise in Zeno's famous riddle, but when we try to think about it logically he seems always thwarted, this famously fleet warrior, getting closer to the lumbering tortoise but never reaching him, no matter how quickly he runs.

In 1995, the science-fiction writer Bruce Sterling, whose body resides most of the time in Austin, Texas, posted a message on the Web inviting people to write what he called 'The Handbook of Dead Media', an exercise in 'media forensics' or (varying the metaphor) 'a naturalist's field guide for the communications paleontologist'. The idea was to track the history of the once vibrant but now forgotten, the junk store of silenced communications along the road of obsolescence: the phenakistoscope, the teleharmonium, the stereopticon, the Telefon Hirmondo, the Antikythera Device, and a thousand more gadgets and extensions of human experience that once lived and do so no more.

The point of the Dead Media Project, beyond its surface technoanthropology, is to counter the hype of Net gurus, their tendency to champion nonexistent 'vaporware' in terms otherwise reserved for the Second Coming and to load all technological change into the operating system we might call Progress 2.0. This 'Whig version of technological history', as Sterling calls it, not only generates unspeakable hype but spins off into aggressive, upgrade-or-die evolutionary imperatives — as if we're going somewhere in particular, as if technology really is teleology. Aging techies and watered-down McLuhanites can make a lot of money packaging and selling that brand of fear to the rest of us. But this is a phantom economy.

'We live in the Golden Age of Dead Media,' Sterling writes on his Web site. 'Our entire culture

has been sucked into the black hole of computation, an utterly frenetic process of virtual planned obsolescence. But you know — that process needn't be unexamined or generic. We can examine that process whenever we like, and the frantic pace is entirely our own fault. What's our big hurry anyway?'

The Dead Media Project has a deeper lesson than historical awareness, though. It doesn't simply unsettle the fallacies embedded in techno-rhetoric; it doesn't just hint that the speed of technological 'progress' has far more to do with money, power, markets, and politics than with simple technical efficiency. It also, more importantly, undermines the _essentialism_ of speed, the dangerous and false idea that media themselves have an internal desire to go faster. Media don't crave speed. We do.

Extreme speeds are not available to most of us. They are the preserve of the elite who get to rise above the slow yet frenetic plodding of the urban lifescape. Sitting in traffic these days, watching the dollars count themselves off in the red numerals of the taxi's meter as helicopters take off from distant office buildings, I realise that speed is the ultimate luxury good. Our cities' momentous flow of corpuscular traffic, pumping and squeezing in the arteries (physical and virtual) of our movement, our progress, is more and more sclerotic, slowing with the sludge of its own success. More than 700,000 cars enter Manhattan every day, joining the estimated 176,000 that are already there, along with the delivery trucks that block narrow streets and nearly 12,000 yellow cabs. Traffic crawls along in midtown at seven miles per hour. Mad cabbies honk and speed through the gaps and help maintain the average pedestrian injury rate at about 250 per day. The bicycle couriers are the ones on speed.

The traffic stops, again. The meter in the taxi doesn't. I think: I can run a mile in seven minutes, but I have only a 14.4 modem and operating system 7.5 in my laptop. Am I fast? At what point, I wonder, do I get out and walk?

'Reading', says Virilio, 'implies time for reflection, a slowing-down that destroys the mass's dynamic efficiently.' Like Kundera, we feel we should resist speed by engaging in activities, like reading or gardening or ambling, that are perforce slower. We feel we should make ourselves slow down. Indeed, there is an underground of this resistance in the culture, a theme of sundial slowness set against the overarching digital quickness of life — a theme that grows more obvious, and somehow more oddly frenzied, as we near the socially constructed limit of the millennium.[2]

But notice the paradox. Time for reflection, the indispensable precondition of reading or any other 'slow' activity, is possible only with the prior benefit of speed. Leisure time is a luxury good, too, the flip side of being able to move fast _when you want to_. Those idyllic gardens, so conducive to rest and restoration, are mostly found in rooftop condos or in the leafy confines behind million-dollar brownstones. For most of us, precious moments at the golf course or at a tropical island resort are purchased only at the cost of long, harried hours on the expressway or waiting for connecting flights in Dallas, Texas.

Anyone who believes that the current young generation thinks and works faster than people in some notional, low-tech past hasn't been paying attention. And those who accuse kids today of a generalised attention deficit disorder, a compulsion to whip their heads around like distracted cats at

the profusion of jump-cut images in our world, are also missing something crucial. Certainly there are more images and information now, more advertisements in our lives — three thousand 'marketing messages' a day, according to some estimates — and kids seem to grow up faster, to be faster, than ever before. But it has yet to be proved that our enormous investment in computer technology in recent years has resulted in increased productivity, or that the ability to 'process' hundreds of images and millions of bits of information has anything to do with thinking — with constructing or analysing an argument, with making good decisions — much less knowledge in the strong sense. And the sum total effect of this explosion of velocity is not a feeling of speed but one of boredom; the frustrating truth about the World Wide Web is that it is slow.[3] Worse, it's often slow to no purpose, the seconds and minutes ticking away only to reveal that there is after all nothing of interest on the downloaded page. We are here approaching the metaphysical limits of speed, where the fast becomes the slow, and vice versa. In such moments, the newspaper as delivery system is state of the art.

Media have rates of speed, but not essential ones. Action movies get faster, and more kinetic, all the time — a sharp acceleration of retinal-nerve stimulation from the wide-screen scenes of old epics like Spartacus. But some movies are now, Titanically, longer than ever; and John Woo, perhaps the best action-film director alive, has a fondness for extended slow-motion sequences, protracted exercises in the instant mythologisation of anti-speed, that rival, in sheer unreality, the massed, from every angle replays of a televised professional football game.

In the late Seventies I used to listen to punk-rock singles that made it a point of pride to last no longer than two minutes, while my brother listened to prog-rock double albums with symphonic backing tracks and hour-long running times. The contemporary novel spans the continuum of speed from Elmore Leonard to David Foster Wallace, from Kundera's Slowness (which can be read and pondered in a single evening) to Don DeLillo's Underworld (which, suffice it to say, cannot). Short books sometimes demand many readings, however, and it is often necessary to read long books quickly. Is there more philosophy in John Rawls's A Theory of Justice (weighing in at 607 pages and more than two pounds) than in Donald Hall's poem 'The First Inning' (three pages and as weightless as the parabola of a high fly ball)?

I have a new channel on my television now. It arrived late last year long with the Food Network and the Golf Channel and the History Channel and the Family Channel. (The package is called, amazingly, 'MeTV'.) The new channel is called Speedvision. It is all about motor racing: F-1 cars, NASCAR cars, top fuel cars, funny cars, midget cars, sprint cars, Indy cars, as well as boats and planes. The commercials are dominated by spots for crash videos, those technological snuff films so popular lately, in which fast boast and cars and motorcycles explode off the track or spin into the air, one after the other, amid hails of flames and smoke and flying metal debris.

Here is the secret of Speedvision: It is incredibly boring. There is no real tension, no suspense, because its creators have ignored the ancient narrative techniques that we use to manipulate speed and create drama. The speed-reading infomercials, on another channel, which

New York Skyline

4 Of course, Bailey isn't really the fastest man ever. In 1988 Ben Johnson ran 100 metres in 9.79 seconds at the Olympic Games in Seoul. He was later disqualified after officials discovered that he was using performance-enhancing steroids. Johnson was perversely in tune with the spirit of the time: he was just trying to upgrade his hardware.

5 The horror of the Rwandan genocide was amplified by the speed with which some 800,000 Tutsis and moderate Hutus were slaughtered with old-fashioned, low-tech machetes. If they had been murdered slowly with mortar and sniper fire — proper weapons, civilised weapons — as the Bosnians were, perhaps our shock would not have been so acute.

Alexei Leonov
Study of earth's atmosphere as
seen from Soyuz spacecraft 1975

*play on our fear of being 'overcome' by all the
information that needs to be 'mastered', are scarier.
The Golf Channel, with its whispered commentary
and endless instructional videos, is more exciting.*

*The sensory overload of speed leads
necessarily to saturation, to senselessness, which
is what the Greeks really meant by ekstasis. Not a
singular rapture now but rather a digital version of
the Rapture: the chosen ones carried into
technoheaven, the rest of us left behind. A human
body can tolerate no more than about seven g's of
acceleration, the sort of load shouldered by an F-16
pilot pushing his ride to the limit in a sharp turn or
power climb, a curve. After that, consciousness
comes apart. The pilot blacks out, and the plane,
still carrying his body, his fragile wetware, crashes.*

*The fastest man in the world right now is a
Canadian sprinter named Donovan Bailey. In 1996
Bailey ran 100 metres in 9.84 seconds to set a
world record. How do we know this? Because
we measured it with a clock that tracks time to
the level of one-hundredth of a second, an Omega
or a Finishlynx or a Seiko — a clock that can, in
short, model Zeno's paradox in machine terms,
in increments of time invisible to the naked human
eye. Is Donovan Bailey the fastest man in the world
without that machine? Is anybody? Is a world
record compelling, even intelligible, without the
slow-motion clock that can measure the man's
incremental progress? At the limits of speed, not
even the simple running human is free of the inbuilt
upgrade logic of our machines.*[4]

*But the imperatives of speed, like those of
utility and efficiency more generally, are crazily self-
defeating. Speed's upper limit is found not in the
laws of physics but in those of production: when the
volume of movement, the rush of molecules or bits
or consumer durables, decelerates, slows, and then
stops. When nuclear war is so fast and so efficient
and placeless that it surrenders to the frozen logic
of Mutual Assured Destruction, then we see not
futurism's promise but rather the seized-up engine
of material progress. War now has to be slowed
down, artificially, to make it interesting.*[5]

*Faster and faster can only mean, in the
end, stasis. The logical outcome of efficiency is
uselessness: solving problems has no point but the
ultimate elimination of problem-solving itself. What
is the point of being able to read a page every three
seconds? To read every book ever written? Then
what? Meanwhile, the vehicles of our speed ruin
the planet as fast as we move around it.*

*Speed, we might admit, is our pre-eminent
trope of control and domination. But even as speed
excites us, we are drugged into a narcolepsy of
cheap contentment whose danger we don't even
recognise. The Canadian political scientist and
performance artist Arthur Kroker labels ours 'a
crash culture', one in which we are always speeding
up to a standstill, a spasm of useless speed that
masks the coercion of 'contemporary society as it
undergoes a simultaneous acceleration and terminal
shutdown'. Not Marinetti's pure modern speed
worship anymore but rather a curious postmodern
double movement of velocity and lethargy.*

*For the citizens of a decadent techno-utopia,
boredom, not failure, is the great enemy of human
happiness. And fear of boredom is the heart of the
gentle domination of our new speed-driven regime.
Yet there is no simple equation here, and the
calculus of boredom's vectors and variables is more
complex than we know. It is possible, even easy, to
be bored at five hundred miles an hour. It is also*

Alexandra Exter
<u>*Composition (Genoa)*</u> *1912*
Oil on canvas
115.5 x 86.5cm
*Private collection. Courtesy Julian
Barran Ltd., London*

Charles Demuth
<u>*Incense of a New Church*</u> *1921*
Oil on canvas
66 x 51.1cm
*Columbus Museum of Art, Ohio.
Gift of Ferdinand Howald*

Ivan Illich, Matthias Rieger and Sebastian Trapp
Speed? What Speed?

*We were sitting together at the large living-room
table of Barbara Duden's house over a good pot of
tea, chatting, when a letter from the Netherlands
came in. It was an invitation to a conference of the
Netherlands Design Institute. We read: 'The theme
of the fourth Doors of Perception conference is
speed. By design or not, we now live in a world
dominated by speed — from the TGV to CNN.
Speed defines our products, our environments, our
way of life, and our imaginations.'*
 *Or does it? We looked at each other.
Where was 'speed' to be found by a field biologist,
a musicologist or a philosopher? Our imaginations
stumbled over this dominance. Could it indeed be
as unquestionable as the programme suggested? To
find an answer, we went back into history to distance
ourselves from modern certainties, to see whether
we could find speed outside our speedy society.*

Frederic the Second and the Speed of a Falcon
*In the early morning of February the 18th, 1248 the
people of Parma in northern Italy attacked the
enemy that had besieged them. They burst out of
their town and stormed Victoria, the city that the
hostile army had built and so self-assuredly named.
They knew that the Emperor who had assailed them
and his most important men were not there.*
 *For several months the Parmesians had
observed the everyday-life of their hated enemy and
they knew, therefore, that the right time to attack
was when the Emperor left his camp to hunt with
his falcons. The Parmesians were successful; but
more than that, they not only defeated their enemy,
but spoiled him of nearly everything. They took the
crown that he wore on high feast days, a
marvellously crafted affair studded with diamonds
and 'as big as a pot', as a contemporary recorded.
Furthermore the seal of the King of Sicily fell into
their hands, forcing him to issue several decrees in
order to prevent its abuse by his opponents. The
Carrocio of Cremona, a richly-decorated wagon,
was the most famous trophy. The enemies of the
town of Cremona, which was allied to the Emperor,
could not resist the temptation to take souvenirs;
shortly after the victory there was little of it left but
the wheels.*
 *The only truly unique and irreplaceable
booty of the expedition was not listed in the
chronicles. It was a manuscript, specially prepared
for the king, wrapped in leather and ornamented
with gold and silver, the text embellished with*

possible for an instant to expand to fill the available space of consciousness, to watch a household accident or botched lay-up decelerate into the brain-jamming significance of heroic narrative, a real-time slow-motion sequence à la John Woo. We experience both hasty leisure and deliberate speed, moments that never end and decades that pass in a blink. How fast you move is not the same as how fast you are going.

Where, then, are we going in our fast-forward drive toward the future? Whence this urge, this speedy imperative? Is 'technology' to blame? We might derive some solace from distancing ourselves from the principle of our rapidity, from blaming our machines and repeating the mantra that the medium is the message — but this would be too easy. And it would be a lie. Our machines do not make us forget. Our quick vehicles do not cause our panic, our wretched driveness. The motor of speed, the transcendental impulse, lies buried not in the engine or the microprocessor but within each one of us, in our mortality. Speed was born of death, of both the desire to inflict it with weapons and the desire to transcend it. We are forever dividing more and more space by less and less time, yet we cannot escape time except in the liminal ecstasy of death. We love speed, because it means we can leave our unhappy consciousness in the dust — can for an instant pull apart the Cartesian mind-body confection with these superb machines. That's what the overload of sensory volume and pulsing adrenaline achieves: a minute and trilling breach in the mostly impregnable union of mind and matter. We don't just risk death in speed; we press the limits of our mortality.

The final irony of our speed mania is that death, when we finally get there, may not be a kind of escape velocity at all but instead something like what was imagined by the ancient Greeks, a dull impatient wishing to be elsewhere. Hitting the wall, crashing into the ground, we may dissolve, not into sweet unconsciousness but rather into a bleak waiting room of forever thwarted speed, a shadowy endgame in which nothing ever happens. And even when it arrives after a long, painful illness or years of institutional dullness, death almost always comes too soon. It takes us from the hurly-burly of this quick life and seizes us, suddenly.

The Bastard in Shakespeare's <u>King John</u> says, 'The spirit of the time shall teach me speed.' But while the velocities go up, our mortality remains unchanged. No matter how quickly you move, death drives the fastest car on the highway. In the end, death always does the overtaking. Our desire to escape the vile earth necessarily ends with us buried in it. End

Ivan Illich, Matthias Rieger and Sebastian Trapp
Speed? What Speed?
Continued

1 Kaiser Friedrich der
Zweite, Über die Kunst mit
Vögeln zu jagen.
Kommentiert von Carl A.
Willemsen. 3 Bd. (Frankfurt
a.Main: Insel-Verlag, 1970). A
detailed account of the
history of the book is given
by Dorothea Walz, Das
Falkenbuch Friedrichs II .
Micrologus 2:161–185,
(Brepolis, 1994).
2 Thomas Curtis van
Cleve: The Emperor Frederic
II of Hohenstaufen (Oxford:
1972).
3 Wolfgang
Schivelbusch, Geschichte
der Eisenbahnreise
(München, Wien: 1977).

paintings and miniatures. It was seen for the last time twenty years after the battle of Victoria — it is mentioned in a letter written in 1265 — and was never found again.

It is the book, On the Art of Hunting with Birds, written by the besieger of Parma himself — Frederic the Second, King of Sicily and Jerusalem, and Emperor of the Roman Empire. Because of other, lesser copies, it is still in print today.[1]

Frederic II was a truly remarkable character. Because of his contact with Arabian scholars and his undogmatic thinking — as shown by his interest in philosophy and the natural sciences — the clergy became very much opposed to him. He was excommunicated by Pope Gregory IX as being the personified Antichrist. The biographer of this Pope wrote that 'he [Frederic] turned the title majesty into a hunting-tenancy and, instead of being decorated with arms and laws, became surrounded by dogs and shrieking birds, a hunter instead of an emperor. He traded in the sublime sceptre for the hunting-spear and released the eagle of triumph, setting aside the revenge on his enemies, on hunting birds.'[2]

Only very few could appreciate Frederic's work, which in many respects remains valid to this day. It is remarkable in being based not on narration and what one may call 'ear-witness', but on skilful observation and detailed description of the observed. One of his contemporaries wrote: 'Thanks to his extraordinary ability of mental penetration, which was occupied mainly with the understanding of nature, the Emperor composed an opus on the nature and cultivation of birds with which he proved how deeply he was devoted to penetrating investigation.'

Reading the book one cannot help but be deeply impressed with the extensive knowledge Frederic had compiled, not only on the breeding and training of the falcons he used for hunting, but also on their anatomy and their illnesses. But the scope of the huge book is much greater than that: it covers not only birds of prey, but the life of all different kinds of birds, with detailed insights into their life-cycles, their preferred habitats, their habits including their travels in autumn and winter-time and much, much more. In modern language one would say that he gives a detailed account of the anatomy, behaviour and ecology of birds, including a taxonomy.

In the fourth book of his Opus, Frederic describes the different ways falcons attack a standing crane. He gives his opinion on the reasons for these different tactics:

'Of those falcons one throws against standing cranes, some fly high, others low and others again in medium altitude. [...] Those, who fly high, straight and fast, do so to get faster to the crane which they choose and be able to swoop down on him harder.

'Those who fly in a curve and fast, do so to get the best direction of the wind, if they aren't thrown directly against it.

'Those who fly slow and in a curve do both because of the wind and also to rouse the cranes which they don't dare to attack on the ground. [...]

'Falcons that fly in a moderate altitude and slow do so to rouse the cranes; those who fly in a moderate altitude and fast, do so in order to reach the game as fast as possible, that is, before it flies up and away.'

Perhaps now you begin to get an idea why I talk to you about this old and little known book. After all, this is a conference on speed, not on possible grandfathers of modern natural science, be they ever so fascinating. But Frederic II can serve me as a starting point for the argument that I wish to present here. For this argument it is important that, while he may have lived long ago, he was in many ways a very modern man.

He was modern in not believing what he had not actually witnessed himself. He was modern in his attention to details and in his attempt to understand what he had seen in relation to their setting, the environment in which the observation was made. But in another respect he is very old-fashioned: he never talks about speed. My descriptions of the ways in which falcons approach the game demonstrate that clearly. He does use the words 'slow' and 'fast' to describe the falcons, but that is all. Even when he comes to rating his birds, he is only talking about the different ways to fly to the prey: 'The high flight is the most laudable and praiseworthy one because for those falcons it is easiest to swoop down upon the game. [...] Even if the cranes soar up in the distance, high-flying falcons get to them quick, precisely because they swoop down from great altitude.'

Despite his use of words, Frederic never talks or thinks in terms of speed. He never compares the speed of one falcon with that of another, let alone the speed of a falcon to the speed of its prey.

Today this is very much possible. In school textbooks one can read that the falcon reaches a speed of up to 200km/h, much faster than all the birds he attacks. But this — being faster than other birds — is not the reason why falcons are successful hunters. Frederic, who devoted much of his life to hunting with birds — too much of his life, many would have said — knew why they are. In fact, the idea of seeing the reason for the falcons success in his extraordinary speed could not occur to him. The reasons are two-fold: the first lies in our culture. The concept of 'speed' as we know it is a very recent, a very modern one. The Oxford English Dictionary gives old meanings of speed, which sound strange and alien to us: abundance, success, fortune, lot, assistance, help. Today, if somebody talks about 'speed', we understand it to be the property of a process, mostly a movement in time, that — at least in principle — can be measured by an instrument, by a technical device, and therefore can be compared. This notion of speed — as expressed in units like km/h or rpm — connotates a uniform movement. It is a mechanical speed.

Mechanical speed was invented together with the railroad. Before this people travelled by coach. Not only did they see how strenuous it was for the horses to pull the carriage, but they themselves were shaken up and down so that at the end of the journey animals and passengers alike were exhausted. The movement was a highly irregular one; at every turn, at every obstacle the coach slowed down and after a while the horses tired and became slower.

This irregularity of movement was clearly seen once the railroad was invented. In 1826 an advocate of the railroad described the movement of a horse as 'limping and irregular' and compared it to a locomotive which drives 'uniformly and fast on its rails, not the least constrained by the speed of its movements'. It didn't take long until the perception of travellers changed and the uniform and fast movement of the locomotive was seen as natural, whereas the nature of the animals pulling began to

appear as dangerously chaotic.³

Therefore it is not surprising that as early as 1825 one predicted that 'soon the nervous man will board a wagon pulled by a locomotive and feel much more secure than he did in the time when he travelled in a coach drawn by four horses, all of them differing in strength and speed, being stubborn and uncontrollable and subject to all the weaknesses of flesh'. So the kind of speed that we talk about today — and that we talk about on this conference — came into being more than half a millenium after Frederic's death. He could not talk about speed in the way we do.

The second reason is much more important for me. It lies in the nature of the falcon; in the nature of his prey; and in the nature of nature. To talk about the speed of a falcon is an abstraction, an a priori that, at least for some purposes, can be a meaningful one. But it is also a distraction. It distracts from the way in which falcons actually hunt. Comparing the speed of the falcon and the speed of his prey leads us almost inevitably to the image of a race, with the end being the falcon reaching the other bird, and ultimately, the kill.

But a falcon should — and would — never try to outpace his prey. Frederic — who for living in the middle ages couldn't be distracted by the modern notion of speed — saw that clearly. He knew that there are birds (he gives the example of the bittern) who, if a bird of prey would fly after them, trying to catch them, would throw their excrements towards it. Taking into account how caustic these substances can be, this would be a serious threat that any pursuer would definitely try to avoid.

So Frederic never saw the hunt with birds as being a kind of race. The quotations I gave show that clearly: he always describes the behaviour of the falcon — how it leaves the fist, how it approaches the prey, what it has in mind when choosing a certain route to the crane. He considers where the cranes stand, what they do and which method of attack would be the best for the falcon, the 'most laudable' one, as he puts it. In all this flying, curving and circling, the rousing and gaining altitude, the hesitating and swooping down, in all this, there simply is no place for our notion of speed.

When I say, 'the falcon reaches a speed of up to 200km/h' then I talk only about a very brief moment, a blink of the eye, in which the falcon approaches something that is compatible with our idea of speed — mechanical speed, that is — the moment where he darts down on the other bird, the wings pressed against its body, unable to steer and therefore moving in a straight line. This is the only moment where our idea of speed is actually applicable, and it is only this moment that is addressed in the textbook. A second later — when the claws of the falcon hit the other bird, it tumbles, catches itself, tries to gain altitude —'speed' again is without any real importance, even for the human observer. This also holds true for humans, at least in principle. But technology has prolonged enormously the moments of mechanical speed that we experience. We are used to sitting in a train, taking an aeroplane or driving along a motorway in a car. We are used to the experience of uniform, mechanical speed. So much so, that for us it even makes sense to talk about the 'speed' of a pedestrian, even though he may stop all the time, talk to other people or look at the window of a shop. For an object moving as irregularly as a pedestrian we manage by talking about 'average speed'.

The first passengers of the railroad were
irritated and confused by the uniform movement of
the train, unaccustomed as they were to the
sensation of speed within a machine which ridiculed
their own rhythms. It took quite a while until people
started to get used to places they knew floating by
as a landscape, impressions that are much too
familiar to us to be noteworthy. We — being
transported all the time — are so much used to the
kind of speed machines produce that to us 'speed'
makes perfect sense.

Looking at a falcon high up in the sky or
at a kid romping and roving about in the street, I
doubt very much that this notion of speed, brought
forth by the machines which humans invented, is
the idea one should have in mind when talking
about humans themselves, about ourselves. It
doesn't really matter whether we wish the 'speed of
the human society' to accelerate or to slow down —
as long as we look at humans with speed in mind,
we won't look at humans humanely.

Some remarks about speed from a belly-dance
drummer's point of view
When I prepared for this conference about speed, I
was somewhat at a loss for what to say in front of
people who would have come from all over the
world by car, train, or plane. This event, so I read in
the programme, should give scientists, designers
and philosophers a chance 'to rub their brains'.
After a while, I decided to ask my drum teacher
Mohammed for help. He is a good friend
of mine and an experienced musician. For two
years now, he has worked hard to introduce me to
the art of belly-dance drumming. After the weekly
drum lesson, I told him that I was invited by the
Netherlands Design Institute to speak about speed
in music. I planned to talk there about the
introduction of the concept of speed into society.

I wanted to use the example of the
metronome to demonstrate how speed came into
music. This device was invented in 1812 by the
Dutch technician Nicolaus Winkler, who lived in
Amsterdam, maybe just around the corner from
the place where I speak now. His idea for the little
machine, designed to give the right speed for the
performance of music, was stolen by a German
technician, Nepomuk Maelzel, who patented
Winkler's idea in Paris and London, and
commercialised it in 1816. The metronome is a
technical device that sounds a regular beat at
adjustable speeds dictating to the musician the
beat he has to follow. The mechanism is based
on the principle of the double pendulum, i.e. an
oscillating rod with a weight at each end, the upper
weight being movable along a scale. A clockwork
maintains the motion of the rod and provides the
ticking sound every beginner in music knows so
well. By adjusting the movable weight along the
rod, the pendulum swings, and the ticking can be
made slower or faster. An indication in a musical
score that some note-value is to be performed at
MM (Maelzel's Metronome) = 80, for example,
means that the pendulum oscillates from one side
to the other (and ticks) eighty times per minute, and
the note-value specified with the indication should
be performed at the rate of eighty per minute.

'Very interesting,' Mohammed said, 'But,
what do you think speed could mean in music?
What do those people want to talk about?' Well, I
said, if I have understood them right, they want to
figure out how one can reduce speed in society by
creating new designs for a slower society. I guess

that means something like reducing speed on highways from 120 to 90 kilometres per hour, or music, from 98 beats per minute to 60. I explained to Mohammed that I would try to illustrate the introduction of speed by the example of a discussion in the field of musicology dealing with so-called historical performance practice. This controversy started at the beginning of this century with a renaissance of baroque and classical music. Since then, opinions clash about the interpretation and use of the metronome indications given by the composer. One side in this controversy argues that classical music today is performed too fast. They maintain that this occurs because of the general acceleration of all aspects of modern life since the invention of the railroad. They suggest cutting the indications of the scores by half, from 120 to 60 beats per minute, for example. Let me call them 'slobbies', taking a cue from economists who have created the term for 'slower but better performing people'. Those on the other side insist on performing the music in exactly the tempo indicated in the score; this is the only way to get the 'original' sound.

'Ah,' Mohammed interrupted me, 'I understand: Porsche and Beetle drivers reflecting on music.' One of the first composers who gave metronome indications was Ludwig von Beethoven. He was a friend of Maelzel and supported the introduction of the metronome in Germany. But Beethoven was utterly shocked when he listened to the first performances of his music, following his metronome indications. MM did not work. He decided to change them several times. Finally, he came to the conclusion that the use of measured tempo makes no sense in music, and he was not the only composer to do so. But, I asked, didn't we both use a metronome for my first belly-dance drumming performance? It seemed the best way for me to get the exact speed for the dancer. 'Well,' Mohammed replied, 'at that time you had almost no experience with belly-dancing. Otherwise you would never have agreed to follow a technical device instead of your own certainty of the right, the appropriate, the good way to perform. This certainty arises out of the interaction between the experience of the dancer and your own.'

As you can imagine, I was disturbed by Ali's remarks. I decided not only to continue my two hours of daily practice but I also wanted to figure out how in the history of western music musicians found the right tempo for their performances.

One week later I called Mohammed and invited him for a cup of tea in order to continue our conversation. He was delighted and promised to come with a friend. Her name was Abla. She was a belly-dancer who had worked with Mohammed for a long time. After they arrived I prepared some good tea, served some sweets and we began to chat. Well, Ali, you really set me thinking with your remarks on the metronome and music. I looked into the history of western music because I wanted to figure out how musicians in the past thought about musical tempo. You can hardly imagine my surprise when I found out that until the nineteenth century the musical tempo was always determined by the setting: a special event, a place, a type of work or action. For example, work songs are related to the rhythm of work, the tempo of dance music to the acoustics of the place and, of course, to the mood of the dancers and musicians.

The need for some kind of indication of tempo began to be felt only at the beginning of the seventeenth century. Composers started to use Italian time-words like adagio ('at ease'), allegro ('cheerful') or presto ('quick'). However, these time-words did not refer to a measured time that could be expressed by units per minute. They were at once indications of the mood and spirit or character of the piece. Carl Philip Emanuel Bach wrote in the middle of the eighteenth century in his Versuch, über die wahre Art das Clavier zu spielen: 'The tempo of a piece, which is usually indicated by a variety of familiar Italian terms, is derived from its general mood together with the fastest notes and passages which it includes. Proper attention to these considerations will prevent an Allegro from being hurried and an Adagio from being dragged.'

I then took a look at the writings on dance and, there again, I found that it simply does not make sense to compare the tempi of different kinds of dance. A sarabande is not faster or slower than a minuet or a waltz. It is simply a sarabande and you should perform it as a sarabande has to be performed. They all have their own character and you cannot simply reduce this to an indicated mechanical time.

The first machine to measure musical tempo was invented in 1698, long after the first pendulum clock had been built in France. This machine, called 'Chronomètre', was invented by the French music theorist Etienne Loulie, and was still famous in the eighteenth century. It was very expensive and almost two metres high, and was only used by few musicians, but mainly music theorists and scientists. Even after Winkler had invented his much smaller and easier to handle version, the metronome was not important for most musicians. It was only later, with the commercialisation of the metronome by Maelzel and the support of famous composers like Beethoven, that the metronome became the instrument for measuring musical tempo.

Although the metronome became common at the beginning of the early nineteenth century, other non-technical ways were found to hint at the right tempo. One was the use of the musician's pulse as a measure. This method was mentioned first in the sixteenth century by an Italian monk named Zaccini, who gave a brief description of measuring time with the pulse in his Prattica di Musica. The then famous flautist Johann Joachim Quantz wrote in his Versuch einer Anleitung die Flöte traverse zu spielen the following marvelous sentences: 'One would like to make certain of this: take as a basis the pulse of a cheerful and healthy person of hot-tempered and careless disposition or, if one may be permitted to say so, of a person with a choleric temperament, after lunch, towards evening. Then one will have selected the correct one. A depressed, sad, or cold-blooded and sluggish person might take the tempo of every piece somewhat more briskly than his pulsation.'

But all these methods of measuring tempo were mostly used by music pupils or dilettantes, people who had little experience, like young belly-dance drummers today. These were crutches to get an idea of the appropriate tempo. Quantz, who described the method of pulse measurement, also wrote: 'If one has practiced this for some time, then gradually the mind will become so familiar with the tempi that it will not be necessary to consult the pulse.' And Leopold Mozart, at this very same time, went even a step further. For him, knowing the appropriate tempo from one's experience, without a technical device, was the main qualification for being a musician.

'This is very interesting,' Mohammed said to me with a sly smile. 'Come on, pick up your drum and let's try to reflect on the concept of speed with the help of Abla. Just play a simple rhythm. Abla will dance with you. See if you can get the right tempo with the help of the metronome.' So I adjusted the metronome at 60 minims per minute and started to play. I immediately recognised that something was wrong. Abla moved, but not at ease. She really had difficulties following my drumming. Drum and dancer did not harmonise. 'Stop,' Mohammed shouted, 'you are wrong.' Yes I know, I said — it seemed to me that Abla had started to hate me. Shall I play slower or faster? 'No,' Mohammed replied, 'you should not play faster or slower, you should play right.' But I played exactly 60 minims, I answered. 'I know,' Mohammed said. 'Following the machine is the best way to play with exactness, which also means to be always wrong. There cannot be a fit between you and Abla, as long as you look at her from the machine's point of view. If I have understood you right, Matthias, this is exactly what the people at the conference in Amsterdam have in mind when they reflect on speed in society. Try it again without the metronome and just concentrate on Abla.' So I took my drum again and started to play. It was not easy, but after a time and with the help of Abla I found the right groove, the appropriate tempo. It fitted. I think I got it, I said to Mohammed with some pride in my voice. 'Yeah,' he said, 'if you continue to practice very hard for ten or twelve years, you might really make it.'

It was getting late and Abla and Mohammed had to go. Ali, I said, I still have to speak to those people in Amsterdam. 'Well,' Mohammed replied, 'try to look at it from a belly-dance drummer's point of view.'

Prisoners of Speed
First let me thank Michiel Schwarz and the organisers of this conference for challenging us to prepare an intervention. My circle of friends in Bremen owe it to your programme that we have examined a neglected subject, the historicity of speed. Let me take you right to the core of the issue by expressing my thanks in old-fashioned English: Michiel, 'God speed thee and thy close!' Milton's words would fit the occasion well. 'To speed' then meant 'to prosper' and not 'to go fast'.

We come here as a trio to give you a sense of the conversation you have provoked among us. Like myself, Matthias Rieger the musicologist, and Sebastian Trapp the limnologist, owe you a debt. We began to focus — each in his domain — on speed as an age-specific phenomenon. The three of us, a historian, a musicologist and a biologist, are by no means alone. Just as speed played no role in the performance of music, falconry and fishery, so commerce, medicine, and architecture, until the seventeenth century, thrived without reference to it. While preparing for this event, each of us became aware of distortions people tend to project on past epochs when they look back with the prejudice that the idea of speed was relevant for Aristotle, Archimedes or Albert the Great.

From the programme of the conference, and from the tone of those lectures I have heard so far, it is obvious that I am addressing people imprisoned in the age of speed. Common sense tells them that some idea of 'space over time' and, more generally, 'process correlated with time', is part and parcel of all cultures. The task incumbent on the three of us, then, is that of shaking your common sense. We know that the idea of speed is assuredly historical. Starting with the late Middle Ages, concern with speed emerged and, step by step, decisively contributed to the era of machines and motors. By 1996, the historical Epoch of Speed lies behind us. During that time, homo technologicus had been harried by the experience of speed: from home to factory, through schools and jobs, from work to vacation, forever suffering time-scarcity on a tight schedule run by the clock. Rush shaped the mood.

If today you are still hurried, it is a mark of your privilege, a sign that you have not yet been forced from the culture of time-scarcity into a new period of the megahertz and unemployment. RPM and labour-power are eclipsed by MHz. Transformations in production, switching from employees to computers, from classroom to the Internet, from clerks to credit cards, have not prepared us for this new culture, the age of the megahertz; it is based on the speed of light. In this new epoch, also the age of the constant c, real time processes simulate global omnipresence, and do get us electronically from here to there, but the experience of the in-between, which fed the speed addiction of modern man, is gone.

Here I am with my conviction. Call it an insight or a prejudice or take it as an outsider's possibly fruitful hypothesis: the Age of Speed had a beginning, and we talk about its history because we witness its end. Made into outsiders by this conviction, we address an assembly of professionals who search for methods to incorporate speed into the crucial dimensions of design. In this plush theatre, I witness a conversation on the speed appropriate to human existence; soul searching about the moral demands placed on designers by self-proclaimed 'slobbies' (slow but better working people) who plead for designed deceleration; planners who discuss high and low, fast and slow, endurable and destructive speed. These are the people we are called to inform. They are professionals, self-imprisoned by the certainty that speed encompasses everything, but needs proper control. It's speed which matters for them, which matters like the term for the man in gaol.

As I ruminated on this fixation, I was reminded of a meeting in Oslo last year. A conference was held at the Northern Academy of Science, organized by Nils Christie, the criminologist, the one who writes on Gulags, western-style. In all political jurisdictions today, the Gulag now grows at a faster rate than other types of welfare institutions. The meeting brought together the heads of prison administration in fourteen countries, from the general who runs Russian prisons to the Federal Commissioner of Corrections in the USA. The theme: brakes that have to be put on this growth. I listened to three days of country reports, and then led the final day's discussion.

I was impressed by the unanimity among these top wardens. Each report stressed that prison terms do not accomplish what they are meant to do: they do not prevent crime, do not correct tendencies or behaviour, and do not punish to the satisfaction of the prisoner's victims. The chief gaolers present insisted that prisons are useless, but all of them nevertheless advocated more funds to improve the job they do.

My task was to make a summation. Professor Christie wanted me to place this conundrum into an historical frame. I happen to

know the 'Prince's Mirrors' medieval books about the duties of lords. Christian princes were forbidden to use the tower as a punishment; it was confined to housing people until public execution, torture or mutilation. How should I explain that all modern societies make costly investments in prisons that have proven ineffective in any of the purposes assigned to them? How should I explain the readiness of criminologists, politicians and taxpayers to support the costly job of wardens? How should I understand the reason for the unreasonable certainty that Gulags must be?

To answer these questions, I must first determine the effects of the Gulag. What the Gulag does is counter-productive, if you measure it against the purposes that imprisonment is supposed to serve. The institution obviously does the opposite of what it is meant to do. So, let me examine what the Gulag says, focusing my attention on the Gulag not as a tool but as a sign, a sign for those willing to pay for it, rather than a sign for those held in it — prisoners and wardens. I must come to hear what the Gulag says to those who finance it, because they are stuck with the need for it. What each story or news item about the expanding Gulag says to them is: Unlike those in for a term, you are free! and, You must enjoy this freedom! You are free in spite of jumping at the alarm clock and punching in with the time clock, regardless of how long you wait to see the welfare worker for your unemployment benefits. Being outside prison, you have wider educational opportunities. You have options to select among offerings, but only if you translate thirst into a desire for a Coke … or a Pepsi. You have good reasons to forget about water, because what comes from the tap is bad for your health. You enjoy a choice of selections in a range of alternatives much larger than that of the man in for a term. The Gulag tells you, 'Pick your preference!'.

In Oslo, I was faced by prison-providers, both experts on the counter-productivity of the Gulag and administrators committed to its quantitative development and qualitative improvement. What kind of assembly could I compare them to? I addressed them as cardinals, but I really thought of Pueblo shamans at a rain dance. The shaman prepares for the yearly dance that must be celebrated in the village, but he also has the authority to declare why the rain does not come, in spite of the ceremony. It does not rain because somebody goofed up in the dance. Sociologists use the rain dance as a technical term for a myth-making ritual, a mythopoeic event that generates belief and confirms social dogma. Max Gluckman speaks of such ceremonies as a social pattern that blinds all participants — be they priests or faithful — to the contradiction between the rite's alleged purpose and its effects. The liturgy is meant to bring rain, but in fact establishes the need for the dance.

For some years I have looked at the great service institutions of modern societies, not just for what they do, but also for what they say; not as productive agencies, but as myth-making rituals. In my jaundiced view, compulsory school is a rain dance performed for the sake of equality, but in fact provides society with the certainty that school must be. Looking for actual results, one can find the grading of twelve levels of class-specific drop-outs. In a similar way, modern penologists claim that imprisonment, even capital punishment, maintains the state's sovereignty, based on the need for an agency to define crime and punish criminals. Today,

with my two friends, I want to underline the ritual, ceremonial myth-making function of design.

Here I speak to a very special kind of shaman — not teachers or physicians, not prison officials or transportation engineers, but designers. They do not conduct, rather, they design liturgy. They do not govern the enclaves, but act as advisers to those who construct them. They are not the progeny of shoemakers or masons, but the descendants of a Renaissance brain child, the <u>disegno</u>. They are experts in the intentional and reflected integration of sundry artefacts; sources of a new weave that distinguishes the Baroque from the Gothic.

However, designers not only provide the shape of integration, they inevitably spread guiding assumptions about the principles to which the elements of a whole ought to be subservient. Both the cockpit of the car and the humble door handle sell ergonomics; they tickle and attract your seat and your hand. For half a century ergonomics — things designed to fit the body — has been an assumption spread by designers. But the new given you want to put on the agenda, speed, has the power to disembody. It disembodies one's perception of the falcon no less than of the Beethoven sonata. That is what my friends Trapp and Rieger have just tried to explain, and that is also my main point.

For decades, design has peddled speed, most of the time surreptitiously and uncritically. Faster seemed better. Now you want to open a new epoch with the claim that slow speed can be beautiful, and appropriate speed optimum. You want to open an era of intense speed awareness, and promote it by means of design. You want design that hails the postmodern slobbies: slower but better working people who punctiliously protect their appropriate pace.

In the twentieth century, the quest for high speed privileges a minority and consumes the majority's time. Drive-and-Fly is not everyone's business, but every person must get around the distance that fast vehicles create. Aerodynamic streamlining sold industrial models of a chair or coffee pot in 1970. The suggestion of speed meant up-to-date, and high speed seemed as alluring as the latest body fashions.

What you now propose goes much further: you assume that everything is drenched in speed, the speed you want to control. This cannot but confirm the omnipresence and omnipotence of an addictive fix.

Yes, it's a new kind of fix, a chimera unrecognized before Galileo Galilei, and hard to believe for a century after his death: the idea of s/t, space-over-time. We are here, Trapp, Rieger and I, to stress that neither falconers nor musicians nor philosophers grasped this conflation of space and time. That notion of motion did not fit their world, a world centred on each person, and stretched out before each, to be encompassed step by step. A world in which inns sat at the end of a day's journey; twelve hours had to fit from morn to night, in winter as well as summer; and squares were measured by feet. Experienced expanse cannot stand in a fraction above lived time.

As one of us just said, the experience of speed appalled the first rail passengers. They felt that the train, speeding through the world, required a new word, and adopted 'landscape' for places they saw rushing by the compartment window, without ever setting foot in one. We are told that train schedules brought the minute into society, ticking time for the passenger by the whistle of the engine. Speed replaced rhythm with measured beat. Your current pet project offers to moderate this transfer. My friends and I, however, explore the overlooked speed-less zones of experience. We do not seek an escape from the gaol of high speed into a world of less irksome restraints; we ask if and where the shadow of speed can be shirked altogether.

Beethoven's experience with the metronome still holds true, and not only for the three of us. When we sing or listen to live music, speed fades. It neither has a grip on us, nor do we feel the urge to control it. Rhythm takes over. When I read hexameters, I enter their rhythm, because I well know that tempo was assigned to antique poetry only after 1630 by zealous schoolmen. Speed is in conflict with aliveness.

For people like us, speed is a crude example of historical congeries gratuitously attributed to nature. It comes out of a bodyless lust that lies deeper than the major assumptions on which the modern world is built — the need for an appropriate institutional treatment for crime, education, the pursuit of health, or insurance. Today's Pantheon is inhabited by these gods, who govern the modern world. But one finds speed in the dark zone beneath them, where the Greeks placed the Titans, the mighty ones who gave birth to divinities.

As far as speed goes, my friends and I are nihilists. When Galileo proposed this notion to study gravitational attraction on an inclined plane, and Kepler applied it to calculate the movement of heavenly bodies along elliptical trajectories, they recast physics. They astonished their contemporaries as, three hundred years later, quantum physicists astonished their peers. They had to disembed the click of time from the flow of temporality, and detach abstract space from the here and now, where the three of us try to enjoy life with our friends.

I have tried to live as a pilgrim, taking one step after another, entering into my time, living within my horizon, which I hope to reach with the step, the surprising step I take to die. *End*

Martin Creed
Thirty-nine metronomes beating time,
one at every speed 1995–1997
Work no. 112 (2/3)
Metronomes
Dimensions variable
Private collection, London

About the Authors

JG Ballard
is a novelist and cultural commentator. After working for many years as a science journalist, his first novel, _The Drowned World_, was published in 1961. Among his many subsequent books are _The Atrocity Exhibition_ (1970), _Crash_ (1973), _Myths of the Near Future_ (1982), _Empire of the Sun_ (1984) and _A User's Guide to the Millenium_ (1996).

Nancy Campbell
is an independent writer and curator. She has curated numerous national and international exhibitions of new technologies including _Stan Douglas, Frankenstein_ and _David Rokeby: The Giver of Names_.

Blaise Cendrars
was the pseudonym of Frederic-Louis Sauser (1887–1961), a Swiss-born poet and novelist. He was the author of more than twenty books including _Moravagine_ (1926) and _Aujourd'hui_ (1931). He was associated with the Cubist movement and was one of the founders of the modern movement in literature.

Edward Dimendberg
is assistant professor in the Department of Germanic Languages and Literatures, the Program in Film and Video, and the College of Architecture and Urban Planning at the University of Michigan. He is editor (with Anton Kaes and Martin Jay) of _The Weimar Republic Sourcebook_ (1994) and the author of _Film Noir and the Spaces of Modernity_ forthcoming.

Susan George
is an independent scholar and political economist based in Paris. She is associate director of the Transnational Institute, Amsterdam and author of many books including _A Fate Worse than Debt_ (1992) and _Faith and Credit — The World Bank's Secular Empire_ (with Fabrizio Sabelli; 1996).

Ivan Illich
is a philosopher and social thinker based in Cuarnavaca, Mexico. His many books include _De-Schooling Society_ (1970), _Celebration of Awareness_ (1970), _Tools for Conviviality_ (1973), _Energy and Equity_ (1974), _H_2O and the Waters of Forgetfulness_ (1985) and _In the Vineyard of the Text_ (1993).

Mark Kingwell
is a political theorist, author and critic, teaching in the department of philosophy at the University of Toronto. He is the author of _A Civil Tongue: Justice, Dialogue, and the Politics of Pluralism_ (1995) and _Dreams of Millennium: Report from a Culture on the Brink_ (1996).

Scott McQuire
lectures in art and architecture in the School of Social Inquiry, Deakin University, Australia. He is the author of _Visions of Modernity — Representation, Memory, Time and Space in the Age of the Camera_ (1998).

Jeremy Millar
is an artist, and Programme Organiser at The Photographers' Gallery, London. He has written for numerous publications and is the editor (with Steven Bode) of _Airport_ (1997). He is curator of exhibitions on 'Speed' at the Whitechapel Art Gallery and The Photographers' Gallery, London, and, with Nancy Campbell, at the Macdonald Stewart Art Centre, Ontario, Canada.

Robert Musil
born at Klagenfurt, Austria, in 1880, was a trained scientist, philosopher and one-time army officer. He was engaged in his unfinished masterpiece, _The Man Without Qualities_, from the early 1920s until his death in exile in Geneva in 1942. Among his other literary works are _Young Törless_ and _Tonka and Other Stories_.

Judith Nasby
is the Director of the Macdonald Stewart Art Centre, Guelph, Canada. She has been a curator and public art gallery director for 25 years. Recent curatorial projects include _Qamanittuaq_, a touring exibition of Inuit drawings by Baker Lake artists from the Art Centre's collection of contemporary Inuit drawings and a touring exhibition of 1930s design drawings, paintings and jewellery by the Canadian artist Rolph Scarlett.

Helga Nowotny
is professor of philosophy of science and social studies of science at the Swiss Federal Institute of Technology, Zürich. She is the author of _Time — The Modern and Postmodern Experience_ (1994).

Matthias Rieger
trained in literature and musicology, currently lives and works in Bremen, Germany, where, among other things, he is engaged in doctoral research into the history of acoustics.

Kristin Ross
is professor of comparative literature at New York University and the author of _Fast Cars, Clean Bodies — Decolonization and the Reordering of French Culture_ (1996).

Wolfgang Sachs
is senior researcher at the Wuppertal Institute of Climate, Energy and Environment, Germany. He is the author of _For Love of the Automobile — A Cultural History of Our Desires_ (1992) and editor of the _Development Dictionary_ (1993), _Global Ecology_ (1994) and _Greening the North — A Post-Industrial Blueprint for Ecology and Equity_ (with Reinhard Loske, Manfred Linz, et al, 1997).

Michiel Schwarz
is an independent researcher and writer on technological culture based in Amsterdam. He programmed and chaired the 1996 'Doors of Perception' conference on 'Speed' (with John Thackara), at the Netherlands Design Institute, where he is currently senior advisor. His books include _The Technological Culture_ (edited with Rein Jansma; 1989) and _Divided We Stand — Redefining Politics, Technology and Social Choice_ (written with Michael Thompson; 1990).

Peter Sloterdijk
is one of the leading contemporary German thinkers. In the German tradition of cultural criticism his work includes a wide range of topics including politics, literature, architecture, psychology, philosophy, the media and fiction. He is professor of philosophy and aesthetics at the University of Karlsruhe. Among his many publications are _Critique of Cynical Reason_ (1987) and _Eurotaoismus — Zur Kritik der politischen Kinetik_ (1989; not translated into English) an excerpt of which is published in this volume.

Sebastian Trapp
is a biologist and writer currently working on ecological research at the University of Bremen, Germany.

Paul Virilio
is an urbanist, architect and writer who
has pioneered the field of dromology (the
social analysis of speed) He is professor
at the Ecole Spéciale d'Architecture,
Paris. His works include _Speed and
Politics_ (1986), _War and Cinema — The
Logistics of Perception_ (1989), _The
Aesthetics of Disappearance_ (1991),
Bunker Archeology (1994), _The Vision
Machine_ (1994), _The Art of the Motor_
(1995), and _Open Sky_ (1997).

Peter Wollen
is film theorist, film maker and professor
of film and critical studies at the
University of California at Los Angeles.
His books include _Raiding the Icebox:
Reflections on Twentieth Century Culture_
(1993) and _Visual Display — Culture
Beyond Display_ (edited with Lynne
Cooke; 1995).

Scene of strewn wreckage.

(Right) Illustration showing distance wreckage traveled. (Figure in foreground points to impact area. Figure in background stands at farthest point of wreckage, 189 feet from point of impact.)

Lenders to the
Macdonald Stewart Art Centre

Art Gallery of Ontario

Corinne McLuhan,
Toronto

Art Gallery of Hamilton

Macdonald Stewart Art Centre

University of Guelph

Leo Kamen Gallery,
Toronto

Montreal Museum of Decorative Arts

Twentieth Century Gallery,
Toronto

and those lenders who
wish to remain anonymous.

Note
Where appropriate works reproduced in this book are accompanied by the appropriate page number.

Catalogue of works in the exhibition at the Whitechapel Art Gallery, London

RA Bertelli
Continuous Profile of Mussolini 1933
Glass fibre and resin copy of terracotta original
34 x 28cm
Collection Imperial War Museum, London
Page 114

Joseph Beuys
Schlitten (Sled) 1969
Wooden sled, felt, flashlights, fat
35 x 90 x 35cm
Collection Richard Hamilton

Pierre Bismuth
L'histoire de Soldat 1998
VHS video, infra-red headphones
14 minute loop
Courtesy of the artist

Umberto Boccioni
Unique Forms of Continuity in Space
1913, cast 1972
Bronze
117.5 x 87.6 x 36.8cm
Tate Gallery, London. Purchased 1972
Page 107

Mark Edelman Boren
Budgie stuffed with JG Ballard's 'Crash'
1991
Mixed media (bird, book, wood)
33 x 21 x 13cm
Collection Mark Edelman Boren
Page 129

Arthur D. Bracegridle, USA
Keracolour Television c.1969
White GRP housing on pedestal base
110 x 80 x 60cm
Courtesy Bonhams Design Department,
London

Marcel Breuer
Club Armchair, 'Wassily' 1927–28
Chrome-plated tubular steel with coach hide seat and straps
73.5 x 78.8 x 70cm
Courtesy Aram Designs Limited, London
Page 105

Chris Burden
C.B.T.V. to Einstein December 28, 1977
Hand-made model airplane, wood and paper mounted within plexiglass box lined with velvet, printed card
21 x 39 x 34cm
Collection Mandy and Cliff Einstein
Page 27

Vija Celmins
Untitled (Large Desert) 1974–75
Graphite on acrylic ground on paper
48.3 x 36.2cm
Collection The Chase Manhattan Bank, New York
Page 132

Blaise Cendrars
La Fin du Monde filmée par l'Ange N-D
(The End of the World filmed by the Angel N-D)
Compositions in colour by Fernand Léger
Paris: Editions de la Sirène, 1919
54 pages, 32cm
Edition of 1200, no. 988
Chelsea College of Art & Design Library
(The London Institute)

Ilya Chasnik
Horizontal Composition c.1921
Watercolour, gouache and pencil on heavy paper 17.5 x 28.5cm
Private collection
Page 49

Ilya Chasnik
Design for a Suprematist Architectonic Composition c.1923
Watercolour, gouache and pencil on paper
16.6 x 22cm
Private collection
Page 48

Le Corbusier
Automaxima Car 1928/1989
Wood
140 x 360 x 180cm
Design Museum, London
Page 107

Martin Creed
Thirty-nine metronomes beating time, one at every speed 1995–1997
Work no. 112 (2/3)
39 metronomes
Dimensions variable
Private collection, London
Page 158

Sonia Delaunay and Blaise Cendrars
La prose du Transsibérien et de la Petite Jehanne de France (The Prose of the Transsiberian and of little Jehanne of France)
Paris: Editions des Hommes Nouveaux, 1913
Paper, ink, parchment covers
197.5 x 35.5cm
The Board of Trustees of the Victoria & Albert Museum, London
Page 25

Charles Demuth
Incense of a New Church 1921
Oil on canvas
66 x 51.1cm
Columbus Museum of Art, Ohio. Gift of Ferdinand Howald
Page 147

Jan Dibbets
The Shortest Day at the Van Abbemuseum
1970
Coloured photo panel
177 x 171cm
Stedelijk Van Abbemuseum Eindhoven
Page 134

Marcel Duchamp
In Advance of the Broken Arm 1915,
replica by U. Linde, signed by the artist, 1963
Metal spade
109 x 42cm
Moderna Museet, Stockholm
Page 92

Marcel Duchamp
Rotoreliefs (Optical discs)
Paris: Edition MAT, 1959
6 discs with offset lithographic print on each side, with black velvet wall-mounted turntable.
Discs: each 20cm diameter
Edition of 100, Schwarz no. 441b
Chelsea College of Art & Design Library
(The London Institute)

Charles and Ray Eames
Rocking Chair 1950's
Fibreglass shell, steel frame, oak rockers
60 x 60 x 60cm
Courtesy Penthouse, Highpoint, London

Jacob Epstein
Study for 'Rock Drill' 1915
Charcoal on paper
67.5 x 42.5cm
The Garman Ryan Collection, Walsall Museum and Art Gallery
Page 100

Alexandra Exter
Composition (Genoa) 1912
Oil on canvas
115.5 x 86.5cm
Private collection. Courtesy Julian Barran Ltd., London
Page 147

Dan Flavin
Untitled (Monument for Vladimir Tatlin)
1975
304.5 x 61 x 12cm
Fluorescent tubes
Musée d'Art Moderne de Saint-Etienne
Page 96

Manifesti del Movimento futurista
(Manifestos of the Futurist Movement)
Milan: Direzione del Movimento futurista, 1909–14
30 x 23cm each
Chelsea College of Art & Design Library
(The London Institute)

Filippo Tommaso Marinetti
Manifesto del Futurismo
(Futurist Manifesto)
Published in *'Le Figaro'*, 20 February, 1909

Umberto Boccioni, Carlo Carrà, Luigi Russolo, Giacomo Balla, Gino Severini
Manifesto dei Pittori futuristi
(Manifesto of Futurist Painters)
11 February, 1910

Umberto Boccioni, Carlo Carrà, Luigi Russolo, Giacomo Balla, Gino Severini
La Pittura futurista – Manifesto tecnico
(Futurist Painting – Technical Manifesto)
11 April, 1910

Francesco Pratella
Manifesto dei Musicisti futuristi
(Manifesto of the Futurist Musicians)
11 January, 1911

Francesco Pratella
La Musica futurista – Manifesto tecnico
(Futurist Music-Technical Manifesto)
29 March, 1911

Umberto Boccioni
Manifesto technico della Scultura futurista
(Technical Manifesto of Futurist Sculpture)
11 April, 1912

Filippo Tommaso Marinetti
Manifesto tecnico della Letteratura futurista
(Technical Manifesto of Futurist Literature)
11 May, 1912

Filippo Tommaso Marinetti
Supplemento al Manifesto tecnico della Letteratura futurista
(Supplement to the Technical Manifesto of Futurist Literature)
11 August, 1912

Luigi Russolo
L'Arte dei Rumori (The Art of Noises)
11 March, 1913

F.T. Marinetti
L'Immaginazione senza fili e le Parole in libertà (Imagination without ties and Words in Freedom)
11 May, 1913

Guillaume Apollinaire
L'Antitradizione futurista (The Futurist Anti-tradition)
29 June, 1913

Carlo Carrà
La pittura dei suoni, rumori e odori
(Painting of sounds, noises and smells)
11 August, 1913

Naum Gabo
Kinetic Construction (Standing Wave)
1919–20, replica 1985
Metal, painted wood and electrical mechanism
61.6 x 24.1 x 19cm
Tate Gallery, London. Presented by the artist through the American Federation of the Arts, 1966
Page 98

Rodney Graham
School of Velocity 1993
Yamaha disklavier piano, computer, two purpose-built tables and twenty-four musical scores each of sixty pages representing twenty-four hours of music
Scores: 32.5 x 45.5cm each
Tables: 102 x 376 x 129.5cm each
Lisson Gallery, London

Richard Hamilton
Hommage à Chrysler Corp 1957
Oil, metal foil and collage on wood
122 x 81cm
Tate Gallery, London. Purchased with
assistance from the National Art
Collections Fund and the Friends of the
Tate Gallery, 1995
Page 102

Siobhán Hapaska
Mule 1997
Fibreglass bodyshell, two pack acrylic
lacquer, upholstery, electronic and audio
components
216 x 178 x 92cm
Jedermann Collection, N.A.
Page 127

Siobhán Hapaska
Land 1998
Moulded fibreglass, two pack acrylic
lacquer, air plants
147 x 246 x 100cm
Collection Thomas Dane and
Anne Faggionato
Page 127

Sir Hubert von Herkomer
Die Zunkunft (The Future) 1905
Coloured photogravure on menu card
24 x 16.5cm
Yale Centre for British Art. Gift of Hans
and Agnes Platenius

On Kawara
May 7th, 1991
Liquitex on canvas
25.5 x 33cm
Collection Isabelle and Jean-Conrad
Lemaître
Pages 22–23

Ivan Kluin
Study for 'Landscape Rushing By' c.1914–15
Brush and ink wash on paper
16 x 14.8cm
Private collection. Courtesy Julian Barran
Ltd., London
Page 57

Fernand Léger
Ballet mécanique 1924
VHS recording from 35 mm colour print
20 minutes
Collection Cinématographique du Centre
Georges Pompidou/Musée Nationale d'Art
Moderne/Centre du Création Industrielle,
Paris

Fernand Léger
Hommage à la Danse 1925
Oil on canvas
159 x 121cm
Collection Paule and Adrien Maeght, Paris
Page 105

Barry Le Va
Velocity Piece 1970
Audio tape, 22 b/w photographs, 1 drawing
Photographs each: 40.5 x 40.5cm
Drawing: 58 x 42.5cm
Courtesy Sonnabend Gallery, New York
and Galerie Georges Philippe Vallois, Paris

Wyndham Lewis
Futurist Figure 1912
Pencil, pen, ink and watercolour
26.4 x 18.3cm
Private collection, London
Page 108

Wyndham Lewis
Blast
Review of the Great English Vortex
No. 1, 20 June, 1914
30 x 23cm, 164 pages

No. 2, July 1915
29.5 x 25cm, 108 pages
Collection Austin/Desmond Fine Art, London

Micah Lexier
A Minute of my Time
Acid-Etched Stainless Steel, pins
Each 53 x 33cm
Collection the artist
(June 26, 1998 19:15 – 19:16)

(June 26, 1998 19:16 – 19:17)

(June 26, 1998 19:26 – 19:27)

(June 26, 1998 19:27 – 19:28)

(June 26, 1998 19:28 – 19:29)

(June 26, 1998 19:32 – 19:33)

Roy Lichtenstein
In the Car 1963
Oil and magma on canvas
172 x 203.5cm
Scottish National Gallery of Modern Art,
Edinburgh
Page 17

El Lazar Lissitzky
Composition No. 9 c.1920
Watercolour and gouache over pencil
18 x 24cm
Private collection. Courtesy Julian Barran
Ltd., London
Page 109

Rachel Lowe
A Letter to an Unknown Person no. 5 1998
Super 8 film
1 1/2 minute loop
Courtesy of the artist

John McCracken
Mach 2 1992
Polyester resin, fibreglass and wood
23 x 305 x 41cm
Lisson Gallery, London
Page 45

Filippo Tommaso Marinetti
Zang Tumb Tum, Parole in Libertà
(Words in Freedom)
Adrianopoli October 1912, Edizioni
Futuriste di 'Poesia', Milan, 1914
Book, 225 pages with signed pictograph
inscription on the front free paper by
'Furturist Marinetti' in the form of a full-page
Futurist wedge attacking a Passeist cloud
and dedicated to Lady Constance Hatch
200 x 140 mm x 15 mm
Private collection, Saffron Walden

Henri Matisse
The Windshield, On the Villacoublay Road
1917
Oil on canvas
38.2 x 55.2cm
The Cleveland Museum of Art. Bequest of
Lucia McCurdy McBride in memory of
John Harris McBride II, 1972.225
Page 92

Tony Messenger
30 September 1955 1958
Oil on board
120 x 240cm
Private collection
Page 78

Gustav Metzger
Extremes Touch 1968/1998
Iron rod, electric hotplate, copper tube,
suspended water drop, water
Variable dimensions
Courtesy the artist

John Minton
Composition: The Death of James Dean
1957
Oil on canvas
121.9 x182.9cm
Tate Gallery, London. Presented by the
Trustees of the Chantrey Bequest,1957
Page 74

Octave Mirbeau
La 628-E8
Margin sketches by Pierre Bonnard
Paris, Librairie Charpentier, 1908
416 pages, 25cm
Numbered edition of 225, no. 200
Chelsea College of Art & Design Library
(The London Institute)

Hans Namuth
Jackson Pollock 1951
VHS b/w
10 minutes
Courtesy Museum of Modern Art, New
York, Circulating Film and Video Library

Verner Panton
Stacking Side Chair 1959–60
PU Foam Baydur
85 x 55 x 55cm
Courtesy Aram Designs Limited, London

Eduardo Paolozzi
*The Krazy Kat Arkive of Twentieth
Century Popular Culture*
The Board of Trustees of the Victoria &
Albert Museum, London
Box containing Model *49 Ford Tudor*
Made by Pyro Plastics
12 x 21 x 5cm

Box containing Model *49 Ford Ragtop*
Made by Pyro Plastics
Paper, plastic
12 x 21 x 5cm

Box containing Model *50 Ford Convertible*
3 in 1 set. Made by Trophy Series
Paper, plastic
16 x 24 x 10cm

Box containing Model *Chrysler
Corporation Turbine Car*
Made by Jo-Han Ltd.
Paper, plastic
18 x 27 x 5cm

Box containing Model *Pontiac Club de Mer*
Made by Revell (GB) Ltd.
Paper, plastic
14 x 30 x 4cm

Never Leave Well Enough Alone 1949
Print from 4 lithographs
Published in *Bunk* by Snail Chemical
Publishing Ltd., 1972
Paper
27 x 37cm

Francis Picabia
Portrait of Alfred Stieglitz
Front cover, *291 Journal*, issues 5 & 6,
July-August, 1915
Ink on paper
44 x 29cm
The Board of Trustees of the Victoria &
Albert Museum, London
Page 105

Liubov Popova
Painterly Architectonic c.1919
Oil on canvas
65 x 50cm
Private collection, Germany

Paul Ramírez Jonas
Man on the Moon, parts IV and V 1998
533 Wax cylinders, wood and metal
phonograph, book
Cylinders: each 18 x 10.5cm diameter
Courtesy the artist
Page 29

Ed Ruscha
Standard Gas Station (Study) 1963
Tempera and ink on paper
28 x 45.7cm
Courtesy Anthony d'Offay Gallery, London
Page 130–131

Ed Ruscha
Royal Road Test 1967
Book; 62 pages
Paper, ink
24 x 16.5cm
The Board of Trustees of the Victoria &
Albert Museum, London
Pages 162–163

Ed Ruscha
Miracle # 12 1975
Zinc oxides and pastel on Strathmore paper
98.1 x 74.3cm
Courtesy Anthony d'Offay Gallery, London
Page 142

Ed Ruscha
Miracle 1975
16 mm film, colour
35 minutes
Courtesy Anthony d'Offay Gallery, London

Ed Ruscha
Racecar Drivers 1998
Acrylic and ink on paper
76.5 x 101.2cm
Courtesy Anthony d'Offay Gallery, London
Page 58–59

Alfons Schilling
Untitled (Rotation Painting) 1962
Acrylic on canvas
227cm diameter
Courtesy the artist

Walter Richard Sickert
Miss Earhart's Arrival 1932
Oil on canvas
71.7 x 183.2cm
Tate Gallery, London. Purchased 1982
Page 92

Robert Smithson
Rundown 1969
VHS recording of a compilation of stills
by the artist and others, and Super 8 film
footage shot by Nancy Holt of the artist at
work in 1969 making three outdoor pieces:
Glue Pour in Vancouver, *Concrete Pour* in
Chicago and *Asphalt Rundown* in Rome.
Soundtrack includes excerpts from
interviews with the artist.
Colour, sound, 15 minutes
Producer: Robert Fiore
Director: Jane Crawford
Courtesy Museum of Modern Art, New
York, Circulating Film and Video Library

Robert Smithson
1,000 tons of Asphalt 1969
Ink, pencil and crayon on paper
45.7 x 61cm
Collection Nancy Holt

Robert Smithson
Trailer with Asphalt 1970
Pencil on paper
48.2 x 61cm
Estate of Robert Smithson, Courtesy John
Weber Gallery, New York
Page 123

Jem Southam
Red Mudstone, Sidmouth, Devon,
December 1995 – May 1996
Four colour C-type photographs
30.5 x 40.6cm
Courtesy of the artist
Pages 172–179

Nikolai Mikhailovitch Suetin
Suprematist Design for Cup and Saucer 1923
Watercolour on paper
23 x 28cm
Private collection. Courtesy Julian Barran
Ltd., London

Hiroshi Sugimoto
Union City Drive-In, Union City 1993
Black and white photograph, edition of 25
50 x 60cm
Courtesy Sonnabend Gallery, New York
Page 36–37

Andy Warhol
Empire 1964
16 mm, black and white
8 hours 5 minutes
Courtesy Museum of Modern Art, New
York, Circulating Film and Video Library

Lawrence Weiner
*ESCALATED FROM TIME TO TIME
OVERLOADED FROM TIME TO TIME
REVOKED FROM TIME TO TIME
HAVING FROM TIME TO TIME A
RELATION TO* 1973
Matt paint
Stedelijk Museum Amsterdam
Page 138

Catalogue of works in the exhibition at the Macdonald Stewart Art Centre, Guelph

Giacomo Balla
Volo di Rondone 1913
graphite on paper
Collection, Art Gallery of Ontario
Gift of Sam and Ayala Zacks, 1970

Giacomo Balla
Donna Coricata +Linee di spazio 1915
graphite, chalk, watercolour on wove
paper
Collection, Art Gallery of Ontario
Gift of Sam and Ayala Zacks, 1970

Dianne Bos
Jet Wing, Over the Prairies 1991
pinhole photograph
Collection, Art Gallery of Hamilton

Greg Curnoe
Mariposa T.T. 1978/79
colour serigraph on Plexiglass
Collection, Art Gallery of Hamilton
Gift of the Volunteer Committee, 1983

Karen Eslea
Untitled (Terminals) 1998
Duratrans lightboxes
Collection of the Artist

Harold Eugene Edgerton
Bullet through Jack of Hearts
silver print
Collection, Art Gallery of Ontario
Gift of Mrs. Rhea Jack, 1986

Henri Gaudier-Brzeska
Ornement Torpille 1914
cut brass
Collection, Art Gallery of Ontario
Purchase, 1985

Dan Graham
Time Extended/Distance Extended
lithograph on wove paper 5/50
Collection, Art Gallery of Ontario
Purchase, 1971

Graham Gussin
Untitled Film 1998
VHS Video Projection
38 minute loop
Courtesy of the artist

Richard Hamilton
5 Tyres Abandoned 1964
screenprint on wove paper
Collection, Art Gallery of Ontario
Gift of Walter Carsen, 1991

David Kennedy
*Grand Trunk Railway Bridge, Across the
Speed at Guelph, Canada West* 1861
watercolour and pencil on paper
Collection, University of Guelph
Gift of Alumni, Alma Mater Fund, 1973

Wanda Koop
Airplanes 1993
ink on paper
Collection of the Artist
Courtesy of Leo Kamen Gallery, Toronto

Wyndham Lewis
Portrait of Marshall McLuhan 1944
black chalk on paper
Collection, Corinne McLuhan, Toronto

Micah Lexier
*A Minute of my time (August 26, 1996 –
20:34)* 1996
laser-cut stainless steel
Collection, Macdonald Stewart Art Centre
Purchased with funds raised by the Art
Centre volunteers and financial support
of the Canada Council for the Arts
Acquisition Assistance Program, 1998

Rachel Lowe
A Letter to an Unknown Person no. 5 1998
Super 8 film
1 1/2 minute loop
Courtesy of the artist

Qavavau Manomee
NASA Graveyard 1989
coloured pencil on paper
Collection, Macdonald Stewart Art Centre
Purchased with funds donated by Blount
Canada Ltd., 1992

Etienne Jules Marey
*Movement, Diagrammatic analysis
of a Jump*
line gravure on wove paper
Collection, Art Gallery of Ontario
Gift of Marta Braun, in memory of Robert
Deshman, 1995

Etienne Jules Marey
*Two Chronophotographic studies of the
run taken from overhead* 1887
gelatin silver print
Private Collection

N.E.THING CO.
1/4 Mile Landscape 1968
hand-tinted silver prints, printed map,
watercolour and graphite on
paper
Collection, Art Gallery of Ontario
Purchase, 1980

Verner Panton
Stacking Side Chair 1959–60
PU Foam Baydur
85 x 55 x 55cm
Collection, Twentieth Century Gallery,
Toronto

Pudlo Pudlat
Landscape with Airplane
coloured pencil and felt-tip marker on paper
Collection, Macdonald Stewart Art Centre
Purchased with funds donated by Blount
Canada Ltd., 1982

Pudlo Pudlat
Untitled (flying figure) 1983
coloured pencil on paper
Collection, Macdonald Stewart Art Centre
Purchased with funds donated by Blount
Canada Ltd., 1988

James Rosenquist
Roll Down 1966
lithograph on paper
Collection, Art Gallery of Ontario
Purchase, 1968

Rolph Scarlett
*Selected design drawings for cocktail
shaker, cart, amusement rides,
guided missile* 1930s
Collection of the Montreal Museum of
Decorative Arts

John Scott
The Avatar (The Deathless Boy) 1998
Œ81Honda Interceptor modified with
three Volkswagon engines,
assorted computer parts, halographic image
Collection of the Artist

Claude Tousignant
Accele023rateur chromatique 1968
Acrylic on canvas
Collection, Art Gallery of Hamilton
Gift of Walter Moos, 1982

*Catalogue of works in the
exhibition at The Photographers'
Gallery, London*

*Doug Aitken
American International 1993
Back-lit transparency, laser disc, laser disc
player, monitor, monitor stand
Dimensions variable
Courtesy of the artist and 303 Gallery,
New York*

*Naoya Hatakeyama
Photographs from the Blast series 1995–98
Colour C-Type photographs
Each 100 x 150cm
Courtesy of the artist
Pages 2–9*

*Rachel Lowe
A Letter to an Unknown Person no. 5 1998
Super 8 film
1 1/2 minute loop
Courtesy of the artist*

*Paul Ramírez Jonas
A Longer Day 1997
VHS video projection
20 minute loop
Courtesy of the artist
Page 38*

*Paul Ramírez Jonas
Revolution 1997
Colour photograph
35 x 250cm
Courtesy of the artist*

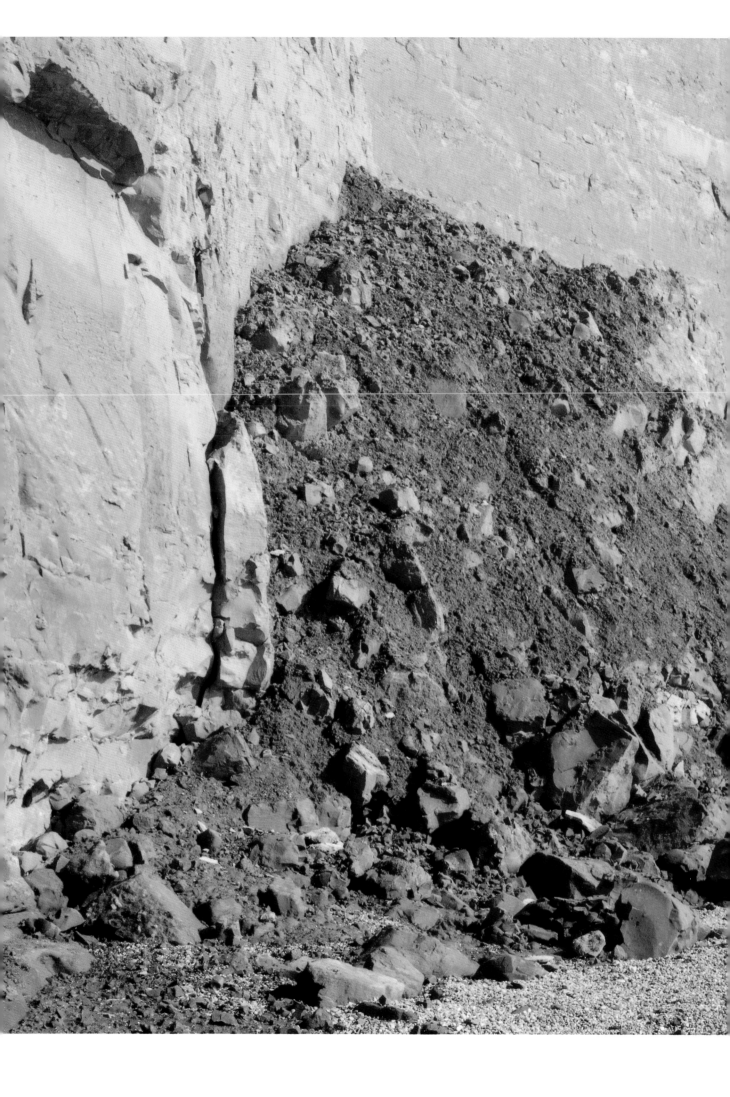

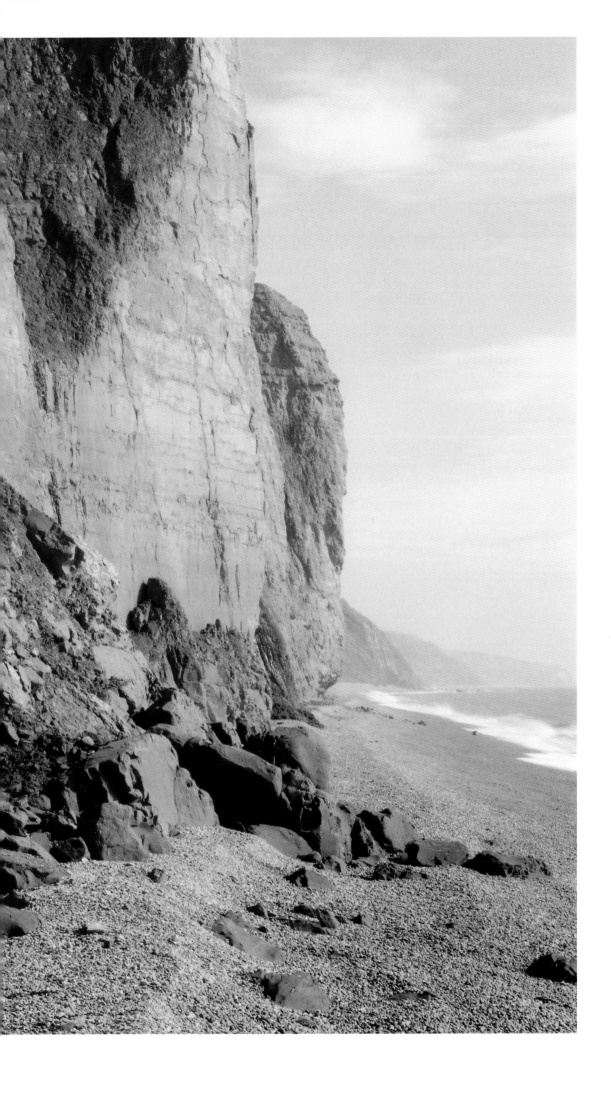

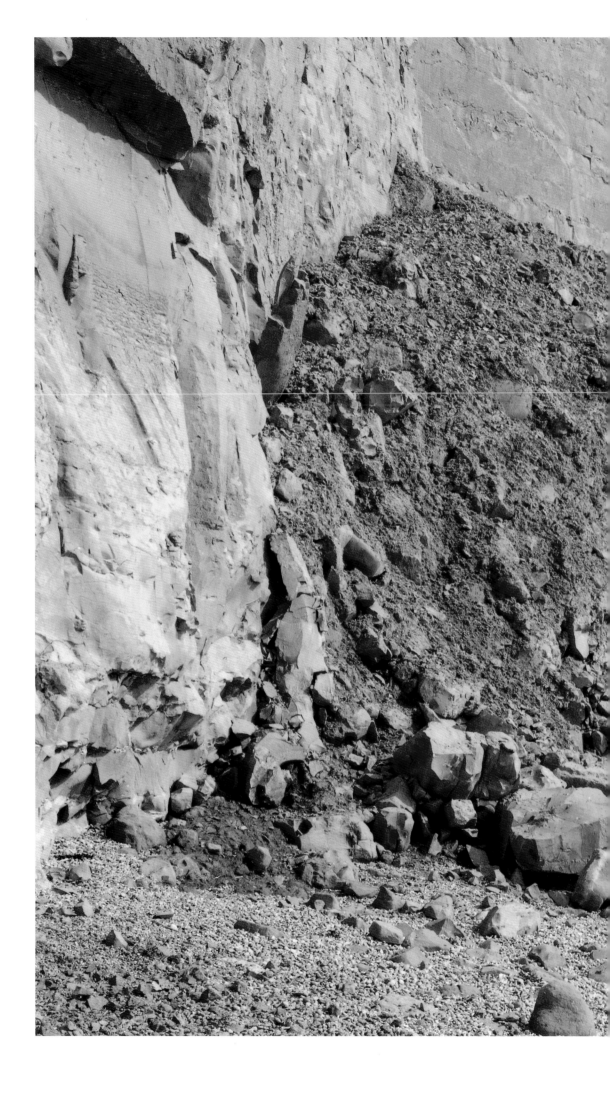

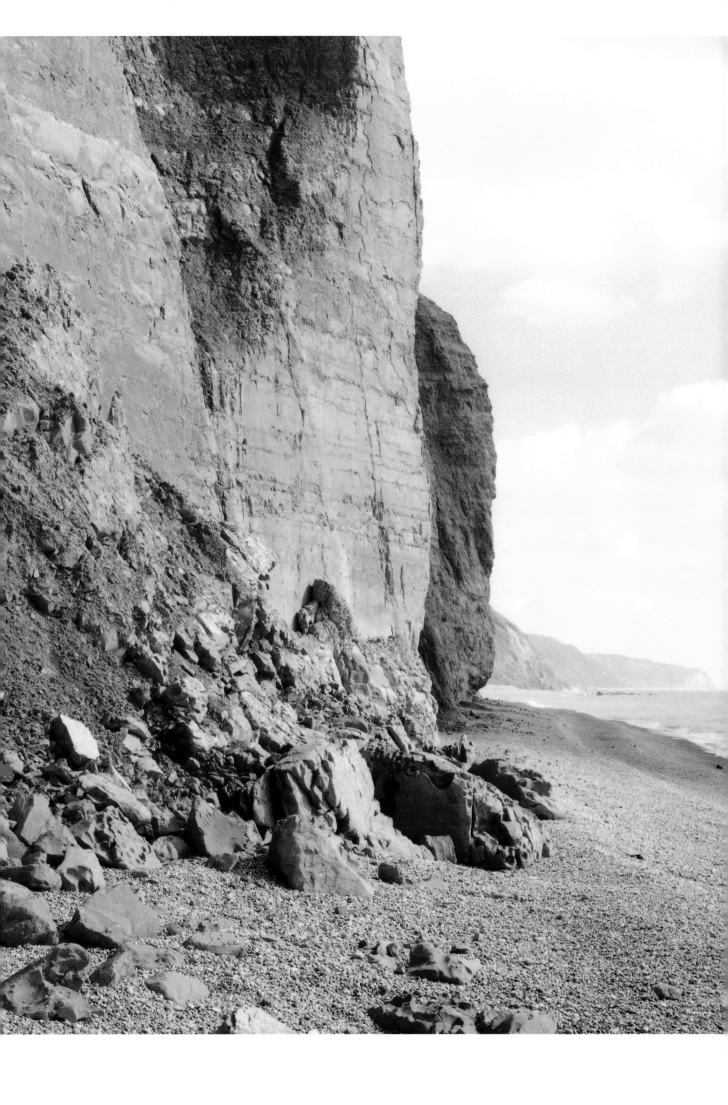

Speed

Whitechapel Art Gallery
11 September–22 November 1998

The Photographers' Gallery
19 September–14 November 1998

Macdonald Stewart Art Centre
24 September–31 October 1998